Art Education
and Multiculturalism

Art Education
and Multiculturalism

Rachel Mason

NATIONAL SOCIETY FOR EDUCATION IN ART & DESIGN

Second (revised) Edition published in 1995 by
NSEAD
The Gatehouse,
Corsham Court,
Corsham,
Wiltshire SN13 0BZ
Tel: 01249 714825
Fax: 01249 716138

First published in 1988 by
Croom Helm
in association with Methuen, Inc.
29 West 35th Street
New York, NY 10001

Printed in Great Britain by
Sebright Printers, Bristol

ISBN 0 904684 19 9

Graphics **TAG DESIGN** Mike Burns
Typesetting **TAG DESIGN** Rick Alexander

Cover Picture: The Swing, Fragonard
By kind permission of the Trustees of the
Wallace Collection, London
Cover Inset: The Swing, Kangra
By kind permission of the Trustees of the
Victoria and Albert Museum, London

© Rachel Mason 1995
National Society for Education in Art & Design

Contents

Figures

Foreword to Second Printing

Interest in the topic of multiculturalism has not abated since the first printing of this book. There have been important changes in British art education since 1988 including general acceptance of the case for more culturally diverse forms of curricula and increased emphasis on discipline-based teaching in primary schools as a consequence of the introduction of a new National Curriculum. Nevertheless, the majority of the multicultural issues and initiatives the book explored remain pertinent today and have continued to evolve. I have taken the opportunity offered by this second printing to make small adjustments to the original text such as correction of typographical and writer's errors, but have elected not to alter wording of quotations and other small passages that, with the passage of time, appear a little dated and, in some cases, sexist. The new edition is in paperback form and the layout and presentation are much improved. I hope this will make the book more visually appealing and accessible to readers - especially to student-teachers seeking ways of delivering more culturally diverse National Curriculum and GCSE examination programmes of study. Because both public policy and my own thinking has moved on, I have added a brief postscript that updates the most important literature and developments since 1988. Otherwise, the book's general structure remains unchanged. I wish to thank John Steers, General Secretary of the National Society for Education in Art and Design (NSEAD) for his support and encouragement and in preparing copy for this printing.

R. M. M. September 1994.

Preface

This book consists of a series of separate papers about art in general education written between 1984 and 1987. The majority were originally conceived of in the form of research reports or lectures.

The papers are of two kinds. Chapters one, two and four are reports of practical experiments with children conducted by myself with primary teachers and/or student-teachers. Chapters three and five are more speculative, generalised and theoretical. In my original proposal to the publishers I outlined what I thought was a sequential plan of action in which theory and practice were cleverly intertwined and chapter followed chapter in neat, tidy progression. The plan never materialised.

Admittedly, I set myself an ambitious task and the failure to realise these aims can be explained in a number of ways. In part it was a consequence of my finding myself in the dilemma that faces any would-be academic working in teacher-training in Britain. On the one hand, publications and research are considered worthwhile enterprises by the institutions in which we are employed, on the other hand, time for publication and research is grudgingly given or non-existent. My secondment to the University of London for one year meant, of course, that I was very much luckier than most. Nevertheless, more time was necessary. Freedom from teaching and other institutional commitments to reflect on practice and to consider its relationship to theory is not a luxury, it is essential to intellectual growth. Until this is understood and acknowledged, art teachers' attempts to theorise and write about their discipline will continue to be subject primarily to the vagaries of fashion, and will constitute a kind of academic second best.

In part, however, the lack of precision is due to a personal preference, in line with that of the anthropologist Clifford Geertz, for enquiry that focuses on particulars rather than universals; and for writing in an essay form. I share Geertz's enthusiasm for approaching the broader interpretations of phenomena and events (of, for example, philosophers, social scientists and historians) from the direction of exceedingly extended acquaintances with very small matters and, for a descriptive genre that allows authors to keep a line of thought going across diverse academic situations and to make detours and go down side roads along the way. Admittedly, this kind of research endeavour has what he describes as a 'stuttering quality'. But for me the avenues opened up are infinitely more thought provoking and challenging than findings that emerge from more hard-nosed kinds of social science research.

In part the book's disarray reflects, also, the nature of the school subject, or discipline, under discussion and the awkward relationship between theory and practice that is part of the larger educational

enterprise and of the field of curriculum overall. As Elliot Eisner has pointed out, practitioners need educational theories and models on which to hang their classroom practice, but theorists' ideas are always challenged and modified when they enter the reality of the educational scene. Neither one can do without the other, yet there is a sense in which curriculum theory and practice always remain separate endeavours, whatever the school-based curriculum enthusiasts or the grounded theorists may say. My writing reflects this dilemma.

While its various chapters consist of a series of descriptive accounts of somewhat disparate educational ideas and events, the book is informed throughout by a particular conceptual problem and addresses a common practical theme. The research problem, which arises out of the recent multicultural, multiracial or multiethnic trend in British educational thinking, is that of the nature or substance of the multicultural curriculum. Its underlying theme is the everyday business of curriculum planning in art and design.

With regard to the first, both the study of the literature and the experience of writing this book have convinced me that is not my place to, nor am I capable of, speaking for the black presence in Britain. But I can and must make more of an effort to alter the conception of my subject which I imbibed during my initial training and take on a much more extensive commitment to teaching about non-European art forms. Also, I can and should make much more space for the views of black colleagues and pupils in the curriculum situations to which I am privy and for their alternative interpretations of both historical and contemporary art and design events. With regard to the latter, my knowledge and experience of curriculum in other countries has led me to believe that art and design teachers in Britain frequently take a somewhat cavalier approach to the professional activities of curriculum construction, implementation and evaluation and, indeed, to the whole complex business of teaching and learning. If the book, in its entirety, or part of it, serves to stimulate other teachers, or student-teachers to probe some of their more traditionally British assumptions about the nature of their specialist subject, and to embrace into their planning the difficult curriculum issue of cultural diversity, the effort of writing it will not have been in vain.

In closing, I am acutely aware that 'multicultural education' is something of a buzz word so that the viewpoints expressed will already be dated. Since completing the manuscript, The Multicultural Centre at the Institute of Education, University of London, has published *Racism, Diversity and Education.* There has been a flurry of interest in non-European artist-in-residence schemes (the policies and practices for which, in Leicestershire at least have, already, been thoroughly criticised and surveyed). Furthermore, the news sheets being circulated by the *Art and Development Education 5-16 Project* team are recording numerous examples of the resistance teaching that I identified as being in short supply in chapter three. In essence, therefore, this book

reflects a personal view of the art educational scene with reference to multiculturalism at a particular point in time.

I must apologise, also, for its seemingly inconsistent application of the terms 'art' and 'art and design'. Again, this reflects the state of the game. To North Americans, the term 'art and design' is virtually unknown in general education. In this country, some teachers (primarily in secondary and tertiary rather than in primary education) see art and design as distinctive and separate subject areas in the curriculum, whereas others, like myself, understand them as one and the same thing. The book reflects this confused state of affairs in that the chapters that refer in the main to primary education or which draw upon North American literature use the term 'art', others refer to 'art and design'.

These difficulties apart, I believe my writing touches on some fundamental concerns that colleagues will recognise as significant. Their stuttering quality notwithstanding, the first three chapters mark a progression of sorts in my own thinking from a state of wonder at the phenomenon of multiculturalism, as manifested in a particular local authority's primary schools, through to an increased knowledge and awareness of alternative strands of multicultural curriculum thinking in art and design elsewhere. What follows, in chapter four, is a brief flirtation with the concept of 'humanistic education' and a discussion of its implications for secondary school teaching. The enquiry that informs the final chapter led to a more considered understanding of the importance of two strands of social science reasoning as tools for multicultural curriculum reform. At its close, a tension between the critical-historical and the more 'actor-orientated' anthropological approaches to the interpretation of social events that had become apparent during the writing presented me with a new curriculum challenge. To date, this curriculum dilemma remains.

Acknowledgements

A book about curriculum can only be a collaborative effort. The list of people who have made it possible is lengthy.

My thanks are due firstly to individuals in the two higher education institutions that have so generously supported both its research and funding. The Centre for Postgraduate Studies and Research in Education at Leicester Polytechnic has an established reputation for research into art and design education and multiculturalism. Brian Allison, Martyn Denscombe and Chris Toye's three year project, Art and Design in a Multicultural Society (The AIMS Project) enabled me to launch an enquiry in this field confident in the knowledge that background information was already available at the centre and that it had been systematically documented and researched. Brian Allison's work, in particular, was exemplary. My colleagues, Joyce Park-Hutson's and Lisa Conway's liaison with schools proved invaluable, as did my collaboration with PGCE and MA art and design students and with Mashuq Ally and David Smith. I own thanks, also, to John Grace, of the School of Graphic Design and to Geoff Ridler and Gavin Blair, who produced the Gujarati/ English children's reader and the animated film.

My associateship in the London University Institute of Education enabled me to reflect on multiculturalism from an alternative perspective. My particular thanks are due to Jagdesh Gundara, Keith Kimberley and Crispin Jones, at the Centre for Multicultural Education, to the teacher-fellows similarly seconded to the centre and to Diane Nair. Also to Anthony Dyson and Elsbeth Court in the Department of Art. Attending John Picton's lectures on anthropology and aesthetics at the School of Oriental and African Studies was a stimulating experience also, which provided me with much food for thought.

Secondly, I wish to thank the Leicestershire Education Authority and, in particular, Tim Ottovanger, Multicultural Adviser and the staff of the Rushey Meade Multicultural Teacher's Centre, for their support of the curriculum development reported in chapters one and two. I am even more indebted to those headteachers, teachers and school liaison officers who so generously gave of their time and offered me the schools and classrooms in which the curriculum experiments actually took place. The participating schools included Charnwood Primary School, Abbey Primary School, Catherine Junior School, Ratby County Primary School, Merrydale Junior School, Herrick Junior School, Knossington Church of England Primary School and Hollywell County Primary School. The individuals who were of particular assistance were Roger Wheeler, Kathy Chalk, Brian Owens, Moyra Darrock, Liz King, Maureen Williams, Jim Nind, May Dowdall, Sue Forrester, Bela Sabherwal and Jay Sodha. I wish to thank all the children who participated in the curriculum trials.

I am grateful to the artists, museum education and gallery personnel and librarians in London who facilitated my enquiry into multicultural resources for art and design teaching. In particular, I want to thank John Van Santan for sharing his insights into multicultural provision in the ILEA with someone who lives and works 'north of Watford'.

My thanks are due, also, to colleagues overseas. To Graeme Chalmers and Ron Macgregor for the invitation to teach summer school in the Faculty of Education at the University of British Columbia, and for affording me the possibility of investigating multicultural education Canadian style; to the staff of the University's Museum of Anthropology; and to James Mroczkowski and Karen Smith, students on the Arte 541 course, for their perceptive analyses of two 'foreign' curriculum texts.

Readers will recognise that the book as a whole is indebted to Elliot Eisner's ideas on curriculum. Art educators are fortunate indeed in being able to claim him one of their own; also, to the late Lawrence Stenhouse's thinking about curriculum development in action and teacher-based research.

I am grateful to the Journal of Art and Design Education for permission to reproduce the following copyright material: vol.4, no.1, 1985, 'Some student-teachers' experiments in art education and humanistic understanding'; and to the following for permission to reproduce paintings or photographs: To A. and C. Black (Strands series), S. Lyle, 1978, Pavan is a Sikh/Jeremy Finlay (p.55); The Trustees of the Victoria and Albert Museum, London (pp.113,116); The Trustees of the British Museum, London (p.13)/Jackie Chapman (pp.136, 137); Leicestershire Museum and Art Gallery, New Walk, Leicester/Iona Cruikshank (p.132); UBC Museum of Anthropology, Vancouver (p.150) /Phil Slight (fig.5.14); Centre for Multicultural Education, Rushey Meade (p.86); Afro-Caribbean Education Resource Centre, London (p.82); Ethnographic Resources for Art Education, Birmingham Polytechnic/ Phil Slight (pp.74, 82); Urban Studies Centre, Leicester/ Douglas Smith (p.9); UNICEF (p.95); OXFAM/Dick Copeland (fig. 3.10), Nick Fogden (fig. 3.9)(p.94); United Nations Committee Against Apartheid (p.140); British Film Institute (p.156): Paul Popper Ltd., (p.156); Eduardo Paolozzi/ John Webb (p.135); Emmanuel Jegede (pp.77, 140); Sonia Boyce (p.77); Beverly Berger (p.147); Chris Thomas (p.22); Mark Parnham (p.147): A. Jabolonski (p.95) and Colin Brookes (p.132).

Finally, I want to thank Chris Goodman for her expert typing and the staff of the Photography Centre at Leicester Polytechnic for their advice and assistance with illustrations. Last, but not least I want to express a debt to Brian Shield for putting up with me throughout the difficult period of the book's authorship and for his help in the manuscript's final preparation.

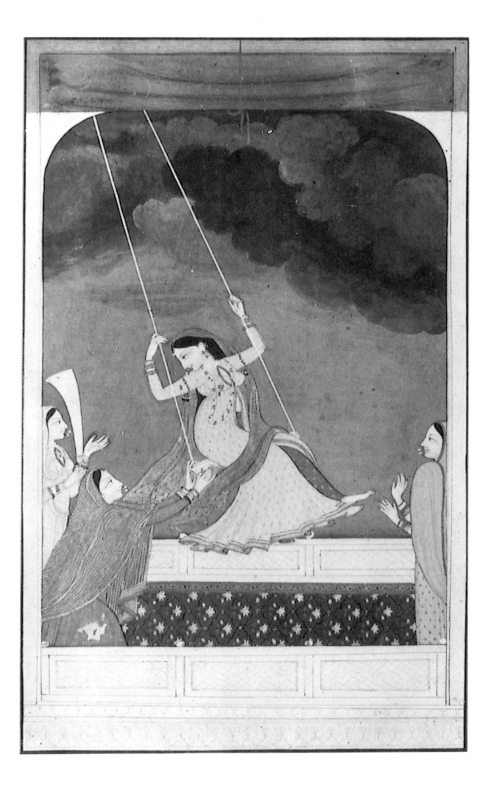

Chapter One

Art and Environment:
Two Case Studies

Four Types of Multiculturalism

In typically caustic manner, Ralph Smith [1] has identified four distinct types of multiculturalist currently in evidence on the art education scene.

Exegetal multiculturalists read their own ideas into foreign cultural situations and extol 'other' cultures primarily so as to criticise their own. This brand of multiculturalist, according to Smith, claims that alienation and fragmentation are rampant in technologically advanced societies such as our own and deplores what he or she describes as the anti-egalitarian tendencies of their art such as the fact that it is separated from everyday life. Exegetal multiculturalists set up models for emulation from other cultures which are purported to be superior or, purer. (He suggests that almost any model will do.) Smith says that their assumptions about the baseness of their own culture are largely unargued and they approach foreign, alien and cross-cultural situations with a particular kind of bias and with a closed mind.

Dogmatic multiculturalists are the exegetal multiculturalists' mirror image. They have equally closed minds because they assume the superiority of their own culture and expect the values of other cultures to conform to it or to be dismissed. Cultural chauvinism of this kind is less rampant now than it used to be, according to Smith, because exegetal multiculturalism has become very fashionable, but it is a mistake to think that it is the prerogative of Western European societies alone. There is little doubt, that dogmatic multiculturalist attitudes exist in non-Western societies and that they are, in fact, widespread throughout mankind.

Agnostic multiculturalists do not make the error of imposing their own preconceived notions and judgements on an alien culture. On the other hand, they are rather like souvenir collecting tourists in that their concern is, almost exclusively, either antiquarian or, aesthetic and microscopic. Smith dismisses this kind of interest in another culture on the grounds that it is shallow. He describes art educators who are agnostic multiculturalists as having a botanizing interest in collecting exotic cultural artefacts such as children's drawings, and is critical of the fact that they do not bother to reflect on alternative cultural values and are seemingly indifferent to these objects' historical or cultural contexts.

Dialectical multiculturalists [2] are unlike other multiculturalists in that they do not presume that the ultimate wisdom about multiculturalism lies either in themselves, or, in any given cultural phenomena. More importantly, they are willing to engage with and learn from alien cultural traditions with a view to improving their knowledge of self and of the right relations of self to culture. They do this, according to Smith, by focusing on a particular concrete event (which he calls a text) and by moving from a close examination of this event to a consideration of the relation between it and culture. Prior to undertaking this kind of interpretive or hermeneutic exercise, Smith says that dialectical multiculturalists must be desirous of, or willing to undergo culture shock and must acknowledge the right of their cultural text or event to question them. Their pursuit of self-understanding necessitates their making the effort to pursue the kind of historical-philosophical research or investigation that will enable them, at a later date, to compare their text or event to others in the same culture, or tradition, so that they can begin to learn about and understand its alternative point of view.

The dialectical approach to enquiry that Smith describes as the most promising for advocates of multicultural education and art, and, which is characterised by an attitude of nervous wariness, is not without its critics. [3] Nevertheless, it provides an underlying structure to the following narrative account of my personal experience of teaching in two of Leicester's multiracial inner-city schools.

The First Case Study

The curriculum problem

On my return to England in 1981, after seven years teaching overseas, I was immediately aware of changes in the structure of British society which were affecting educational thinking and practice. In supervising student-teachers of art in inner-city schools in Leicester, I encountered large numbers of so-called ethnic minority pupils whose parents had emigrated to Britain (most typically from East Africa or the West Indies), during the last twenty years and who were the heirs to Indian and Afro-Caribbean cultural heritages about which both the students and myself knew nothing. [4] The official literature on education - by which I mean government and local authority papers and reports together with policy statements produced by community relations groups, teachers' associations, unions etc. was full of references to the need for multicultural or multiracial curriculum practice, none of which made much sense to me at that time.

In an attempt to clarify what I found to be an extremely confusing situation, and, to assess its implications both for my own and the student-teachers' classroom practice, I initiated an educational action that constituted merely the beginnings of the long-term curriculum development project and research that is the focus of this book. At this

preliminary stage, however, the enquiry cannot be said to have had any preordinate design or plan. Rather, my intention in initiating the action was (a) to identify an educational situation in Leicester with the potential for engaging me, (a white, middle-class, female art teacher trained exclusively in the Western-European tradition of art) in culture shock; (b) to practice my profession within that context; (c) to encourage the pupils I was teaching to communicate their cultural experience to me through the medium of the visual arts; and also, (d) to record and document what occurred in a way that would allow for my further deliberation about multicultural (or multiracial) educational practice and ideals. In choosing to proceed with an enquiry in this manner, rather than to undertake a survey or engage in quantitative research, I understood myself as operating according to phenomenological research principles[5] and, as adopting Ralph Smith's dialectical multicultural stance.

Preliminary research

The choice of an alien classroom context necessitated a great deal of preliminary detective work. In this I was helped enormously by colleagues who already knew the scene. The assistance of a university colleague who liaised with local schools for the purposes of student-teaching placements, the leader of a curriculum project researching 'Art and Development Education materials' and a representative of the Islamic Foundation, was particularly valuable. Over a period of some six months and at their recommendation, I visited at least ten inner-city primary schools and spoke with deputy or head teachers. The Belgrave district of the city was chosen as a suitable location because it had absorbed a high proportion of Asian immigrant families from Kenya, Tanzania and Uganda during the late 1960s and early 1970s[6] and because the locality visibly reflected their Indian cultural

Figure 1.1:
**Belgrave
High Street**

3

identity. The majority of the residents were Gujarati speaking and Hindu and they had developed strong social networks and ties. The community supported a Hindu temple, Indian cinema, and numerous Indian newsagents, restaurants and shops.

Figure 1.2:
**Old Men,
Belgrave Park**

Selecting a school

A primary school located in the heart of the Belgrave district was selected as an appropriate educational context for research. The school had been recommended to me initially on the grounds that it had promoted a multicultural curriculum for a number of years. In the course of my preliminary visits, I had observed that the staff worked closely with the community and encouraged pupils to take a pride in their Indian cultural heritage. At Diwali, the Hindu Festival of New Year, for example, the classrooms were filled with visual and verbal information relating to the Hindu religion and the Indian subcontinent and children painted Rangoli patterns and staged an evening of Indian drama, music and dance.

Figure 1.3:
**Pupils in an
inner-city
primary school**

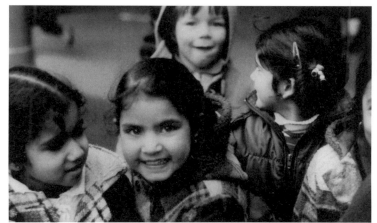

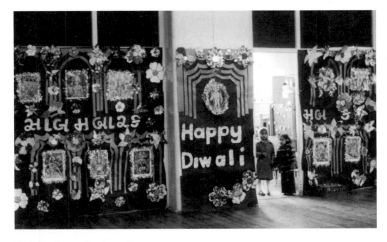

Initiating the project

The proposal to involve a small group of children at this school in some curriculum activity that resulted in the production of an animated film, was first made to the head teacher in the spring of 1983. At this stage I made the tentative suggestion that, during extra art classes, pupils should write stories and poems, compose music and songs and, make drawings and paintings that described the Belgrave community's characteristic ways of thinking, acting and behaving and that illustrated both its everyday and special cultural events. It was not until the autumn of that year, however, that the plan was implemented. This was because while the head teacher and deputy were enthusiastic, the rest of the staff were not. At a curriculum meeting called for the purpose of discussing my proposal, they questioned my curriculum intentions and expressed the view that its emphasis on their pupils' ethnic identity was misguided. The preliminary plan was revised several times in response to their criticisms and was finally accepted only on condition that I assumed the entire responsibility for its teaching and that any story-line developed for the purpose of making an animated film was fictional rather than autobiographical in focus.

I mention all this not because I wish to criticise the staff's unwillingness to accept my curriculum ideas at that time, but because I think it illustrates important truths for other teacher-trainers, curriculum developers, researchers etc., seeking to engage in similar kinds of educational enquiry. Firstly, remodelling and revision in the field is a necessary and indeed essential, part of any curriculum development or project work that is school-based, and outsiders who approach schools with a view to imposing their curriculum ideas on teachers are unlikely to achieve much success. Secondly, the antagonism of these particular teachers towards my proposal and their reluctance to participate, can be explained at least in part, I think, by my perception of pupils they knew intimately as alien or 'other' and by the school's prior history of multicultural curriculum work. It would be inconceivable, I imagine,

Figure 1.5:
**Shree Sanatan
Mandir**

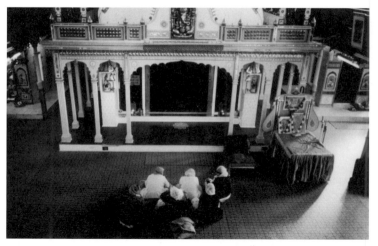

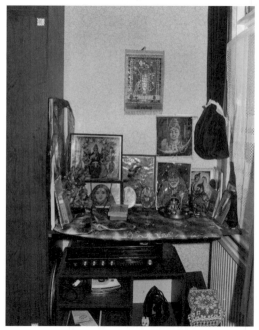

Figure 1.6:
**Domestic
Interior with
shrine**

for any primary teacher to perceive the pupils they interact with on a daily basis in class as 'foreign'. Moreover, a number of these teachers had expressed concern about the future welfare of children who were encouraged to develop pride in their Indian cultural identity at primary school but were destined for secondary schools in which the curriculum focus would be resolutely European and Anglo-centric. At another level, however, I suspect that their rejection of its focus on their pupils' ethnic identity reflected a reluctance among the profession as a whole to accept the challenge of initiating classroom practice which emphasises cultural difference, together with a general disillusionment with the pluralist cultural perspective that dominated the official rhetoric about multicultural, multiracial curricula in the

previous decade. Over the past four years and, in the course of conducting the enquiry as a whole, I have found the practitioners' reluctance to promote classroom activity that addresses the issue of cultural diversity and their unwillingness to admit to ever having had ambivalent feelings about foreigners and 'otherness' a recurring and somewhat puzzling feature of the multicultural, multiracial educational debate.

Developing the story and artwork

In October 1983, the head teacher and staff finally selected a group of children, aged nine to twelve years, for extra art and language classes. They indicated that the selection had been based on the children's giftedness in, or talent for the visual arts. Against my better judgement, in view of the project's intended ethnic and environmental focus, they insisted that three non-Asian pupils were included in this group. Accordingly, and in collaboration with a classroom teacher seconded from another school and a university student studying graphic design and film, I undertook to organise language and art activities for the group on Tuesday afternoons over a period of twelve weeks. In the course of ten two-hour lessons, the following curriculum actions ensued.

First, the children learned some concepts and principles of animation. This part of the teaching-learning activity was undertaken by the design student's supervising lecturer for his course work in animation and film. He initiated the project by showing the children a video, telling them stories and, having them animate cut-out characters. At a later date, the group toured a professional film studio and looked at specialist camera and picture synchronising equipment.

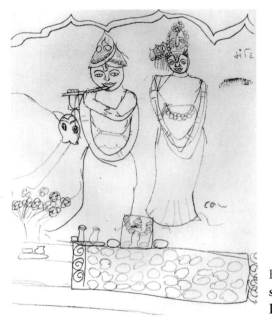

Figure 1.7:
**shrine imagery,
Dhamistra**

7

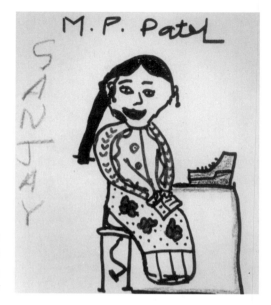

Figure 1.8:
**Saleswoman
in a saree shop,
Sanjay**

Second, the children invented a story about an imaginary boy and girl living in Belgrave. The classroom teacher advised them that it should illustrate some day-to-day events in the community and some special celebrations, but that, as far as possible, its form and content should be their own. They invented a hero and heroine called Sanjay and Sunita and a plot centred on a mishap with fireworks during the festival of Diwali. The final script read something like this:

> *During the week preceding Diwali, Sanjay and Sunita prepare for the celebrations. They accompany their parents shopping for special food and clothes and presents of jewellery. At school they take part in preparations for a Diwali evening. While their father is at the temple and their mother is finishing some last minute shopping the children find some fireworks and cause a fire in the kitchen. A neighbour calls the fire brigade and the fire is put out, but not without causing some damage to the kitchen. When he finds out, their father is so angry he cancels the family's Diwali celebrations. Luckily he has the good fortune to win the football pools so he relents. The story ends happily with the family enjoying fireworks at the local recreation ground on Diwali night.*

Third, they engaged in streetwork. The term 'streetwork' was coined by the *Art and Built Environment* curriculum development group [7] to describe a range of art educational strategies they devised which were aimed at increasing pupils' critical awareness and understanding of urban design and town-planning. In this particular instance, we took the children out into the neighbourhood to make drawings of and notes about people and places they had identified in the story. Streetwork strategies were employed with a view to their providing a basis for developing the quantity of finished artwork that was a necessary part of translating language into the visual medium of film. In the course of the twelve lessons, we visited and documented a Hindu

temple, private homes, the park and shops in Belgrave road.

Fourth, the children utilised tempera paints, coloured inks, felt pens, sequins and glitter, cut-paper shapes and assorted coloured, metallic and white cartridge paper to make pictorial representations of the characters, objects, settings, actions and events in the story. For this work, the group was located on the stage in the school hall. The hall was used by other classes and painting and drawing took place against a background of physical education, dance, and drama. There was very little space to work and no running water.

Making the film

The film was completed in the studio after lessons in school had come to an end. The children's story-making sessions had been recorded on tape (Appendix 1). The student edited the tapes and produced a film sound-track which was five minutes long. He sorted out their art work

Figure 1.9:
Film Still -
Sanjay &
Sunita getting
a telling off

Figure 1.10:
Film Still –
They all lived
happliy ever
apfter

into nine scenes and utilised a rostrum camera to shoot the film. The children's drawings and paintings were animated by hand.

Cross-cultural interaction in class

While the above description supplies an overview of the curriculum activities involved in the production of the film, it says little about the patterns of cross-cultural and intercultural interaction that occurred in the teaching-learning situation while this was going on. The emphasis on the Asian-Indian character of the Belgrave environment, which was a necessary consequence of our adopting Smith's dialectical multicultural education stance, caused us considerable problems both in eliciting a real-life story and in dealing with one non-Asian member of our group. With this in mind, the classroom teacher's descriptive account of the process of developing the film script and of some of its attendant difficulties is included at this point:

> *Having sung a few verses of 'Old Macdonald' and talked about animation, we settled down to the serious business of story-telling. It was difficult at first to convince the children that we were serious. We stressed the fact that we wanted an adventure story that really could take place in the neighbourhood and, so, were able to divert suggestions for stories involving Superman or King Kong. We showed them visuals of a busy city street to promote the idea that we wanted a local story-setting. Their ideas came thick and fast. Too fast for us to write them all down. Fortunately, the tape-recorder picked up the suggestions - quiet ones from the front and noisier ones from the back. This included a series of unhelpful mutterings, as if from a Greek chorus, by Matthew.*

> *It soon became obvious that Jagruti and Ravinder were highly motivated story-tellers. They carried the story line and the others provided details. Matthew was the only person who appeared unwilling to participate at all. He seemed to want to remain on the periphery of the group. He let it be known that the story and its characters had nothing to do with him.*

> *Suggestions for a major event ranged over a bank robbery, an accident, someone getting run over, a fire, a murder and a building falling down. (At this stage, we appeared set to produce a disaster movie.) To lighten the atmosphere, someone said we should have everyone killed. The locations for these events were all places we could visit in the neighbourhood although Matthew made a valiant, last-minute stand to locate the story on a farm. We came back on course with suggestions for a factory, local shops and for a Diwali party to be included. We had a diversion into the recreation ground and the library. Then we came back to the supermarkets and their vegetable displays in the high street. By this time, it was obvious things were getting too complicated for Dipak. He asked whether we would have to dress up to appear in the film.*

By the end of the first discussion session, a fire was decided upon as the major event in the story. (Matthew, of course, wanted the fire to be set in the school.) Following this, Jagruti launched into an intricate explanation of two children causing a fire by playing with fireworks in their garden at Diwali time. ("Oh, its always Indian!"- another aside from Matthew!) By the end of the third session, however, the story of Sanjay and Sunita was finished.

(Readers may be interested to learn that it was the activity of painting a picture of the school that finally convinced Matthew that it was worth his becoming both a part of the project and the group. Having completed a drawing outside, he elected to work with Sunil on enlarging this and painting it in class).

The community liaison officer's role

Inner-city schools in Leicester employ ethnic minority community liaison officers who act as cultural mediators on a whole range of formal and informal educational issues. A school community liaison officer's help in negotiating access to people and places in the neighbourhood was absolutely vital to this project's success. On one occasion, for example, we needed visual material for the scene in which Sanjay interrupted his father at prayer to tell him about the fire. It took place in the temple. The community liaison officer contacted the Shree Sanatan Mandir on our behalf and arranged a visit. We spent an entire afternoon sketching and making notes and were treated as welcome guests even though religious ceremonies were in progress at the time. She contacted local shopkeepers when we needed to research visual information about Indian food and clothes. (Dipak and Mehool's drawings of displays of 'Burfi', 'Penda' and 'Jellabis' drawn from inside a sweet shop window and Sanjay's felt-tip pen sketch of the proprietress of a gift shop in a floral 'Sari' were two of the most authentic visual ingredients in the film.) On another occasion, her own living-room provided us with a location for Sanjay and Sunita's house.

Motivating artistic production

The most time-consuming activity was, undoubtedly, the production of the artwork. (A contributory factor was our location on the stage of the school hall.) A considerable amount of effort went into painting the film's background scenery or locations. A large frieze of shops and other buildings for the shopping scene was constructed out of street-work drawings by groups of two or three children at a time. A great deal of attention was paid to detail. Matthew was particularly concerned with the lettering on Barclay's Bank and Michelle and Jagruti spent a long time carefully painting in vegetables in front of their supermarket. Even more time, however, was needed for the creation of film characters. We started with pictures of the hero and heroine and their mum and dad, who, for the purposes of animation,

had to be represented from the front, sides and back. The large numbers of background figures for crowd scenes were produced more quickly. Miscellaneous items and special film effects included street furniture, a bonfire, a fire engine and fireworks.

The children's drawings and paintings were an important ingredient in the curriculum experiment as a whole. So, we kept a record of their work and of our own teaching strategies. It was never our intention to emphasise a particular approach to art or to teach specific aesthetic concepts, processes, techniques and skills. But looking back later, we realised that in our capacity as art educators during the project we had motivated the children's expressive-artistic production in a number of standard, typically Western European ways.

First, we had shown the group exemplars in the form of illustrations in books. Consequently, Emma and Dhamistra's crayon drawing of a fire engine was very similar to a graphic image executed by a professional illustrator in a children's book; and Jagruti's cut-paper firework was almost a facsimile of a design she had looked at briefly in a copy of the primary teachers' journal, *Art and Craft.*

Second, we had engaged them in observational drawing and portrait painting. The chief characters for the film were painted in front of live models posing in 'Jubba', 'Linga' and 'Saris' for one half hour. Background figures were sketched more quickly during streetwork. The group also made quick sketches of each other adopting five minute poses.

Third, we had provided them with photographic images. Some of the figures in the film resembled people I had photographed previously in the local park. The children viewed some slides of Diwali festivities before they produced drawings of people performing in a Diwali play.

Fourth, we had suggested that they draw from imagination. Given total freedom of choice, several of the ethnic minority pupils elected to draw and paint Hindu gods. Sundip, on the other hand, always drew cars. Kiran was engrossed for one whole session in painting a tambourine dancer. Sunil and Emma produced caricatures of their teachers in felt-tip pen.

Finally, we had asked them to complete work at home.

Research findings

Our group included children from different cultural backgrounds. Given that Western European and Indian artistic conventions vary, we were curious as to the extent to which the artwork the children had completed during our project reflected these cultural differences; in particular, we wondered what effect our predominantly Western European methods of teaching had had on the images of people produced for the film. My colleague spent some time analysing the children's paintings and drawings and came to some tentative conclu-

sions. She observed, for example, that Indian artistic influences were evident in only a very few drawings and that these were drawings that had been produced spontaneously. Also, that the ethnic minority children were able to cross cultural boundaries and to utilise different cultural conventions according to the nature of the tasks we set. Drawings of images of Hindu gods, for example, were constructed according to a traditional Indian schema, whereas drawings of figures posed in class were recognisably European. In their spontaneous drawings of temples, these same children paid little or no attention to perspective whereas in their drawings of shops and houses completed in class, they struggled with rulers and other measuring devices to achieve an illusion of pictorial depth.

A goal for multicultural curriculum research

While I admit that these kinds of research questions have some appeal, I think they run the risk of Smith's agnosticism and, that they avoid the issue of self-understanding that is the key to his dialectical multicultural stance. Having completed this particular phase in the enquiry, I began to see the goal of a multiculturalist researcher as being not that of isolating, analysing and separating cultural differences, but as that of seeking out ways in which Smith's notion of fruitful dialectical encounters between two cultures could function as an approach for further work in curriculum development in art and design. In this I was helped enormously by Dan Nadaner's account of a curriculum development research project implemented in Vancouver, in 1983. [8]

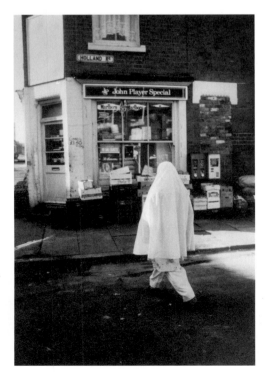

Figure 1.11:
**Street scene,
Charnwood
district**

Nadaner's project had operated on the same basic premises that had underpinned my own approach to teaching and learning during the making of the film. Namely, he had proposed that understanding persons whose culture is different is a prerequisite purpose of education and had encouraged young children to record their experiences of their everyday lives through the media of the visual arts. There were some important theoretical distinctions, however. First, Nadaner's approach to multicultural education had been grounded in social theory. His report stressed the significance of interpersonal dialogue and the exchange of subjective accounts of experience in the development of an understanding of peoples whose cultures were different, and his project had exploited Alfred Schutz's suggestion that art that is 'open and expressive' is the next best thing to a face-to-face encounter. [9] Second, while he promoted children's expressive production in the arts as an instrument of multicultural learning, he urged art teachers to embrace the concept of communication into

Figure 1.12:
Curriculum development project group

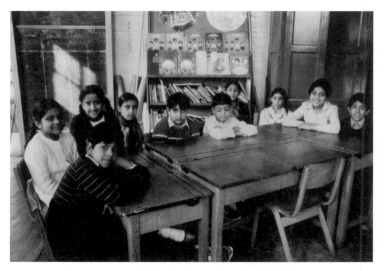

their curriculum by instructing children in a method of art criticism. This, he claimed, would enable them to reconstruct and talk about the expressive meanings they built into their own and other people's art.

Nadaner's research interests lay in comparing the social meanings children learned from each other in art with those that emerged in face-to-face interviewing. Given the assumptions on which the film project had operated, I found myself most interested now in pursuing Nadaner's question of the social meanings the film communicated and of what other children had to say about the life-worlds it revealed.

The Second Case Study

The school and community

Shortly after the animated film had been completed I began negotia-

tions to teach in a second school. This school was located about four miles distant from the first, and closer to the city centre. It was an imposing red-brick Victorian building entered through two arched doors labelled 'Girls' and 'Boys' and topped by a turret with a wrought-iron weather vane. Its small, concrete playground was surrounded by high walls and sandwiched in between a railway shunting yard and a row of terrace houses. The yard afforded little or no space, either for pupils to play or staff to park cars but, inside, the walls of the corridors, the winding stone stairway and the classrooms were crammed full of displays of children's artwork. Once again, the school's student population was 90 percent Asian and the majority of the parents had emigrated to Leicester from East Africa, India or Pakistan. Unlike the residents of the Belgrave district, however, these Asian families were predominantly Muslim, not Sikh or Hindu. While the majority, but not all of them, were Gujarati speaking (as were the residents of Belgrave), the influence of the Muslim faith on both the visual appearance of the locality and the school's curriculum was noticeably different.

Initiating the project

On this occasion, I did not have to sell my curriculum ideas to a reluctant school staff because the head teacher, for reasons I did not fully comprehend, took a personal interest in them. One advantage of this was that my art room facilities were very much better (I was provided with an annexe above some toilets in the school yard). One of the disadvantages was that, to a certain extent, he made the project his own. My plan for practical work was to involve a group of children in creating a picture-story book about themselves and the neighbourhood. The head teacher was keen that its emphasis should be autobiographical rather than fictional. (In fact, he was so keen that he came into my classroom at one point to extract autobiographical information from pupils himself.) Accordingly, he selected a group of ten pupils all of whom were Gujarati speaking and Muslim and instructed their class-teacher to co-operate in whatever ensued. Since the school had pioneered mother-tongue classes and employed native speaking teachers for language work in Gujarati, Urdu and Bengali, he proposed, also, that the book function as a bilingual text and be printed both in Gujarati and English.

Before the project commenced, however, he judged it expedient that certain preliminary activities and negotiations took place. First, he suggested that I seek parental consent before involving Muslim pupils in drawing images of people. Second, he insisted that I became better acquainted with the school's physical and cultural environment. Accordingly, he released the school's community liaison officer from her normal run of duties and she and I made a number of pre-arranged visits and excursions to pupils' homes and to other places they judged to be of interest.

In the majority of homes we were received hospitably and, given my ignorance about Muslim culture and the way of life, the visits served to protect me from exhibiting some of my more severe symptoms of culture shock in front of the children at a later date in class. All the houses had quotations from the Quran over the front door. One father, recently returned from Hajj, offered us holy water and dates. He was eager to show us a textbook about Islam that he had purchased for his son and voiced some concern about researchers, such as myself, because, he said, they tended to paint a negative picture of Muslim religious customs and culture.

The students

The two Ebrahims, Ayub, Zakir, Juned, Bilquees, Naila, Saheda, Anisha and Salma were some of the most delightful and co-operative pupils it has ever been my good fortune to teach. They were shy and somewhat silent at first, but it was not long before their individual

Figure 1.13:
Muslim girls posing in class

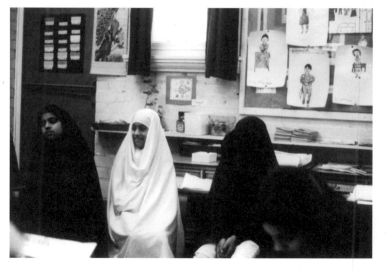

personalities emerged. Anisha was our star artist who could be relied on to turn her hand successfully to anything. Bilquees, (whose parents' corner store became a feature of the book), had a tempestuous nature and was the group favourite. Ayub always needed three sheets of paper to complete his drawings because he experienced difficulty calculating proportions. Ebrahim worked long and hard and was keen to monitor the accuracy of any information about Islam. He seemed to find it difficult to laugh. The other Ebrahim was a recent arrival from India and his English was poor. He had considerable ability at drawing, however, and his eyes registered pleasure whenever he was praised for his artistic achievements in class.

As a group it appeared that these children did not readily exhibit emotion or express their feelings when they communicated either with

myself or with each other in the English language. As the project progressed, however, they began to utilise mother-tongue to talk to each other in class quite frequently. At the same time their mood became considerably more ebullient and volatile. In this situation, of course, I became the outsider and felt myself to be in a minority. I suspect that this resulted in my being excluded from commentary about the project (and about myself) which could have proved useful and provided me with much food for thought.

The first lesson

At this school I was fully responsible for the teaching, although a student observer was present on three occasions and made notes. We began our activities by watching the animated film about Sunita and Sanjay and by discussing who made it, why, when and where. In the process of talking about the film's plot, characters, action, settings and message and, of evaluating what it told us about the people involved, the group learned that they would be making an illustrated book for children they had never met. Next we looked at and discussed a range of 'multicultural' textbooks available at the school.[10] These books had been very much in evidence in most of the primary classrooms I had visited previously in the authority. They sought to supply young readers with an insider's viewpoint of ethnic minority children's lives and were lavishly illustrated with coloured photographs. My intention in utilising the readers at this stage was to provide the group with models for their future text's content and form and, also, to establish the fact that both I and other readers would be interested to learn about their specifically Asian-Indian and Muslim (albeit British) way of life. Once their content and form had been analysed, I asked them what they would wish other children, who lived elsewhere in Britain, to know about them.

The overwhelming response and one for which I was by no means fully prepared, was that they wanted them to know about the Islamic

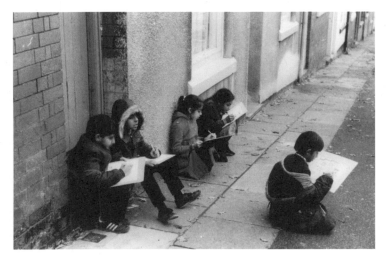

Figure 1.14:
Streetwork

faith and its impact on their lives. It is interesting, in the light of later criticism, that I was worried by this response and worked hard at eliciting autobiographical information that was both more secular and more child-centred. The plan of action during this warm-up lesson had been to involve them in discussion about topics such as their favourite games, people and places, their responsibilities at home and their parents' jobs. These topics were introduced in later lessons, but their relevance in terms of the children's views of what they wished to communicate was questionable. As an initiation into a foreign culture for me, however, the next twenty minutes were instructive.

I learned that the mosques and 'madrasahs', (or mosque schools), played a central part in the children's lives. We established that there were five mosques in the neighbourhood, one of which was located in an old factory and another in two houses that had been knocked into one. One day, when the Muslim community in the neighbourhood had saved enough money, they were going to build a proper mosque with patterns and a gold dome. I was informed that visits to the madrasah, lasting approximately two hours, took place every day after school and that a considerable amount of time was spent at the mosque on Saturdays as well. The boys described the 'topis' or caps they wore in the mosque and the girls described their 'burkhas'. It appeared that girls and boys were separated during religious and instructional activities, and that they all spent a considerable amount of time learning the Quran. Two boys were training to become 'hafizs', or priests. In a second discussion, at a later date, the following details about mosques were considered important enough to include in the book. The boys described 'wuzu', a ritual washing ceremony performed before prayer and identified the different postures they adopted while praying. They said they knelt on the floor in front of a bench in the madrasah to learn the Quran. A girl mentioned the perfume, or 'attar', the boys put on at the mosque. They described the mosque walls as bare, apart from quotations from the Quran and told me that people had to remove their shoes before they went in. Also, that they knelt down on a carpet called a 'mussala'.

The festival of Eid, which took place after a period of ritual fasting during Ramadan, turned out to be the group's favourite time of year. It lasted for three days, each of which had a special name. (At this stage of the proceedings it became apparent that both I and the book would probably require a glossary.) Again, the boys' and girls' experiences of Eid appeared somewhat different. The boys talked about excursions to the mosque and to family graves, while the girls discussed visits to and from relatives' homes, trips to the local funfair and the preparation of food.

The details about Eid, mosques and madrasahs were legion and their accuracy was hotly debated by the group. The opinions of individuals were challenged by the rest if they were judged to represent a false, or inaccurate picture of Muslim life. Consequently, our discussion of

these three items took up nearly all the allotted time. My attempts to introduce alternative topics were received unenthusiastically. The lesson ended with what was probably, for many of the children, their first formal attempt at drawing self-portraits in crayon and felt-tip pen.

Producing an illustrated book

The original plan of action had been to accumulate sufficient visual and verbal material for an illustrated book in school and to hand it over to a university student studying information design with instructions to prepare it into camera-ready copy for publishing. For reasons that may become apparent, no book was ever published. A text was completed, however, together with illustrations. Autobiographical information was accumulated under the sub-headings of 'Ourselves', 'Our Families', 'Highfields', 'Eid', 'Our School', 'Mosques', 'Madrasahs', and 'Djinns'. The development and refinement of the written text and of the artwork occurred simultaneously so the lessons promoted what could be described as an interdisciplinary art and language teaching approach. Both the text and the illustrations for the sub-heading 'Ourselves', for example, were established during the portrait session in the first lesson. To avoid the children's initial efforts in portraiture appearing wooden and lifeless it was established that they should depict each other 'doing their favourite thing'. Consequently, Salma was represented making chapatis; Ayub's portrait showed him playing football and Zakir was characterised as liking to pray. Each lesson began with a single motivational activity, such as looking at and discussing a reproduction of a painting or

Figure 1.15:
My house,
Saheda

slides, responding to questions or reading a poem. The remaining time was spent either writing, drawing or painting, or, engaging in street-work related to one or more of the chosen sub-headings or themes. Work completed on an individual basis was pooled at the end of each lesson so that the group as a whole could discuss its relevance and make judgements about its appropriateness for inclusion in the final

text. Since the finished text was intended to function as a Gujarati-English reader for children aged seven to eight years, it required merely a few sentences and illustrations under each sub-heading. But our progress was extremely slow. It took us a further ten lessons to accumulate sufficient information and to agree on its visual presentation.

Writing

One writing exercise on the topic of families established that the conversation in these children's homes was permeated by discussion of alternative modes of existence overseas. Saheda wrote that her mother and father frequently talked about their youth in India. They told her about going to the well to get water, milking the cow very early in the morning and complained about the work involved. Animals, trees and birds featured in many family reminiscences. Zakir wrote that his parents talked about their black-and-white goats. Saheda's parents told her stories about snakes and monkeys that stole mangoes off the trees and threw them at people. Some of the stories had tragic overtones.

Figure 1.16:
Street scene, Charwood district

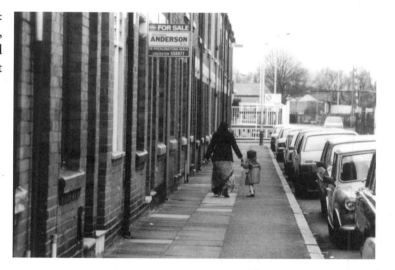

Saheda wrote that her mum and dad often talked about a big river in India in which her elder brother had drowned. Some children wrote that their mothers and fathers were homesick for foreign countries and were making long-term plans to return. Bilquees' mother missed the trees in her Indian garden. But Salma wrote that while her mother had wanted to go back to Malawi when she had first arrived in Britain, she no longer did now.

The majority of the group had been born in England and had visited their parents' countries of origin. This writing exercise revealed that all but one of them identified this country as home. Only Naila expressed a wish to go and live in Pakistan with relatives. The others claimed

20

that they would not want to live in India, Pakistan or East Africa because 'they were too hot and too full of flies'.

Streetwork

Compared with this wealth of information about life overseas, my attempts to accumulate written information about life in Britain were disappointing. They resulted in little more than inventories of rooms at home or place-names - that is until I planned some excursions out of school. The notes and sketches we accumulated during streetwork provided the impetus for more discussion and writing together with painting and drawing ideas. The boys returned from an outing to a mosque with sketches of an imam, the mussala and men praying, the majority of which found their way into our final text. Their excursion led, also, to some homework during which every member of the group produced a sample of Arabic script from the Quran because they insisted that this was an essential ingredient of any text which referred to Islamic culture or to what goes on in mosques. My visit to Bilquees' shop and an Indian sweet store with the girls resulted in illustrations of shop interiors and exteriors and the following passage of text:

> Bilquees' mum and dad own a corner shop. Her dad gets up at half past five every morning to open it. He gives extra sweets to her friends. Across the road, there is the New Purnima Sweet Store which has rows and rows of packets and smells of pan. It sells sweetmeats like Burfi and Penda.

The visits to shops in the neighbourhood also prompted information about halal meat and fish and chips, factories in which fathers were employed and vans that delivered clothes for mothers to sew at home. Sketching and note-taking in the local park resulted in some group paintings of trees, flowers and children on swings and verbal reminiscing about name-calling, bullies and troublemakers of indigenous British origin.

Artwork

Given the Muslim restrictions on painting human images it was hardly surprising that we only accumulated one illustration under the sub-heading 'Families'. (The idea of drawing mothers and fathers for homework was politely but firmly ignored by everyone with the exception of Naila.) But portraiture and observational drawing and painting was a regular feature of artwork in class. In two lessons, for example, the children painted a range of items included in our discussion of Eid, such as greeting cards and 'pan' which I purchased, at their request, from local shops.

Whereas drawing and painting functioned as a stimulus for further discussion on several occasions, writing proved itself to be far more effective as an expressive-communicative medium taking the project as a whole. In this connection, it is interesting to note that the

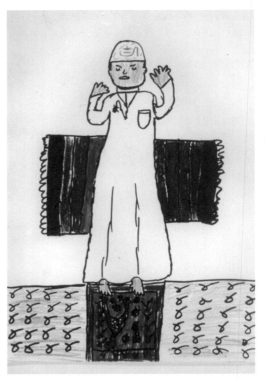

Figure 1.17:
Muslim prayer position, Ebrahim

anthropologist Clifford Geertz[11] has described Muslim aesthetic consciousness as verbal, not visual. I suspect, however, that a number of contributory factors combined to produce what we came to see as our less than satisfactory artistic results.

First, the children's rate of artistic production was painstakingly slow and deliberate. Second, while the directive to engage in observational drawing and painting was guaranteed to produce at least a few concrete results, drawing or painting from imagination yielded practically nothing. My only success in eliciting so-called imaginative work occurred after the class teacher had engaged them in writing. As a consequence of her organising a writing exercise around the topic of 'Our hopes, anxieties and fears', the group identified djinns - invisible spirits present in the home and around the mosque at night - as a topic for the book. Djinns were frightening because people who were unfortunate enough to view them ran the risk of going mad. When asked to speculate about their appearance, the children said they looked 'wobbly' and had long flowing beards. A painting session that followed yielded a series of wraith-like images reminiscent of phantoms in silent movies. Amidst a lot of laughter and after a group vote, Anisha's djinn with white hair and red teeth eventually found its way into the text.

Third, the book's autobiographical style was too factual. This was probably a direct consequence of my having introduced the multicul-

tural reading books into the project during the first week. These books had a social documentary rather than a literary or artistic structure and orientation.

Fourthly, our increased knowledge and understanding of Muslim aesthetic attitudes altered the graphic design student's vision (and mine) of the artwork's function and form. Given that some of the children appeared visibly distressed by my instructions to draw people, we began to view its function as decorative, not expressive. Furthermore, the Gujarati script introduced a novel design element into the situation. Towards the end of the project we changed tack and began to instruct children to produce decorative border patterns and cover designs out of Gujarati letter forms and traditional Islamic motifs.

The bilingual text

The production of a bilingual text ended up being time-consuming and controversial. The translation of ideas originally expressed in English into Gujarati took place in the children's mother-tongue classes, each pupil speaking a sentence in turn into a tape-recorder for the teacher to write down. The controversy centred not only on the issue of the correctness of his translation, but also on the text's general content. When it was presented to a second native speaker, a lecturer in a college of higher education, she criticised it on the grounds that it projected a stereotyped image of Muslim life. The mother-tongue

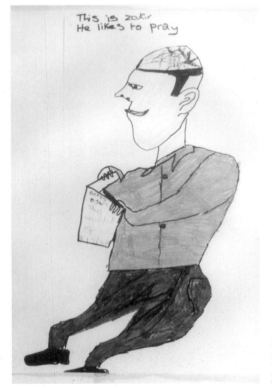

Figure 1.18:
**Portrait of
Zakir**

23

teacher was Muslim and had trained in India. While I was sorry that his efforts at translation came to no avail, I learned a great deal from my encounters with him in his mobile classroom in the school playground. They increased my awareness of differences in Muslim patterns of belief and afforded me an opportunity to examine his bilingual reading books. (These books, produced in India, were very poorly illustrated.) His accounts of his experiences of racism as a teacher in a small Scottish mining town shortly after his arrival from East Africa in the 1960s were illuminating; as was his criticism of what he described as the fundamentalist outlook of the Muslim community in Leicester and of the control exercised over his pupils' thinking by the imams. He appeared genuinely pleased however, that a British-born teacher, was interested in discussing Muslim cultural values and willing to listen to his non-Western point of view.

Critical response

When the text was completed it was submitted to the Islamic Foundation for perusal. The Foundation personnel and the school governors and staff judged it acceptable, but all manner of objections surfaced once it was disseminated to a wider public. The objections were raised in the main by teachers and by representatives of Black and Asian minority cultural groups. The representatives of one such group suggested that the remarks the children had made in the book about India being too hot or full of flies, about their believing in, or being afraid of djinns, and about their fathers getting angry when there was too much oil in the food, for example, promoted negative images of minority life-styles and values. They described my attitude in eliciting such remarks as 'patronising'. Anisha's drawing of Bilquees in her

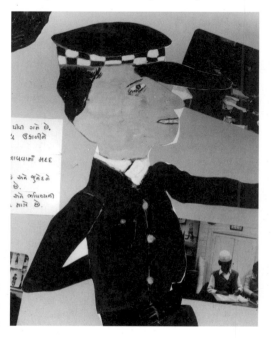

Figure 1.19:
Self-portrait as a policeman, Juned

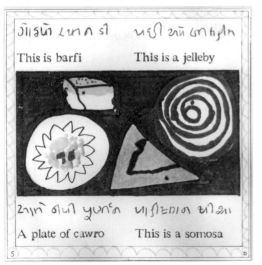

અ‌ં‌ગ્ર‌ે‌ જ‌ી‌ મ‌ા‌ ર‌ બ‌ ફ‌ી‌

This is barfi

મ‌ ફ‌ ળ‌ ા‌ ં‌ મ‌ ા‌ ં‌ જ‌ ા‌ ળ‌ ઈ‌

This is a jelleby

અ‌ ં‌ ગ‌ ્‌ રે‌ જ‌ ી‌ મ‌ ા‌ ં‌ ચ‌ ા‌ વ‌ ળ‌ ા‌

A plate of cawro

મ‌ ા‌ ર‌ ફ‌ ળ‌ ા‌ ં‌ મ‌ ા‌ ં‌ સ‌ મ‌ ો‌ સ‌ ા‌

This is a somosa

Figure 1.20:
**Rough proof,
Gujarati –
English Reader**

burkha, which was included in a slide presentation at a conference for art and design teachers, provoked laughter from a predominantly monocultural (white) audience and I was sympathetic to the complaint that this reaction was offensive to Muslims. The response to this same slide presentation at a second conference, from some Afro-Caribbean members of the audience, was that my multicultural approach was racist.[12]

Muslim education and art

The objections outlined above were difficult to disentangle because they were voiced at a populist level, and in common sense terms. But my subsequent reading in the theory of Muslim education and art served to extend my understanding of the potential for conflict that existed between my Western European, dominant aesthetic and educational values and Muslim minority points of view.

Titus Burckhardt, writing on 'The role of fine arts in Muslim education', for example, found the European and Islamic conceptions of art 'different to the point that one may ask whether the common use of such words as art and artist does not create more confusion than mutual understanding'.[13] He went on to explain the Islamic negation of anthropomorphic art, or, of art that imitates living bodies, as an rejection of art that 'apes the creation of God'; and he identified the proper study of the fine arts in Muslim education as 'a study of the geometric lore which allows Islamic artists to develop harmonious forms from fundamental geometrical patterns'. Art education in Burckhardt's terms had to be understood as 'a way of approaching the spiritual background of the whole Muslim culture'.

Likewise, Dr. Hadi Sharifi writing about the need for a complete reorientation in Muslim education because of the confusion that the 'profane' philosophies of the West had caused,[14] discussed the true

aim of traditional Muslim education in madrasahs as 'the making of a man who was committed to God and would learn to obey his commandments as laid down in the scripture'; rather than of 'a being who thinks there is no limit or end to the possibilities within him and, that he can, without divine guidance, mould the world within which he lives'. While recognising that there can be no question 'in this modern age' of rejecting science and technology, he castigated modern Western systems of education because of their emphasis on material and economic advancement and on knowledge and information at the expense of ethics and morality.

Faced with this new information culled from Muslim education journals and books, I was forced to admit that my taken-for-granted, child-centred philosophy of teaching, with its unqualified assumption that children's statements about their life-experiences were worth listening to was questionable. Also, that my directives to ethnic minority children to imitate or represent human forms could be understood as blasphemous, not merely controversial.

Dialectical multiculturalism

The art educational activities reported in this chapter were conducted primarily with a view to their clarifying my own confusion about multicultural education and art. To return, in closing, to Smith's notion of dialectical multiculturalism and to his suggestion that immersion in the activities of other cultures with a significant relationship to one's own can prove fruitful, in that it leads to increased understanding on the part of the researcher, what did I find out? First, I gained an increased knowledge and understanding of Muslim and Hindu religious customs and culture (e.g. of the Hindu festival of Diwali and of Islamic principles of art). Second, I gained first-hand experience of ways in which schools with large ethnic minority populations were responding to multicultural educational demands (e.g., through mother-tongue teaching schemes and modified art programmes). Third, I gained important insights into the general process of curriculum change (for example, I learned about the resistance of classroom teachers to change and the benefits of a headteacher's intervention and about the need for community liaison). To the criticism that Smith's model is invalid because teacher-pupil relationships are not truly dialectical, I would argue, together with Louis Arnaud Reid [15] that the fact that the children in my classes were captives of a system which afforded me the possibility of manipulating and controlling their thinking was not necessarily abortive; and that Smith's dialectical element of reciprocity is possible even in asymmetrical human relationships.

To return to Smith's notion of multiculturalism yet again, and to those community spokespeople who argued that I exploited the classroom situation by turning my lessons into quasi-anthropological experiments during which I extracted information about minority children's culture purely for personal gain, once more, I protest. The

benefits that accrued in these curriculum situations were not entirely one-sided. As Smith himself has commented, it is neither possible nor profitable for an individual to enter into a cross-cultural relationship without a sense of their own cultural identity or personal point of view - although that view may be severely challenged and, in fact, altered during the engagement - and it is important that both sets of participants in the situation have something to put into it. The context of this particular cross-cultural encounter was educational. With this in mind, I want to insist that the children concerned benefited from having an extended period of art teaching under the auspices of a trained specialist. They received instruction in a range of art techniques and participated in a number of different kinds of art educational activities including streetwork, observational drawing and criticism. They experienced a curriculum which was deliberately constructed with a view to it increasing their knowledge and understanding of book illustration and film. Their artwork was realised in the form of professional products which they could equate with the real world of art and design and not in the form of 'school art' which does nothing to contribute to their reality building abilities.[16] Moreover, I want to suggest that they may have benefited from being asked to reflect on their immediate experience and to utilise it as a stimulus for art which was intended to express their minority point of view. Hopefully, the opportunity to display something of their communities' beliefs and values and to compare them with mine, contributed to the development of increasingly positive self-images.

In this chapter I have described some curriculum decision making that was subject-based and personal. While the curriculum decision making conducted by individual teachers within their own classrooms is both important and influential[17] it is of limited use if it fails to yield anything concrete other than rough plans or sketchy notes. In the next chapter, I want to explore what happened when the informal strategies created in and for these personal situations were developed into more formal curriculum materials and plans, and when my working hypotheses for art and multicultural education were disseminated to primary teachers who tested them in six different schools.

Notes

1. Ralph Smith, 'Celebrating the arts in cultural diversity: Some right and wrong ways to do it in' J. Condous (ed.) *Arts in cultural diversity* (Holt, Rinehart and Winston, Sydney, 1980); and, 'Forms of multi-cultural education in the arts', *Journal of Multi-cultural and Cross-cultural Research in Art Education,* vol. I, no.1 (1983) pp. 23-32.

2. Donald Crawford, 'Nature and art: Some dialectical relationships', *Journal of Aesthetics and Art Criticism,* vol. 43, no.1 (1983) pp. 49-59. A very general and non-controversial concept of the dialectical, according to Crawford, is that 'in a dialectical relationship, the two

terms of the relation designate conflicting forces'. He says it is common, in addition, to apply this relation to cases in which the conflicting interaction brings into being some third object. In this application, I am taking the third object to be 'curriculum'.

3. Robert Jeffcoate, 'Ideologies and multicultural education' in M. Craft, (ed.) *Education and cultural pluralism* (Falmer Press, London, 1984). My multicultural educational approach would be labelled 'white, liberal racist' according to Jeffcoate. It appears that almost any multicultural approach that does not directly address the question of racism tends to be branded as ineffectual and misguided by radical, social reconstructionist curriculum workers in the United Kingdom.

4. Leicester City and County Council, *Survey of Leicester* (1983). The city of Leicester has an Asian ethnic minority population of 40,000.

5. Alfred Schutz (H. R. Wagner. ed.), *Alfred Schutz on phenomenology and social relations* (University of Chicago Press, Chicago, 1972) p. 14. The enquiry relied on the concept of 'lived experience'. Phenomenologists such as Schutz emphasise the fact that all the direct experiences of humans are experiences of the life-world i.e. of the whole sphere of everyday experience, orientation and actions - through which individuals pursue their interests and affairs.

6. F. Guise. 'To what extent do Asians have a choice in where they live?', unpublished B.Ed dissertation, De Montfort University, formerly Leicester Polytechnic, 1983.

7. Eileen Adams and Colin Ward, *Art and the built environment* (Longman, London, 1982).

8. D. Nadaner, Developing social cognition through art in the primary school. Final project report. Faculty of Education, Simon Fraser University, 1984.

9. Schutz, in Nadaner, D, Developing social cognition, p. 9.

10. e.g. Oliver Bennet, *A busy weekend* (Hamish Hamilton, London, 1984) and S. Lyle, *Pavan is a Sikh* (A. and C. Black, London, 1978).

11. Clifford Geertz, 'Art as a cultural system', in *Local knowledge: Further essays in interpretive anthropology* (Basic Books, New York, 1983,)

12. Guardian, 23 April, 1985.

13. Titus Burckhardt, 'The role of fine arts in Muslim education', in S. S. Husain and S. A. Ashraf (eds.) *Crisis in Muslim Education* (Hodder and Stoughton, London, 1979) p. 97.

14. Hadi Sharifi, 'Aims and objectives of Muslim education' in S. S. Husain et al, Ibid., p. 58.

15. Louis Arnaud Reid, *Ways of understanding and education.* (Heinemann, London, 1986). See chapter four for his discussion of 'agapistic' self-discipline.

16. Arthur Efland, 'The school art style. A functional analysis, *Studies in Art Education,* vol.17, no. 2 (1976) pp. 37-44. Also, Brent and Marjorie Wilson, *Teaching children to draw* (Englewood-Cliffs, New Jersey: Prentice-Hall, 1982). Efland claims that school art has remained essentially the same for 45-50 years. The Wilsons' book contains a useful critique of 'school art'.

17. Elliot Eisner, *The educational imagination: on the design and evaluation of school programs,* (Macmillan, New York, 1979) p.110.

References

Art and Craft, no. 273 (October 1980)

Blakeley, M. (1977) *Nahda's family,* A.and C. Black, London

Bridger, P. (1969) *A Hindu family in Britain,* Religious Education Press, Oxford

Burckhardt, T. (1976) *Art of Islam: Language and meaning,* World of Islam Festival Publishing Co.

Cragg, K. (1978) *Islam and the Muslim,* Open University Press, Milton Keynes

Ewan, J. (1977) *Understanding your Hindu neighbour,* Lutterworth Press, Guildford

Iqbal, M. and Maryam, K. (1976) *Understanding your Muslim neighbour,* Lutterworth Press, Guildford

Marret, V.(1983) 'The resettlement of Ugandan Asians in Leicester 1972-80', unpublished PhD dissertation, University of Leicester

Mountfield, A. (1977) *The firefighters,* C. Tibling and Co., London

Rabinow, P. and Sullivan, W. (1979) *Interpretive social science: A reader.* Berkeley, University of California Press

Rice, D. T. (1965) *Islamic Art,* Thames and Hudson, London

Schools Council (1977) *The Muslim way of life,* Hart Davis Educational, St. Albans

Soloman, J. (1984) *Sweet-tooth Sunil,* Hamish Hamilton, London

Curriculum Trials in Six Primary Schools

Background to Project

Introduction

The study which forms the basis of this chapter was conceived in the form of some curriculum trials. The trials set out to monitor a multi-cultural curriculum strategy for increasing social understanding through art operated by non-specialist teachers in primary schools. At the time I was inclined to define multicultural art and design curricula rather narrowly in terms of the extent to which they opened up the possibility of increased social interaction between children of different ethnic groups. I was concerned, also, to improve on and expand the teaching-learning situation with regard to primary school art. My criticism of the latter was that it was insular (i.e. pre-occupied with traditional British values and subject matter) and too often merely decorative, illustrative or cathartic in intent.

In the event, the trials contributed to the development of my argument for the need for changes in primary school art, while serving to highlight weaknesses in my multicultural curriculum stance. For example, they demonstrated the realisation that communication through the arts is directly related to the question of knowledge and understanding of arts' skills, concepts and techniques and that primary teachers are inadequately prepared for such instruction; and that cultural diversity is an evasive and complicated theoretical construct on which to hinge multicultural curriculum planning and ideals. Moreover, they highlighted the curriculum development principle that, given too much freedom in an innovation situation, teachers merely fall back on the practices and policies with which they are most familiar or which have the most political clout.

The curriculum proposals

My working hypothesis for multicultural education and the arts was presented to the teachers in the form of some curriculum guidelines and an animated film. The film, the story of Sanjay and Sunita's real-life adventure featured in chapter one, incorporated concrete examples of children's drawings, paintings and language work which functioned as possible models for their curriculum practice. The guidelines included some information about how the film had been made and the children involved, together with instructions for implementing a

range of arts-based curriculum activities and themes. The proposed activities were to be implemented in three phases. In the first phase, teachers constructed the content for cross-cultural dialogue by encouraging pupils to produce art, drama or language work that took as its subject matter their experience of their everyday world. In the second phase, they created the necessary conditions for dialogue to take place by exchanging their work with that of pupils from different ethnic backgrounds. In the third phase, they encouraged both sets of pupils to share and accept each others' experience by engaging them in critical discussion of their work. The strategy as a whole had been devised by Dan Nadaner and tested in Canada.[1] Since research had confirmed that the majority of primary teachers in this country subscribed to a child-artist art education rationale, but neglected critical studies,[2] the guidelines included Nadaner's instructions for a method or procedure of art criticism. The guidelines also included the tentative suggestion that the pupils involved in exchanges of artwork might benefit from visiting each others' schools.

Implementing the proposals

Volunteer teachers were recruited with the help of local authority advisers and colleagues. Since the exchange of practical work between children growing up in different cultural circumstances was such an important ingredient in the trials, placements were sought in an equal number of monoracial and multiracial schools in urban, rural and suburban settings. The guidelines were distributed during a meeting at which six primary teachers agreed to implement my proposals in the normal course of their classroom duties during a summer term. At the same meeting, three sets of schools were paired for the purpose of future exchanges of pupils' work.

The number of hours the schools allocated for the trials varied considerably, as did the extent to which the teachers requested help from either myself or student-teachers with specialist qualifications in art and design. By the end of three months, however, the following responses to the curriculum hypothesis had actually occurred. First, pupils and teachers in all six schools had viewed the film and had attempted to apply the suggested critical method in a discussion of its aesthetic and social meanings. Second, all the pupils concerned had engaged in language, visual arts or drama activity related to its suggested subject categories or themes. Third, pupils in the classes paired at the preliminary meeting had exchanged practical work and had visited each others' schools. The proposal that art criticism should be employed in discussion of anything other than the film had largely been ignored. Finally, an exchange of art and language work had featured prominently in one of the school's parents' day display.

Documenting the trials

My assessment of the programme in action comprised classroom

observation, scrutiny of the pupils' work and taped meetings and interviews with teachers. While undertaking this documentation, I supplied specialist knowledge and resources whenever they were requested and noted comments and complaints about the guidelines' conceptual framework or about practical constraints. Throughout the trial period I attempted to witness as many live teaching events as possible and was kept busy recording the interviews and meetings and documenting the myriad ways in which my educational aspirations (and Nadaner's) had been surprised. The descriptive report which follows includes some further information about Nadaner's art-based, multicultural learning strategy in the form in which it was disseminated to the teachers in the guidelines, together with an account of some of the educational actions that ensued. The report is compiled from extracts from my notes. It makes reference to both the practical and critical activities the teachers organised and to the messages and meanings their pupils' exchanged.

Descriptive Report of the Trials

The critical method

Dan Nadaner defined criticism as a process of talk about art during which viewers can participate in the artist's creativity and can share their ideas with other people. He said that it was important for teachers to note that it does not imply negative discussion about art (i.e. pointing out what is wrong or unappealing about it), but that it is a way of gathering all the information possible from a work, describing and explaining what is in it and what it is all about; and of becoming aware of some personal reactions. The information gained in descriptive and interpretive group discussion would be used as a basis for making judgements about a work's worth.

Edmund Feldman's teaching method or procedures for art criticism[3] which Nadaner favoured, has four stages - description, analysis, interpretation and evaluation. They were summarised in the guidelines as follows:

> The descriptive stage is like taking an inventory - noticing and making a mental list of everything seen and heard. Description can include subject-matter, people, buildings, places, actions and events, colours, shapes, textures, sounds, technical styles, media and materials. It can also include factual data - names of artists, dates and places where the work was done. It is very important at this stage, Nadaner says, to go slowly and not to jump to conclusions or make judgements. Language must be kept neutral, avoiding words which suggest emotion and judgement. Teachers should encourage children to notice and recall details such as, for example, what the people depicted in a painting, photograph or film, are wearing. During the descriptive stage, it should be possible for a class to reach general agreement about what exists in artwork. Questions and suggestions teachers could use to stim-

ulate discussion at this stage are, 'Tell me what you saw?', 'What else was there?', 'Have we missed anything?', 'Let's make a list of everything we noticed and heard. Can we all agree on it?' etc.

The analysis stage of art criticism goes further into relationships between different parts of the work. This stage is a more formal look at how the elements of a work affect each other from both the standpoint of design and intended meaning. The ways in which a painter has combined certain colours, textures and shapes, a writer has developed plot, character and action or, a film-maker has utilised sequencing, framing or lighting, provide clues to the effects they are trying to create and how they feel about their subjects. Analysis begins to pull a work apart and ask 'How?' and 'Why?' It is a stepping stone to interpretation in which the meaning in the artwork is the main emphasis.

The interpretive stage follows description and analysis and is probably the most difficult, absorbing and personal of all. It is during interpretation that we begin to put the work back together again from a personal standpoint, but based on what we have learned in the previous two stages.

In interpretation we are dealing with the feelings and ideas expressed by the artist. We become involved in the artist's purpose and what he or she is saying in the work; however, perhaps even more importantly at this stage, we also bring to our work our own thoughts, experiences and feelings. Much of interpretation is based on one's imagination and intuition - the ability to respond to and become involved in a work is a personal way. A good interpretation, however, must make sense of the imagery discovered in earlier discussions. It must, also, have some meaning to the people viewing it. Group agreement about interpretation is not always possible, or necessary, because of the individual viewpoints and life-experiences we bring with us. Children are often freer and more willing to jump into discussion about art than adults. Their responses can be surprisingly perceptive and they enjoy sharing their ideas with adults.

The evaluative, or final stage of art criticism is when we make judgements based on all three previous stages as to the value of the work. Our opinions can now be based on facts and reasons.

Through the process of art criticism and the sharing of ideas and interpretations children will have built up a fund of information and knowledge not only about the specific piece of work itself, but about how it relates to his or her life or feelings.

My own suggestions for capitalising on the film's potential for social or cultural learning, included in the guidelines, were that the teachers extended the above method of critical discussion and questioning in one or more of the following ways. They could ask their class to describe what life was like for Sanjay and Sunita. They could question

them about what it communicated about their feelings. They could utilise the categories referred to previously to help them analyse things about their life-style. They could initiate discussion about ways in which people get their ideas about other people and ask whether this film had challenged or changed their previous point of view.

Film criticism

The film was viewed at least once by all the teachers and children. Viewing was followed by twenty to forty minute question and answer sessions during which the teachers attempted to apply the critical method and quizzed their pupils about what they had seen and heard. The tape-recorded discussions revealed that talk about the film's aesthetic and social meanings tended to be limited to the first stage of Feldman's critical method, description - and that it was dominated by the teachers' questions and explanations.

By far the largest number of their questions were designed to test pupils' memories and their ability to name or label what they had heard or seen. (In other words, to describe the film's literal meaning and content.) In general, it appeared that the children experienced very little difficulty recalling the story sequence and naming people, places and things, but their ability to recall qualitative details about their appearances was much more limited.

In three schools only pupils were questioned about the film-makers' possible intentions and the film's message. There was general agreement that the story had a moral and that its thematic focus was a festival. Questions about the film's formal properties were restricted to colour, drawing and painting and animation techniques. As every specialist-trained teacher knows, it is much easier to demonstrate art and design techniques than it is to describe them. One primary teacher explained the principles of animation as follows. She said, 'In order to make the figures for the film, the film-maker had to cut up the children's drawings. Then he put them on a flat piece of paper and moved them around. While he was moving them around, he took lots of photos.' (e.g., about the film-maker's use of colour and sound effects, camera lighting or animation techniques to create atmosphere or mood.) Questions relating to the effects the film's formal properties might have had on its message, however, were virtually non-existent.

Children in all six schools were asked to evaluate the film. They rated it highly and demonstrated that they were capable of supporting artistic judgements with reference to both literal and metaphorical meaning and to artistic form. One group of children, for example, said they liked the fireworks because of the way their colours and shapes worked. Others commented favourably on its special effects and thought the moral in the story was communicated very effectively because it was 'made by children'.

Discussion in four schools incorporated commentary on the film's real-life location and characters. The characters were identified as 'Indian'. Some pupils mistook the location for India because of the costumes and background music.

All the children who viewed it were asked to compare the location and characters with people and places they knew. A teacher showing the film to pupils at a rural school, halted it during the shopping sequence and asked 'What is this street like?' 'Is it like your main street?' 'How is it the same?' 'How is it different?' Her pupils responded that it was bigger and the houses were 'narrower' and 'old fashioned'. In answer to the question 'What is different about the children and the place where they live?' pupils in a second rural school commented that they were 'mainly black' 'more religious' and 'didn't have anywhere to play'.

In general, the teachers appeared much more interested in discussing religious differences or contrasts between urban and rural living than in dealing with dialogue relating to race. Their pupils' observations about differences in skin colour or racial origin were ignored, whereas their comments about differences in eating habits, socio-economic status, clothing and religion were not. A teacher in a suburban school picked up on one pupil's observation about playing space in towns. After reminding him of his school's location near a forest and commenting on his friend's plans to purchase nets for a private foot-ball pitch at home, he asked why the children in the film did not have similar amenities. Tentative suggestions included 'because spaces in towns are taken up by factories, houses and industrial estates' and 'because they were poor'.

Pupils' responses to questions about what the film had told them that they did not know before, were channelled into extended dialogue about Hindu temples and the festival of Diwali. The teachers' and children's knowledge and understanding of Asian-Indian minority values and life-styles varied enormously. Children at a monoracial (white) rural school did not know what the word Diwali meant and thought the fireworks in the film celebrated 'Guy Fawkes'. In another school, the single practising Hindu member of the class was ill-advisedly placed in the limelight and called upon to act as 'informant'.[4]

Finally, two teachers utilised film discussion time for motivating possible story themes that could be realised in practical work later on. Having questioned pupils about the film's location, characters, action and plot, they asked them to consider similar kinds of stories that would 'tell other people what their lives were like'. In the schools in which these ideas were carried through, the children's art and language work was proof that the film functioned as an exemplar since it incorporated extracts of the script and some of its special effects and visual techniques.

Practical work

The guidelines emphasised the fact that successful practical work in the arts occurs as a consequence of pupils learning arts skills and techniques.[5] They outlined possible ways in which teachers could motivate imagery that was open, expressive and free from stereotypes and suggested forms that practical activities might take. Preliminary work, it was suggested, could include group discussion designed to increase children's awareness of the aesthetic and social concepts 'different perspectives' and 'different points of view'. Following this the class as a whole could discuss the things that they might like other children to know about them. Teachers could direct pupils' attention to the themes mentioned in the guidelines (favourite foods, sports, games, toys, people, places and things to do, parents' jobs, children's responsibilities, etc.), to help them choose items they felt were significant. They could organise games resulting in stories or pictures about people 'like ourselves'. Teachers were advised, also, to display reproductions of paintings, or other artworks, which depicted 'all sorts of people in a variety of daily situations and moods'; and to practice Feldman's critical method in a discussion of the ways in which the artists concerned showed what was important to them.

Once this preliminary motivation had been effected, the situation was ripe for children to begin the process of communicating their own points of view about themselves and how they lived. The products in which this viewpoint was realized or expressed could take many forms. The children could produce a series of paintings, engage in autobiographical writing - or a combination of the two. They could take black and white photographs or they could develop fictional stories about children like themselves into dramatic performances or film.

Writing

The guidelines afforded teachers the possibility of integrating language and writing with the visual arts and/or drama. The teachers participating in the trials exhibited a strong preference for language work and writing.

Two teachers structured the suggested subject themes into daily exercises in writing composed in work books. The writing was displayed later on classroom walls. A display of written work in one school was devoted to the theme of 'My freetime'. It incorporated children's commentary on bike-riding, stamp-collecting, sewing, gardening, computers, train-spotting and a host of sports. (Nigel wrote that he liked playing soldiers in the back yard in spite of the fact that his Mum told him 'war wasn't very nice'.) In another school the theme of the display was name-calling. Pupils wrote that being called 'rat-bag', 'fatty', or 'mouldy-ham' made them feel 'hot and scared' and 'want to run away'.

In four schools, written commentary under headings such as 'My

Figure 2.1:
My hobby is riding

family', 'My room', 'My likes and dislikes' and 'Hobbies', accumulated over a period of weeks, was collated and exchanged. As a consequence, pupils attending an inner-city school learned about children growing up in a small university town. They discovered that their parents insisted on a gruelling round of extra-curricular activities and that their class-teacher was 'very good at sports'. Pupils at another inner-city school, leaned that their more rural counterparts numbered bird-watching among their hobbies, enjoyed walking in the fields and, had a great many pets.

Two sets of pupils in different schools were allocated pen-pals. They exchanged autobiographical information in letters. Ferzana told James that her mother was called Azra and her brother was called Hussein. She wrote that she attended mosque school every day and collected ants and snails. In return, James explained about cubs on Mondays (which he did not like) and tennis, athletics and swimming-coaching on Wednesdays, Thursdays and Fridays. His favourite pop-star was Bruce Springsteen. James wrote that he was pleased he did not have to share his room because his sister 'pinched his toys and messed around with his headphones'. Rodney opened a letter to Courteney - a fellow football enthusiast - with the proud and defiant declaration, 'I'm black'.

Art

Practical work in art tended to be figurative and representational. Some painting activity occurred, but the preferred medium was drawing on white paper with coloured pencils, wax crayons or felt-tip pens. In several schools teachers organised formal sessions of portrait painting or drawing. One teacher cut out his pupils' finished self-portraits and displayed them on the classroom wall. Children growing

up in a rural environment painted themselves 'doing their favourite thing'. Their favourite pastimes included riding bicycles, tractors and horses, reading, skipping, eating and playing sports.

In one school the activity of painting was delegated to me. This afforded me first-hand experience of the practical constraints that militate against its success at primary level. In the school in question, progress was severely hindered in the following ways. First, painting materials had to be collected from another room; second, the pupils had little previous experience of handling the medium and lacked even rudimentary technical and manipulative skills; third, their classroom was completely devoid of flat surfaces and, fourth, their painting equipment, (brushes, for example) was in poor condition and no routine had been established for its proper use and care.

Figure 2.2:
I like to skip

Streetwork

Nearly all the teachers attempted to engage children in streetwork in preparation for further work in class. My assumption that they would be familiar with the concept from environmental studies programmes proved correct, but my assumption that they would know how to implement it was not. (One teacher mistakenly displayed a highly finished two-hour pencil study of a house as an exemplar of good streetwork.) In the majority of schools, streetwork was judged feasible only if and when it could be delegated to other adults. Consequently, ancillary helpers were directed to withdraw small numbers of children from classes for short periods of time and to escort them into the neighbourhood to compile written notes and make pencil drawings. The teachers' limited understanding of streetwork strategies, coupled

with their delegation of its organisational responsibility to ancillary workers, detracted from its utility as a mode of curriculum response during the trials.

Art and language

In several schools pupils utilised the medium of drawing to illustrate ideas developed in language work. Formal instruction in art and design techniques played little or no part in these interdisciplinary art and language activities. In the majority of instances the teachers' lack of interest in helping children to convert pencil, crayons, paints or pen into media of expression resulted in the production of visual imagery that was stereotyped and impersonal.

Figure 2.3:
Portrait of Shaheen, Melinda

Figure 2.4:
Observational drawing, Nicolai

Figure 2.5:
Illustrated class book

Name. AMANDA Venables

Date of birth: 31/5/1975
Age: 9¾ years.mounths 8½

height: 1.44m weght 30 kg
Colour hair: Ginger
eyes:blue

Figure 2.6:
Amanda, *Myself*

One teacher, however, was particularly adept at motivating visual and verbal imagery that was authentic and expressive. The illustrated letters her pupils composed communicated personal information in a manner that was humorous and open. Minesh's projected self-image, for example, was of a self-confessed romantic, partial to girls, good clothes and discos. Home was a problem because dad liked to relax on the settee and because the next door neighbour, who was 'Indian,' tended to 'act Irish' by banging on the wall while he watched TV. A demure young lady called Rita enjoyed swimming, knitting, sewing and reading stories about ghosts. In contrast, Amanda played for a local football team and liked all sorts of sports.

The same children produced an illustrated book about their class. It incorporated drawings and a description of the teacher by two girls (who accused her of tending to get cross about nothing) and detailed accounts of the boys' breakin' (break-dancing) and sporting prowess. In a third integrated art and language activity, they created picture-strip adventure stories set in the neighbourhood. The theme of peer group friendship and support was central to all five stories. Their dramatic action was focused on threatening and potentially disastrous events (e.g. falling out of trees, or being chased by skinheads) that occurred during group excursions to the local park. Once a story-theme had been identified by each group it was illustrated. The

illustrations became the focus of class discussion during which their verbal meanings and messages were guessed. Captions were added before they were sent to another school.

Art, language and drama

One teacher devoted a considerable amount of time to a single integrated art, language and drama activity. Practical work commenced when she divided her class into five groups and instructed them to invent real-life adventure stories that told people about their village. They invented dramatic incidents set in the sports club, shops and the wood, featuring ghosts and robbers. The scripts were printed out on the classroom computer and the following highly complex set of activities ensued. First, the children drew, coloured and then cut out their story characters from card. Second, they fashioned them into puppets by glueing them onto bamboo canes. Third, they engaged in streetwork and painted a large-scale collage of buildings which functioned as a stage backdrop. Finally, they dramatised the scripts and performed them as puppet plays. Tape recordings of the scripts, the puppets and the backdrop, were sent to another school where the plays were recreated and their communicative function was discussed.

School visits

Four teachers followed up the proposal that they organise exchange visits to each other's schools. The exchange visits were arranged between city and rural or suburban schools with contrasting multiracial and monoracial (white) student populations.

In two schools they lasted for one whole day, during which visiting children were paired with pen-pals and participated in activities specially organised for them. Children from a rural environment took part in Indian stick-dancing, cooked Indian food and painted 'mende' patterns on their hands when they visited an inner-city school. The city children's return trip included a long climb up a hill through

Figure 2.7:
Multicultural design motif, school display

41

some woods, (described by one member of the party as 'smelling horrible'), to look at the view. A joint day trip was organised by the other two schools. It began with one set of pupils showing their visitors around their school. Following this, both sets of pupils went to a local park for a picnic lunch. In the afternoon, they went to the other school and the procedure was reversed.

The teachers' random comments about the visits indicated that they judged face-to-face contact a more effective strategy for cross-cultural dialogue, than art. This was in spite of the fact that some of the entries in the children's workbooks, completed later, included rather negative comments about pen-pals and about parental reactions to what had taken place.

Figure 2.8:
Page from
Pavan is a Sikh,
multicultural
reader

A parents' day exhibit

The teachers' views about multicultural curriculum goals, objectives and aims were difficult to determine. But the work emanating from one exchange was featured in an open day display in a monoracial (white) suburban school. The display incorporated photographs of the two sets of pupils involved in the exchange together with autobiographical information and portraits. It included drawings and plans of their families and homes, and two painted friezes or collages, one of the inner-city high street, and the other of the suburban housing estate in which the schools were located. A selection of multicultural reading books about ethnic minority children was placed on a table underneath the display. A series of decorative design motifs representing black and white clasped hands were arranged around the following quotation in the centre:

> *All children are the same. Although they appear different. The light, the dark, the ugly and the beautiful. All human beings are the same. Recognise the whole human race as one.*

> G.G. Singh

Critical Evaluation of the Project

Curriculum theorists[6] have described the business of curriculum development as revolving around two activities. First, translating educational ideals and aspirations into materials and plans. Second, modifying and improving them when they are falsified in action by the phenomenon of surprise. At the close of the trials, I did not feel disposed to draw any firm conclusions about the project's worth, since it had become increasingly obvious that the curriculum guidelines were too open-ended and that some of its methodological principles had either been misinterpreted or ignored. But my field notes had recorded numerous instances of surprise. Having reflected on them and speculated as to their implications for the project's future implementation, I identified the following four factors as likely to prove problematic to its success in similar situations elsewhere.

Confusion about the project's multicultural aims

The multicultural educational aims underpinning the curriculum proposal appeared confused. Nadaner's project report had referred to his curriculum strategy as addressing a need for schools to recognise and adjust to an increased cultural diversity in the Vancouver student population. But, on reflection, his report failed to get to grips with the difficult concept of cultural diversity and to define what is meant by a cultural group. Nadaner's curriculum proposals, a modified version of which appeared in my guidelines, afforded primary teachers the possibility of focusing their pupils' attention on a wide range of factors (including age, gender, socio-economic level, urban and rural living, geographical region, religion etc.), all of which could be said to contribute to cultural diversity.[7] (So long as these differences were distinguishable in visible form, either literally or symbolically, their teaching could have been structured in such a way that it highlighted any of them.) In the absence of firm directives, however, as to which of these factors were any more or less educationally significant, the teachers participating in my trials tended to structure the teaching-learning situation around concepts of culture they already knew or which they found least threatening. This made Nadaner's claim that his multicultural curriculum aims were procedural appear questionable.[8]

This leads me to my second point, which is that the multicultural curriculum focus of the guidelines was unfashionable. Multicultural educational policy and polemics in this country have moved through a series of developmental stages each of which has reflected a different set of attitudes and beliefs. At the time of the trials, the standard literature on the topic was antiracist (i.e. it was concerned with curriculum innovation that addressed the question of race and the inequities in British society that exist with regard to this issue). My guidelines were not intended to assist. Their list of expressive themes represented salient aspects of human experience that could have lent themselves to

multiracialism, but they did not incorporate any educational strategies that were specifically designed to combat racial prejudice. All this proved problematic because race relations was a tacit theme underlining much of the work the teachers instigated and because they dealt with the issue very badly on the whole. On the one hand they eagerly engaged pupils of different racial origins in face-to-face interaction, on the other hand, they shied away from any discussion of physical differences related to skin colour, or racial origins, even when they were raised voluntarily by children in their class.

I was surprised, also, by one teacher's objection that the guidelines' proposals were 'socially divisive'. Admittedly, the discussions they had instigated in class following the film had tended to concentrate almost exclusively on cultural diversity - especially in clothes, religious customs and food - and pupils were left to intuit similarities for themselves; but I had understood the guidelines as encouraging teachers not merely to single out and isolate differences in pupils' cultural circumstances, but encouraging them to utilise the media of the arts to help children realise that that they experienced their lives in much the same way. In these trials, therefore, it appeared that the wide choice of subject categories or themes in the guidelines, combined with the prevailing educational mood of antiracism, had contributed to a general confusion about the project's multicultural goals and aims.

Finally, and in retrospect, Nadaner's suggestion (implicit in my proposals) that the mere exchange of cross-cultural information could lead to an increased tolerance of cultural differences on the part of pupils appeared to be, at best, a curriculum hope, not an aim. (He himself admitted that there was little research evidence to support it.) The findings of the trials were that Nadaner's and my own multicultural educational approach was too generalised to be useful and it smacked of the 'social adjustment' philosophy of multiculturalism that antiracist educational lobbyists in the British system decried.

Teachers' and pupils' literal-mindedness

Secondly, the curriculum proposal that children's artworks (i.e. paintings, drawings, stories etc.) constituted an appropriate medium for intercultural dialogue rested on an expressionist theory of art and on a theory of personal knowledge that assumed that they can function to communicate concrete human experience which is subjective, particularised and personal.[9] It is by no means unusual for primary teachers to encourage young children to produce art work that takes as its subject matter their personal response to their everyday experience or to engage them in art activity that is popularly labelled 'expressive'. But, the assumption that the resulting products necessarily perform a communicative function is questionable.

In the first place, so-called expressive artwork does not occur as naturally or spontaneously as many primary teachers suggest. Michael Armstrong's sympathetic account of children's struggles to express

personal experience in writing makes this clear.[10] Having observed one primary class for an entire school year, he reported that the teacher's problem was not that of merely helping them to reproduce in writing the vivacity of their talk, but rather of watching them experiment with different literary genres, and helping them to develop skills in imposing a literary order on their experience and to distil it in ways which were appropriate to the medium. Similarly in the visual arts, expressive paintings and drawings[11] occur as a consequence of children coming to know, understand and be capable of attending to art as an embodiment of feeling or value and acquiring the necessary artistic skills and techniques. For Nadaner's strategy to work effectively, therefore, it required teachers who could attend to the specific relationships between artistic content, form and style that specialists label 'expressive' and who were capable of demonstrating those skills and techniques. Where the visual arts were concerned during the trials this appeared not to be the case.

Figure 2.9:
A picture-storybook

In the second place, even if they had possessed such skills, knowledge and understanding, the evidence was that both the teachers and their pupils subscribed to an imitationist rather than an expressionist theory of art and that they favoured impersonal rather than personal forms of knowing. By the former, I mean that their artistic preoccupations were tied up with the question of whether or not their pupils' work demonstrated a careful observation of the external world, including people, nature and the environment; and by the latter, I mean that they understood knowledge as derived from generalised or so-called objective information, or facts.[12] Once again, the successful and accurate representation of the visual appearance of three-dimensional objects in space on a two-dimensional plane is a taxing task which demands sophisticated artistic skills and knowledge on the part of both child-artists and teachers. Finally, the majority of the work completed by the children participating in the trials reflected their teachers', rather than their own conceptions of what was important in their experience.

This, coupled with their own and their teachers' tendency to hold a somewhat inflexible interpretation of reality, made the prospects for the future of Nadaner's expressive strategy at the primary school level of education appear bleak.

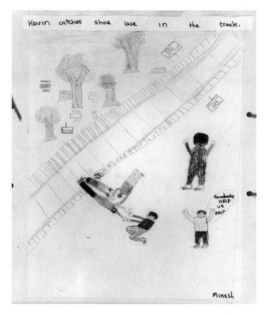

Figure 2.10:
Kevin falls down and catches his shoelace in the track

The failure to implement criticism

Third, the successful implementation of the curriculum strategy as a whole depended on teachers applying the aesthetic principle about communication in art being a two-way process and on their completing all three stages in the implementation process. The field of art education has long been notorious for its neglect of anything other than the productive domain[13] and my estimate that the teachers assisting in trials would be unlikely to have awarded much attention to art criticism in the past proved accurate. The inclusion of Feldman's how-to-do-it instructions in the guidelines did little to remedy this lack. Either the instructions were disregarded or the teachers indicated - by their repeated calls for practical guidance and help - that they found the idea too novel or threatening. Moreover, in a number of sessions where the proposed 'method' was applied to discussion of the film, it was utilised incorrectly. All this suggested that in-service training in the application of art criticism was a necessary prerequisite for the project's successful implementation in future trials.

The project's interdisciplinary focus

Fourth, there was the question of the curriculum's interdisciplinary focus. Recent reports such as *The Arts in Schools*,[14] have tended to favour this approach to the organisation of lesson content in the arts,

but the evidence of the trials suggested that the consequences for the disciplines are dire. The dominance or pervasiveness of verbal and written performance systems in primary education is well documented. Given a choice, the teachers participating in the trials elected to utilise linguistic modes of curriculum response - the ones with which they were most familiar and which the school system as a whole rewards.[15] The arguments for and against integrated curricula abound in educational literature and the oft cited problem of the trivialization or abuse of one subject discipline by another[16] was apparent in the majority of the situations in which pupils were encouraged to utilise the visual arts to illustrate verbal ideas. The complexity of the technical and organisational factors that non-specialist trained teachers must take into account if they elect to implement practical work integrating language and art activity is well illustrated in this extract from my field notes compiled while watching the final performance of the puppet play.

> *When I entered the hall some improvised curtain making was going on and the teacher was hastily fixing a length of fabric to a broomstick with some dressmaker's pins. Groups of children were sitting around on the floor rehearsing their scripts, seemingly devoid of any skills in puppet manipulation. When the performance finally got off the ground, they spoke so fast that the audience failed to recognise that the plays were set in the locality.*

Art Education theorists in the USA are currently arguing for discipline-based teaching or basic arts education even at primary level.[17] As a specialist-trained teacher, I found the lack of even a rudimentary understanding of basic concepts and technical skills in the visual arts on the part of the trial participants extremely worrying. (There are signs that Her Majesty's Inspectorate feel the same.[18]) At the close, I was forced to conclude that, since the fundamental arts skills and concepts that are a necessary prerequisite to all other kinds of arts-based curriculum activity appeared to be lacking in the primary

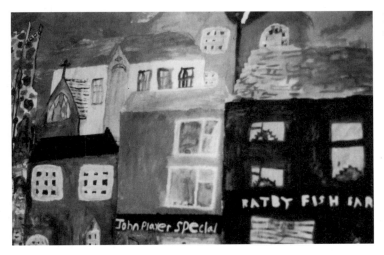

Figure 2.11:
Group collage,
Our village

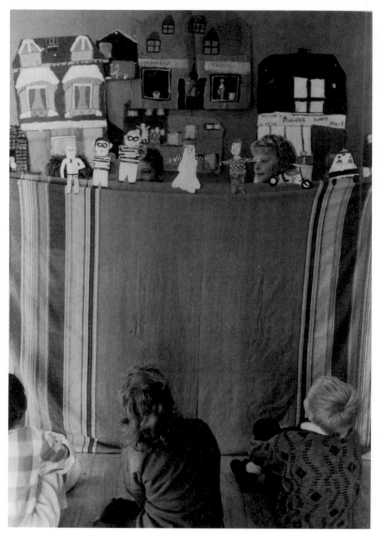

Figure 2.12:
**Rehearsing the
puppet show**

educational context, instrumentalist[19] and interdisciplinary rationales for their inclusion could only serve to aggravate a situation in
which they are already poorly taught and understood, and therefore,
would contribute to their low esteem.

Summary

In summary, the following key obstacles appeared to stand in the way
of the successful realisation of both Nadaner's and my multicultural
curriculum ideals. First, our stance on multiculturalism was too generalised and was unfashionable. Second, the proposed curriculum
strategy rested on theories of art and of knowledge that non-specialist
teachers did not fully comprehend and were not really capable of
implementing. Third, the proposed instrumentalist application of the
visual arts with its interdisciplinary structure ran the risk of exacerbating a curriculum situation in which they were already either poorly

taught or neglected and in which the odds against primary teachers paying sufficient attention to anything other than linguistic responses appeared high. But the project's emphasis on the cultural dimensions of artistic activity and on inter-subjectivity was timely. Moreover, my previous experience of collaborative work lead me to suspect that this proposal for an art-based curriculum strategy has potential for the primary educational situation (in which a child-centred learning approach and the concept of expression tend to be favoured), provided it is implemented by arts specialists operating in conjunction with classroom teachers.

In conclusion, I ended up supporting Nadaner's premise that it was vital that arts subjects should be taught in such a way that they reflected the reality of the cultural differences that are a feature of modern industrial societies. I suspected that some of the confusion about the project that had surfaced during the trials was the outcome of faulty curriculum planning on my part rather than mistaken ideals. (For example, my decision to offer the teachers expressive outcomes, goals, aims and objectives and to make 'race' the decisive cultural factor in the selection of schools for exchanges of student work.) However, given the confusion about its multicultural curriculum goals and aims, I was forced to admit that the project's chief value lay in the significance it had awarded art criticism and in its potential for counteracting the bias in visual arts education in favour of the productive domain.

Notes

1. D. Nadaner, 'Developing social cognition through art in the primary school', unpublished report, Simon Fraser University, Vancouver, 1984.

2. B. Nattress, 'Approaches towards art in primary education. An analysis of curriculum rationales', unpublished M.A. dissertation, Department of Educational Research, University of Lancaster, 1983.

3. Edmund Burke Feldman, *Becoming human through art* (Prentice-Hall, New Jersey, 1970).

4. Robert Jeffcoate, *Positive image. Towards a multiracial curriculum* (Writers and Readers Publishing Co-operative, London, 1979) p.33, points out that minority children may well be embarrassed at being placed so conspicuously in the limelight by a sudden intrusion of their own culture and white children may react hostilely, interpreting the teacher's decision to include it as partisan.

5. Brent and Marjorie Wilson, *Teaching children to draw*, (Prentice-Hall, New Jersey, 1982) have challenged the notion that children's drawings occur naturally or spontaneously. They insist that their visual images are always the result of graphic influences emanating

either from peers or adult artists and note, that when left to themselves, they often adopt the most stereotyped and banal imagery available to them in their culture.

6. Lawrence Stenhouse, 'Case study and case records: Towards a contemporary theory of education', *British Journal of Educational Research*, vol. 4, no. 2, (1978) pp. 21-8.

7. D. Gollnick and P. Chinn, *Multicultural education in a pluralistic society* (C.V. Mosely, St. Louis, 1983), p. 32, claim that most nations are made up of a macroculture and numerous microcultures. They say that cultural identity is based on several traits and values learned as a part of our national and ethnic origin - religion, gender, age, socio-economic level, primary language, geographical region, rural or urban living and, handicapping or, exceptional conditions. Although sharing certain characteristics of the macroculture, members of these smaller groups also have learned cultural traits, values and behaviours which are characteristics of the microcultures to which they belong.

8. J. Coombs, 'Multicultural education and social justice', *International Year-book of Higher Education*, no. 14, (1986).

9. Louis Amaud Reid, *Ways of understanding and education*, (Heinemann, London, 1986), chapter 1, for his account of impersonal and personal forms of knowledge, and of how deeply the impersonal account of knowledge is rooted in our culture. Also, for his distinction between direct knowledge of particulars as opposed to knowledge of abstract concepts and universals. The emphasis on personal experience and on a feeling response is fundamental to Nadaner's multicultural approach since it relies on the principle that it is the exchange of subjective knowledge, (not of facts or general information), that helps us to get to know and respect people whose cultures are different.

10. Michael Armstrong, *Closely observed children: The diary of a primary classroom* (Writers and Readers Publishing Co-operative, London, 1980).

11. Reid, *Ways of understanding*, pp. 64-5 commented on the quite extraordinary difficulty about the use of the words 'expression' and 'expressive' as applied to art. Nevertheless he allowed that there is no harm in saying that expression of feelings is involved in the initiation processes of art making and in the enjoyment of art so long as it is realised that feelings are cognitive as well as affective. Also, that art expresses ideas and feelings of, and for, ideas and things: and, that feelings are for, and of, values. (In other words, that they are acceptable if they are understood reflexively and as being 'meaning embodied.')

12. Howard Gardner, *Artful scribbles* (Jill Norman, London, 1980), argued that the tendency of teachers to hold inflexible interpreta-

tions of reality - their literal-mindedness - is detrimental to children's artistic expression. Two of my student-teachers demonstrated the advantage of holding to a flexible interpretation when they organised an expressive art activity during the trials. Having shown some pupils images of body ornament in Papua New Guinea they instructed them to construct cut-out card body costumes which 'told other children about their hobbies'. The resulting costumes covered with decorative designs of fish, telephones, flags, food, horses and films communicated their interests symbolically rather than literally but the class teacher judged them an enormous success.

13. Brian Allison, 'Identifying the core in art and design', *Journal of Art and Design Education*, vol. 1, no. 1, (1982) pp. 59-66.

14. e.g. Calouste Gulbenkian Foundation, *The arts in schools: Principles, practices and provision* (Gulbenkian, London, 1982).

15. Elliot Eisner, *The educational imagination: on the design and evaluation of school programs* (Macmillan, New York, 1979) p. 129.

16. Richard Pring, *Knowledge and schooling* (Open Books, London, 1976).

17. Chapter 2 of Laura Chapman's *Approaches to art in education* (Harcourt, Brace and Jovanovich, New York, 1978) is devoted to an explication of key concepts in art and their related terms. Whereas she admits that it is not possible for primary teachers to be completely knowledgeable about all its technical aspects, she insists that an understanding of these basic concepts is essential - not the least because this enables them to pursue self-education in the technical aspects of artistic instruction.

18. In their illustrative survey of eighty, first schools in England, *Education 5-9,* The Department of Education and Science (HMSO, 1992), commented unfavourably on variations in the degree to which teachers utilised the interior and exterior environments of schools to develop children's aesthetic awareness, and the disappointing lack of progression in much of children's learning in art and crafts. In *Art in junior education* (Department of Education and Science, HMSO, 1978), they defined 'quality programmes' as exhibiting evidence that teachers used the immediate outdoor environment and arrangements and displays in school, a range of drawing and print-making, textile and three- dimensional constructional materials and children learn to observe form, pattern and colour carefully and to use it in their work. Also, that they turn readily to art media to express personal feelings and visions. The implications of these comments are that they were advocating a more subject based or essentialist approach to art education. One which, it could be argued, primary teachers with general education qualifications are ill-equipped to provide.

19. Elliot Eisner, *Educating artistic vision*, (Macmillan, New York, 1970) has distinguished between an essentialist rationale in which art education is justified on the grounds that the visual arts are unique subjects which are worthy of study in their own right and contextualist, or instrumentalist rationales which advocate the teaching of the arts for any number of extra or non-aesthetic ends.

References

Alexander, R. (I981) 'The evaluation of naturalistic, qualitative, contextualist, constructivist research in art education', *Review of Research in Visual Arts Education*, vol. 13, pp 34-43

Aoki, T. (1978) 'Toward curriculum research in a new key', *Presentations in Art Education Research*, no. 2, Concordia University, pp. 47-71

Burgess, R. G. (1980) Fieldwork problems in teacher-based research', *British Educational Research Journal*, vol. 6, no. 2, pp. 165-73 (ed.)

Burgess, R. G. (1984) *The research process in educational settings: Ten case studies*, Falmer, London.

Denscombe, M. and Conway, L, (1981) 'Anecdotes, examples and curriculum development', unpublished, De Montfort University (formerly Leicester Polytechnic)

Eisner, E. W. (1974) *English primary schools: Some observations and assessments*, National Association for the Education of Young Children, Washington DC

Gilmore, P. and Glatthorn, A. (1982) (eds.) *Children in and out of school: Ethnography and education*, Center for Applied Linguistics, Washington DC

Guba E. G. and Lincoln, Y. S. (1981) *Effective evaluation: Improving the usefulness of evaluation results through responsive and naturalistic approaches*, Jossey-Bass Inc. San Francisco

Rubin, B, (1982) 'Naturalistic evaluation : Its tenets and application', *Studies In Art Education*, vol. 24, no. 1, pp. 57-63

McNeil, F. and Mercer, H. (1982) *Here I am: Primary Language Project*, A. and C. Black, London

Stenhouse, L. (ed.) (1981) *Curriculum research and development in action*, London, Heinemann

Street-Porter, R., (1978) *Race, children and cities*, Open University Press, Milton Keynes

Willis, W. (ed.) (1978) *Qualitative evaluation: Concepts and cases in curriculum criticism*, McCutchan, Berkeley

Multicultural Curriculum Reform and Art

Introduction

The previous chapters have focused on my own work with primary teachers, pupils, and student-teachers and on my personal response to the challenge of cultural diversity in Leicestershire schools. At the end of 1984, I was lucky enough to be awarded a teacher-fellowship at the University of London. This afforded me the necessary time and opportunity to reflect on the issue as it featured in the literature of so-called multicultural, multiracial and multiethnic education and to consider alternative forms of curriculum response.

The review of multicultural education literature concentrated in the main on the critique of art and design that had emerged in Britain over the past twenty years in line with a new 'ethnic' dimension of Government policy and practice. Multicultural education experts,[1] had identified this new ethnic dimension to educational thinking as having had its origins in the Commonwealth Immigrant Advisory Council's recommendations to the Home Secretary that special provision should be made for the children of (black) immigrant families arriving in Britain from the West Indies, Africa and the Indian Subcontinent in large numbers during the early 1960s. They had described multicultural, multiracial and multiethnic educational policy and practice as largely problem-centred; and as having moved from ad hoc responses to the administrative and language difficulties posed by immigrant children in inner city schools to a more general concern with the problems of so-called ethnic minority pupils' disadvantage and failure in the system as a whole. They claimed that multicultural, multiracial and multiethnic educational thinking in this country had been assimilationist, integrationist, pluralist and anti-racist in kind. In the event, I found the critique of art and design that was located within the literature about multicultural, multiracial or multiethnic education and art rather limiting in that it tended to restrict discussion about cultural diversity solely to the issue of inter-group and minority group relationships in the United Kingdom. Consequently, my review was extended to encompass literature about social studies teaching, environmental studies, humanities, media education, development education and world studies which dealt with relationships between peoples from a more internationalist perspective.

The study of curricula took the form of an informal survey of project materials, audio visual resources (such as slide-packs, and videos) and

instructional packs that were pertinent to the above literature and relevant to the teaching-learning situation in art. The search for such materials was exhausting and time-consuming. It took me to education libraries and teachers' resource centres, to minority and third world arts organisations, the Commonwealth Institute, the Centre for World Development Education, The British Film Institute, to artists' homes and a number of museums and art galleries all of which were located in London. Word of mouth reports about relevant teaching in Inner London Education Authority (ILEA) schools were not pursued because I was anxious to locate models of practice that were available to the profession at large. Of assistance also, were the formal and informal discussions with fellow teacher-researchers at the University which directed me to multicultural curriculum exemplars in specialist disciplines other than my own. They drew to my attention, for example, multicultural education texts and strategies for teaching science education and history and a whole industry geared towards the censorship of racism in children's literature, none of which appeared to have any equivalents in art and design.

The multicultural critique of art teaching

The multicultural critique of art and design teaching in Britain was located in educational reports, articles and books published between 1972 and 1986. Anne Taber's article on art and multicultural education, published in 1981[2] referred to her experience of working in a language centre or special reception school during the 1970s. The article commented on some of the ways in which her immigrant pupils' Indian and East African cultural backgrounds had challenged her preconceptions about teaching and it described some of her ad hoc responses to the curriculum problems they had posed.

In the course of teaching them drawing and painting, she had noticed that these children were not interested in the kind of observation and representation of phenomena and events that her examination syllabuses emphasised; or, in the devices of pictorial illustration (such as scale, overlapping, foreground and background size adjustment, perspective, etc.), that her British-born pupils deemed important. She had been worried by work that lacked imagination and originality and perplexed by their repeated requests to be told what colours and forms to use. As time went on, however, she had recognised that these difficulties were occurring because their most fundamental conceptions of the subject were at odds with hers. The pupils with Muslim backgrounds, for example, had probably grown up in a tradition in which artists always worked to a set of prescribed rules in accordance with sacred formulae. Their expectation might well have been that art had a religious purpose and meaning. She ought not to have condemned their questions about colour on the grounds that they demonstrated a naive lack of understanding of the importance of colour selection and mixing since their concept of art probably embraced a set of colour

schemes which had iconographic or symbolic significance.

Taber experimented and found that her pupils responded enthusiastically to pattern work of the kind she associated with folk art, and to craft activities such as paper-flower making, pebble-painting or batik. She concluded that the influence of the concept of fine art on an art teacher's thinking was unproductive in multicultural classroom situations like hers. It had caused her to pay too much attention to personal expression, for example, and to attend to a limited range of art and design forms. She had tried out a number of crafts activities, such as pattern making with sticks of the kind that is used to decorate calabashes in Nigeria. As a consequence of this, she advised art specialists that there were numerous ways in which they could and should introduce the art of non-Western cultures into their curriculum in schools.

At about the same time that Taber was experimenting with folk arts and crafts, Naseem Khan discovered a vital cultural life in the Bangladeshi, Chinese, Cypriot, East and Central European, Indian, Pakistani, West Indian and African communities living in Britain that existed in isolation from mainstream culture. Her report, *The Arts Britain Ignores*, published in 1976, made a plea for new arts and education policies that recognised the rich contribution this cultural life had to make. *The Arts Britain Ignores* which was funded jointly by the Arts Council, the Gulbenkian Foundation and the Commission for Racial Equality has been credited with ushering in a period of ethnic minority arts initiatives, such as the funding of a Minority Arts Advisory Service (MAAS) and in-service teachers' courses, which had the potential for effecting considerable changes in the way the arts were taught in the nation's schools.

From the evidence cited in the Commission for Racial Equality's report of five conferences they sponsored on the theme of *Arts Education in a Multicultural Society*, which was published in 1981, it appears that some ethnic minority arts initiatives did, in fact, take place. The report included how-to-do it instructions for teachers in Chinese calligraphy, making Kaylun masks, (henna mende), hand-painting and information about folk songs of Bengal, Afro-Caribbean musical forms and classical Indian dance. For David Wainright, a conference participant and a local authority adviser with special responsibility for ethnic music, however, all was not well. He was quoted as saying:

> *The dominant attitude in this country towards ethnic minority arts may be described as 'cultural imperialism': the belief, not that 'our culture is best', but that 'ours is the only culture'. The school curriculum has both explicit and implicit aspects; that which is not included is therefore considered to be of no value. Non-white children are quick to pick up the implication that their entire ancestry has added nothing of value to the sum total of human knowledge. The*

attitude in schools epitomised in the statement, 'We treat all our children the same way' is a negative one. Immediate steps have to be taken to give minority groups, a positive self-image and we have, secondly, to provide a more positive image of the many advantages this country has acquired in becoming multi-racial.[3]

In 1982, the Gulbenkian Foundation published a major report on the status of the arts in schools. They were critical of art and design teachers who attempted to pass on the British cultural heritage 'as if it were a universally valued archive of stable treasures',[4] and they found programmes which concentrated on mere artistic expression, without reflection and evaluation unsatisfactory. Their report argued for a concept of curriculum in the visual arts in general education which gave equal weight to appreciation and participation and in which children were encouraged to recognise and compare their own cultural assumptions and values about the arts with those in history and other cultures.

The two major government reports of enquiries into the education of ethnic minority children, published in 1981 and 1985, were remarkable for their avoidance of almost any reference either to the visual arts or, to art and design. The Rampton and Swann Committees' major concern was with the failure of ethnic minority children in the educational system as a whole. But they came out against special educational provision for cultural difference and in favour of 'a sharing and reassessment of culture for all'.[5] The Rampton Committee warned against the curriculum being arranged in such a way that it reinforced 'stereotyping of life-styles, occupations, status, human characteristics or one particular culture'.[6] The Swann Committee dismissed multicultural curriculum initiatives such as West Indian steel bands, or 'black' or Asian studies for minority pupils. At the same time, they found teachers who claimed to pursue policies of non-differential treatment in their classrooms wanting, in that their colour blindness was 'a denial of an important aspect of a person's identity'; and they uncovered widespread evidence of racism amongst teachers in schools.

The Schools' Council Discussion Document, *The Assessment of Art and Design Examinations in a Multicultural Society* published the same year as Swann, saw cultural differences as a considerable source of social conflict and as a matter for political and educational concern. Alan Leary, its author, noted that an emphasis on personal expression and on the communication of ideas and emotions through art and design was common to the various boards' exams. But he found it regrettable that their papers tended to reflect the values of the dominant culture and failed to take into account the special needs of that substantial proportion of the school population whose cultural heritage was non-European.

In the course of reviewing 16+ syllabuses, Leary uncovered art appreciation papers with no questions on anything other than essentially

Figure 3.1:
A typical GCSE examination display

Figure 3.2:
Ethnographic Resources in Art Education: A school projects, chinese mask

European themes; together with an emphasis on drawing from observation as a starting point for personal responses in all the practical papers which conflicted with non-European artistic traditions; and unnecessary limitations on content choices in the whole range of categories of examination available to pupils. In a 1982 painting paper, for example, candidates had been asked to carry out a piece of work based on drawings from observation of a particular food or meal.[7] Of the eight food choices offered, almost all had been based on British culture (e.g. bacon and eggs, fish and chips, prawn cocktail etc.) Since preparatory work for observation was intended to be undertaken in the candidates' own time, the Schools' Council's findings were that

those from non-English backgrounds were disadvantaged. The calligraphy and lettering sections of the boards' papers were cited as providing a particularly glaring example of cultural discrimination in that they examined, almost exclusively, skills based on a knowledge of Roman letter forms, (or their medieval and Renaissance derivatives), and neglected to provide questions for Muslim candidates familiar with Arabic and related non-European scripts. Even the candidates' work in textiles, which Leary described as being, in essence, a cross-cultural art form, was assessed for the contribution it made to European design.

Leary voiced a general concern about the absence of papers and project type questions that encouraged 'developmental articulation and communication of ideas, opinions and feelings about art and design'.[8] Whereas his document applauded the fact that a Mode 3 examination structure allowed for the possibility of submitting examination papers which had an ethnic focus (thereby reducing cultural unfairness), it noted that very few such schemes were being submitted. Given all this, the Council's verdict was that the art and design examinations as a whole devalued the cultural and artistic heritages of ethnic minority members of British society, and failed to broaden the artistic experience of the majority. Leary's conclusion was that effective encouragement of the much needed multicultural curriculum initiatives required a fairly radical reorganisation, not only of the boards' examination syllabuses but also, of their assessment modes, criteria and aims.

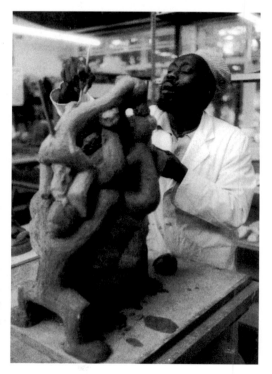

Figure 3.3:
Emmanual Jegede, *Akaba Aguniguntan* **(The endless Ladder) 1985**

Horace Lashley's critique of visual arts practice published in 1986[9] found art and design specialists guilty on every previous count and more. In an article in a book about the multicultural curriculum he accused them of ethnocentrism on the grounds that the work they display on their classroom walls seldom reflected the multiracial mix of British society - even in schools which claimed to pursue antiracist or multicultural policies. They were guilty, he said, of engaging their pupils in the unrecognised practice of the art of non-Western cultures. He described the mixture of arrogance and ignorance they displayed in this regard as a manifestation of a cultural imperialism that is rampant in the professional world of art and design as a whole. Lashley castigated visual arts specialists, also, for their tendency to rely solely on visiting out-of-school expertise for teaching about the art of other cultures and for their failure to take into account the different kinds of roles that their subject played in the lives of ethnic minority communities.

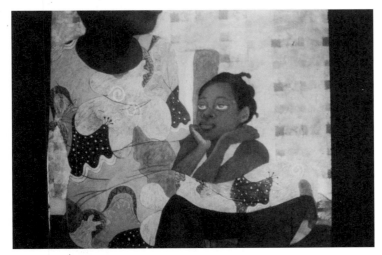

Figure 3.4:
Sonia Boyce, *Big women's talk*

But the most telling multicultural critique of all had been formulated outside the school system by those practising artists and writers who belonged to the new Black Arts movement, many of whom were British trained. Their criticism not only of government arts education policy and practice, but also of the racist structure of British society as a whole was both implicit and explicit. It was implicit in their formation and establishment of separate cultural centres and art galleries which supplied black artists and writers with the space and opportunity to exhibit what they wanted, how they wanted - which, they claimed, had been denied them elsewhere. It was explicit in their paintings and publications which describe their 'struggle to be different and black'.[10] Many of them were extremely critical of the ethnic minority arts education movement which they claimed had tended to emphasise traditional crafts forms and to deny third world artists and crafts people a place in the contemporary arts scene. They were critical, also, of a system of professional training that had denied

them their black cultural heritage and identity. It is important to note that, at the time of writing, some black cultural centres, such as the Africa Centre in Covent Garden and the Black-Arts gallery in Finsbury Park, were offering what could be described as alternative art education curricula for children in the form of informal workshops held on their premises in out-of-school hours.

Lastly, any discussion of the multicultural critique of art teaching in Britain would be incomplete if it made no mention of Brian Allison. Allison has been one of the most persistent advocates of multicultural change in art and design curricula over the last decade, but his focus has tended to be international. As early as 1972, his *Art Education, and Teaching about the Art of Africa, Asia and Latin America*, chastised specialist teachers for their superficial understanding of the arts of the third world and for the fact that non-European art hardly ever entered into school programmes at all. Once again, it was British art-school training that was blamed. Allison has always been a stringent critic of the artist-teacher model of practice and of the significance afforded to the concepts of creativity and child art. He holds art schools and colleges accountable for a sorry state of affairs in which art in primary and secondary schools is little more than a response to the demand that students should make something; and 'rarely are questions asked as to what pupils have actually learned from what they have done, or about what values that learning might have to life outside the confines of the artroom, or to the 99.8 percent of the population who leave school never to touch a paint brush or lino-cutting tool again'.[11] His critique is part of his larger argument for a model of the curriculum which incorporates four domains which he has named productive-expressive, perceptual, critical and historical-cultural.[12]

In Allison's argument, teaching located in the cultural domain is much more important than teaching in the productive domain and it is vital that every child is taught that their own view of art is culturally determined.

Curriculum initiatives in art and design

A survey of policy and practices designed to meet the needs of a multicultural society in art and design teaching was conducted at the De Montfort University (formerly Leicester Polytechnic) under Allison's auspices in 1985.[13] This survey identified three strands of multicultural curriculum thinking which were defined as as global, ethnic minority and antiracist in focus. The global or internationalist orientation implied that art and design policy and practice was directed towards the expansion of the curriculum's goals and content to include a wider diversity of cultures than the dominant, or typically Anglo-European focus generally allowed. The ethnic arts focus implied a preference for curriculum changes intended to foster and perpetuate a respect for the traditions of the minority cultures found in a given locality and attempts to incorporate their art, craft and

design traditions into the curriculum. The antiracist orientation emphasised the need for curriculum materials specifically designed to combat racism. The three orientations were described as similar in that they all sought to reduce ethnocentrism in art and design teaching, but as dealing with the issue of curriculum change for Britain's multicultural or multiethnic society in distinctive, yet overlapping ways.

In my search for alternative approaches to multicultural teaching in my subject, I uncovered curriculum initiatives in the form of audio-visual resources, curriculum packs, teachers' worksheets, project reports etc., that responded to the need for curriculum change in art and design from all three perspectives. As Lashley and others had noted, government reports on art in primary and secondary education were noteworthy for their failure to make reference to the needs of multicultural Britain. The majority of the initiatives were the work of committed individuals, or small local groups operating independently, or with the financial support of non-educational bodies. At the time I was conducting the search, a colleague working in London surmised that the key resources actually being exploited by art and design teachers for the purposes of multicultural curriculum reform were, most probably, museums and galleries, multi-ethnic packs, minority arts group associations and artist-in-residence programmes. These forms of curriculum innovation are, of course, extremely difficult to track down because their application goes unrecorded.

Multicultural resources for art and design teaching in the form of slides were also extremely difficult to locate. Moreover, slide collections were inappropriately classified and catalogued for the curriculum applications I began to explore. The Swann Report, for example, had referred to a comparative approach to the teaching of religion in which the curriculum was organised thematically. The slide collections I looked at which were compiled for religious education purposes, frequently contained cross-cultural packs of images. But the collections for art and design teaching seldom incorporated any examples of work by non-European artists. (The typical response was that these were not in demand or economically non-viable to produce.) The slides tended to be catalogued by European countries of origin and individual artists' names. Consequently, a teacher wishing to engage pupils in exercises in cross-cultural comparison of the kind that the Swann Report claimed was typical of religious education curricula, would have needed to know in advance which artists' works were appropriate. They would have had to single out cross-cultural exemplars one by one. Slides of work by black artists living Britain were virtually non-existent, other than at specialist centres. This in spite of the fact that so-called black arts exhibitions were fashionable in mainstream galleries at the time.

Nick Stanley has commented that the most innovative curriculum initiatives in multicultural education and art and design have been the

work of non-art specialists reaching out and using their subject without reference to them.[14] I tend to agree. Of the more substantial curriculum initiatives I was able to uncover, the most innovative, were certainly not the result of art and design specialists rethinking their philosophy. Had I limited my search solely to initiatives that were exclusively art-based it would have been very much less productive.

Global or internationalist initiatives

I uncovered what the AIMS survey had identified as global or internationalist initiatives in the form of a long term curriculum development project located in an institute of higher education, school-based in-service curriculum work funded, in part, by a charity organisation and in an exhibition in an anthropology museum.

Figure 3.5:
Ethnographic Resources in Art Education,
School project; masks through music

The long term curriculum development project emanating from the University of Central England (formerly Birmingham Polytechnic) entitled *Ethnic Resources for Art Education*, yielded a number of teachers' packs which contained information about traditional ceramic and textile forms and techniques in Africa, Latin America and Indonesia. The teachers' packs called *Art and Play* and *Peoples, Processes and Patterns: Islam and Japan'* were more cross-cultural and comparative in focus. The project as a whole was typical of other internationalist initiatives in that it exploited anthropology and/or history as a theoretical base for curriculum reform. The packs aimed to provide teachers with sufficient contextual and technical information to enable them to instruct children about the traditional arts of

cultures with which they themselves were unfamiliar. Their predominantly production and technique-orientated approach made them easy to apply, given the prevailing emphasis on doing and making in art and design curricula in schools; nevertheless, the initiative had some snags. The project designers appeared to view curriculum as technology (i.e. as something which can be implemented without recourse to the notion of values), and their approach to the issue of multiculturalism was both ethically neutral and a-political.[15] As a consequence their initiative was open to attack from more radically inclined curriculum workers who viewed the question of multicultural educational reform as one of addressing and/or redressing cultural and social inequalities - either in the British system or between dominant developed societies and those in countries labelled third world. Their curriculum orientation conflicted also, with those local education authority policies which had explicitly mandated antiracist curriculum innovation in schools.

The work of the South London Development Education Unit, funded in part by OXFAM, provided a second example of a global or internationalist initiative. The curriculum developers had produced teachers' packs about third world craft forms, such as backstrap weaving in Guatemala, shadow puppets in Indonesia and pottery making in Ghana. The packs included some historical, anthropological and technical information about the crafts together with contextual material intended to 'challenge third world stereotypes'.[16] This material focused on so-called development education issues, such as textile protectionism or the imbalance in world trade. Art and design specialists were urged to introduce these ideas into their teaching so as to avoid the dangers of promoting simplistic and negative perceptions of third world crafts. (The danger of reinforcing the misconception that third world crafts are the outcome merely of the actions of primitive peoples using basic or inferior technologies was cited as one major pitfall.) Whereas the Art and Development Education team could not be accused of neutrality in curriculum terms, their instrumentalist application of art and design practice for development education ends and their emphasis on traditional craft forms, left them open to the charge that their project neglected or demeaned the unique or particular subject matter of the visual arts. (Also, that it denied third world artists and crafts people a role in the contemporary art scene.)

At the time I was conducting the survey, the Museum of Mankind, the ethnological section of the British Museum, staged an exhibition called *Lost Magic Kingdoms*. The follow-up workshops organised by the museum's education services were of particular interest to specialist teachers of art in that they brought to a head discrepancies in the way anthropologists and artists view art and design phenomena. The museum specimens featured in the exhibition included a two-headed animal fetish from Zaire, a papier-mache skeleton featured in the Day of the Dead festival in Mexico, and a human skull with pearl-

shell decoration used in divination in the Torres Straits. They had been selected and arranged by the artist, Eduardo Paolozzi. A teacher's pack produced by the museum's education services described the exhibition as 'deliberately provocative'.[17] In the pack, Paolozzi's selection of items was criticised on the grounds that it demonstrated an overwhelming concern for what was unusual and exotic and neglected the ordinary and prosaic. Artists like Paolozzi were accused of 'wrenching third world artefacts from their cultural contexts', and of imposing on them European aesthetic ideas about their qualities and forms. Anthropologists, on the other hand, were applauded for their interest in exploring the local systems of meaning in which they were embedded and in discussing how and why they had been made and used.

My study of the slide resources available for multicultural curriculum reform confirmed the museum personnels' suspicions that art specialists tended to be ethnocentric and that they discounted contextual information in their analyses of art and design phenomena. The notes accompanying four film-strips concerned with the arts and crafts of Africa, marketed by the largest commercial suppliers of visual arts slides in Britain, for example, referred to these artefacts as if they were fine art objects and adopted a formalist aesthetic stance. An interdisciplinary resources pack about Pakistan, produced by an Australian company, however, provided a striking contrast. The information accompanying a component called *Arts and Crafts in Daily Life*, was highly pertinent to specialist teaching in art and design, but was contextualist and anthropological in kind. The same company's audio-visual pack on Japanese culture emphasised the role arts and crafts played in Japanese daily life. It included a set of thirty slides depicting a variety of Japanese art forms and the natural environment.

Figure 3.6:
Instructional materials, *ACER*

64

Figure 3.7:
A multicultural teachers' resource centre

The information accompanying the slide-images of clothing, fabric designs, domestic architecture, flower arrangements, metal and lacquer work, folk-carvings, bonsai, festivals etc., supplied on cassette-tape, emphasised a so-called Japanese concept of nature and examined the role it played as a source of inspiration for Japanese arts and crafts. The tape identified the above as enquiry topics for class discussion.

Ethnic arts initiatives

The art and design curriculum initiatives which demonstrated an ethnic arts curriculum orientation were the most difficult of all to track down. They tended to be extremely localised, informal in structure, peripheral to the mainstream curriculum and community or Arts Council based. The majority consisted of random collections of printed materials and illustrations about Indian and African arts practices and forms. My visit to a multi-ethnic education resource centre, situated in an ILEA district with a large Bangladeshi population, for example, yielded quantities of line drawings of Hindu gods and of Islamic tile patterns intended as master copies for use by primary teachers, together with a script and cut-out puppet characters for a shadow play about Rama and Sita. An Asian studies resource centre in the same neighbourhood, housed a good collection of slides on Hindu religious iconography and real-life examples of traditional Indian arts and crafts. Similar kinds of resource materials of a more global or internationalist flavour were available from high street shops and retail outlets marketing third world arts and crafts; and in do-it-yourself

craft and design booklets available both from public bookstores and teachers' centres. (A series of cross-cultural design booklets produced by Nottingham Educational Supplies, for example, included instructions in traditional methods of decorating Pysanka Ukrainian Easter eggs with wax and dyes, together with cross-cultural information about design motifs such as the one known as paisley in Britain, as a mango pattern in India and an almond pattern in Persia.) Since many of these curriculum initiatives consisted of little more than pattern sheets or lists of how-to-do-it technical instructions, their potential for effecting anything other than merely cosmetic changes to a small part of an art and design teacher's curriculum thinking appeared limited.

At the time of writing, the Arts Council of Great Britain was

Figure 3.8:
Non-European artist-in-residence, primary school

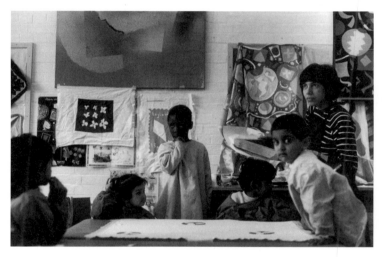

contributing funds to a number of projects such as 'Writers, artists and craftsmen in schools', 'Film-makers and video-artists on tour', and creative writers, photographers and composers residencies, all of which were designed to increase the interaction between the worlds of art and design in and outside school. In the ILEA and some other local authorities, Arts Council and other funds were being utilised specifically for school residencies by non-European, or black artists. The Minority Arts Advisory Service (MAAS) and community arts councils supplied lists of visual artists and other resource persons to interested schools. Few records of the success, or otherwise, of these ethnic arts initiatives existed. It was possible, however, to find out a little more about the manner in which an ethnic artist-in-residence programme might contribute to curriculum change by consulting reports of the *African Arts In Education*[18] curriculum development project located in an ILEA primary school. As Kwesi Owusu, has pointed out[19], the city of London as a whole benefits from what is probably the highest and most exciting concentration of third world artists anywhere in the world. The project leaders had hired a London-based team of black artists who came from Sierra Leone, Ghana and Nigeria to conduct

classes in schools over periods of no less than three weeks. In the workshops that ensued, these artists-in-residence had deliberately set out to challenge Western European conceptions of art in that their curricula did not make any distinction between fine arts and crafts or between drama, dance, music, the visual arts and literature. Each series of workshops had culminated in performances by the children concerned to the whole school during which scenes from Yoruba or Asante mythology and culture (for example, the Asante legend of the golden stool or the Yoruba naming ceremony) were dramatised and during which both the audience and participants had been exposed to African traditions of music, dance, textile decoration, costume, oral poetry and mask-making. Not surprisingly, in view of its interdisciplinary, or related arts focus, this initiative had been realised at primary rather than secondary level. The classroom teachers in the schools in which the initiatives were implemented researched and disseminated back-up information about everyday life in the African cultures, concerned with a view to this helping their pupils to situate the arts activities they were pursuing into their original cultural contexts.

Anti-racist curriculum initiatives

I identified a number of art and design initiatives that were specifically designed to combat racism. Once again, the majority were interdisciplinary and intended for primary rather than secondary educational use. An Afro-Caribbean Educational Resources pack, *Words and Faces*, (ACER) included guidelines for teaching portrait drawing that specialist teachers of art and design in secondary education would be well advised to consult. Its curriculum focus was on observing, talking about and representing (drawing) differences in people's hair, skin colour and facial features. While the Afro-Caribbean curriculum designers had adopted a Western-European convention of art instruction (observational drawing), their primary concern was to devise strategies which responded to the issue of the misrepresentation and stereotyping of black peoples. Of significance, also, was their emphasis on critical discussion, both as a means of improving the quality of children's drawings and, as a form of art education in its own right. Workbooks, included in the pack, incorporated exercises in which pupils were directed to seek out and discuss racial bias and stereotyping in the images of blacks represented in children's literature and magazines.

The ACER initiative was open to criticism on the grounds that the curriculum pack itself was discriminatory (the photographic images of white children and life-styles in the workbooks were, in my view, noticeably less appealing than those of Asians and Afro-Caribbeans), and I judged it unlikely that an educational strategy that ran the risk of making white children feel bad about themselves would bring about the improvement in race relations the developers desired. But, research into black children's art had alerted me to the problems associated

with self-image which are manifested in the manner in which black children often misrepresent themselves as white in their drawings and paintings. Consequently, the ACER team's attempt to devise an initiative that responded to this issue and to utilise drawing as a means of helping black children to develop a more positive cultural identity appeared highly pertinent to the specialist curriculum at all educational levels.

The British Film Institute's curriculum publication, *Images and Blacks*, supplied a second example of an antiracist curriculum initiative. It was described as a resource pack for teachers of use in history, language, multicultural education, film and media studies courses. It consisted of slides of, mainly, American blacks, in drawings, cartoons, advertisements, news photography and cinema films, together with instructions for image analysis. The primary purpose of the course in image analysis as outlined in the teachers' notes, was to get children to look more closely at the way in which representations of blacks have become popular and to examine the myths that they projected. The pack's authors pointed out that while their curriculum strategy did not address the issue of racial prejudice as such, there should be no doubt that many representations of blacks played an active part in maintaining the oppression of actual blacks in white societies; and they claimed that it was evident that an adequate study of images should lead to the demystification of at least some of the more fundamental and popular preconceptions, stereotypes and myths.

Third, a *Race Relations Pack*, produced by All Faiths for One Race (AFFOR), intended as an introduction to the topic for fifth year pupils, included a number of antiracist art tasks for homework which were graded as easy, more difficult or most difficult. While the authors of this pack were keen to advocate what they described as a committed, as opposed to a neutral, approach to teaching about race relations, their commitment to art and design learning appeared negligible. Some art tasks were phrased as follows: a) "Draw a picture of a family migrating and write a sentence underneath saying why they are migrating and what they expect to find in the new country" and 'illustrate the caption "Without prejudice friendships can grow"' (described as 'easy'); b) "Design a poster urging non-citizens who are permanent residents to naturalise or register", (described as 'more difficult'); and c) "Choose a culture other than your own, and draw and colour a picture which illustrates some aspect of it" (the most difficult). These tasks were presented to teachers without any advice as to modes of curriculum presentation and response or instructional strategies. All this, in spite of the fact that teaching about race relations was systematically planned and researched. The resource materials, for example, included a story-book about a schoolboy who had been subjected to racist abuse and a tape-recorded discussion. The tape-recorded discussion contained a clear definition of the term racism, information about racism in its historical context and in contemporary Britain but

nothing about how to teach art.

I was able to locate only one example of the more radical form of antiracist development that had occurred in curricula in English and history and which Jagdish Gundara has called 'resistance teaching'.[20] (Art and design equivalents to the antiracist initiatives exemplified by Chris Searle's *Classrooms of Resistance*, or Cecil Gutzmore's *Caribbean Visual History Project* were not readily forthcoming.) I can see no good reason why art and design teachers should not encourage their black pupils to express strong views about the structural inequalities in contemporary British life in and through the media of the visual arts, although I would hesitate to promote this as a means for their survival. Nor can I see any good reason why white pupils should be denied access to black versions of art history. But I found few records of any formal attempts by teachers to set up art projects in which pupils attempted either to communicate their experience of racial injustice or to celebrate black resistance.

The multicultural curriculum and social studies

Social studies methods and aims

The art-based curriculum experiments reported in chapters one and two operated on different educational premises from the ethnic, global and antiracist initiatives I have just described. But my survey revealed that they had something in common with social studies curriculum methods and aims. The ILEA guidelines for *Social Sciences in the Primary School*, for example, claimed that they were 'about people and their relationship to society' and 'about developing children's critical awareness and understanding'.[21] Their list of broad aims for social studies teaching included encouraging children to recognise their own experience and the experience of others and helping them to develop an enquiring attitude to society and to come to an understanding of other peoples' views of it. A sense of empathy (i.e. the capacity to imagine what it is like to be in someone else's position) and concern and respect for the evidence and experience of other people were attitudes that social studies teachers were directed to cultivate. Searching for information in pictures and learning to organise that information were posited as desired learning skills.

The ILEA guidelines for *History and Social Sciences at Secondary Level* defined them as areas of study that made a systematic analysis of the social life of people and their relationships, and of peoples' interactions with others and with the environment. Social sciences' characteristics were identified as an emphasis on concepts, contentiousness and a concern with values and attitudes. Social studies and history teachers were reminded, however, that while they were expected to teach about values, they did not teach values. The social

sciences in secondary, as opposed to primary education, was identified as subjects which interwove subjective experience with objective knowledge and in which the search for meanings, connections and generalised patterns in the social world encouraged children's capacity to participate through informed imagination' in the lives of others.[22] Above all, they sought to broaden pupils' social experience and to help them develop an open-minded approach to other people and groups. Given the fact that Britain is a multi-ethnic society and interdependent on other countries, the guidelines identified it as an educational priority that social studies teachers helped children to develop a respect for cultural differences.

Much of this discussion about social sciences and about social studies curricula overlapped with the ILEA Inspectorate's policy statements about multi-ethnic education. In their guidelines for *Education in a Multi-ethnic Society*, at primary level, for example, they described the starting point for children's learning as work that stemmed 'from their growing awareness of their personal worlds'. While they acknowledged that it was 'widely agreed in British primary education that teaching should be child-centred and that it should be designed to link up with and extend children's experience in order to develop their potential as individuals', they pointed out that it was 'a teacher's duty to proceed from what was near to what was distant'.[23] Also, that teachers should work towards fulfilling the aim of enabling children to achieve autonomy, which included freedom from their own roots.

Finally, a UNESCO handbook for the *Teaching of Social Studies* printed in 1981 confirmed that their primary concern was that of relationships between man and environment. Like the ILEA guidelines, this handbook included the development of attitudes to help students recognise and respect their own individuality, families, communities, nation states, ethnic cultural groups and, finally, the family of mankind, in its list of recommended educational aims. Curriculum planners in UNESCO member states were advised that 'if we are trying to develop a child's awareness of his participation in his own family, and understand relationships and norms within that, he should also be involved in activities that will help him to recognise that families in other cultures can be different yet share the same basic functions'.[24] The handbook advocated the use of cross-cultural case studies to facilitate the growth of a global perspective wherever possible.

Teachers' resource books and packs.

Some teachers' packs and resource books developed for social studies at primary level included strategies for helping children to take their experience as a starting point for discussion and for enabling them to encounter the concept of difference. *People Around Us*, for example, included instructions for a range of activities organised around the theme of families. The kit included visual and verbal information

about different kinds of family structures, together with two spiral bound booklets of discussion photos illustrating families in contemporary Britain. Also included were two illustrated booklets on life in Victorian Britain and in the Dani society in New Guinea. Suggestions for artwork included paintings of our own families, of particular members of our families and of special family events.

A resource pack, entitled *Just Like Us*, featured black-and-white photographs. Its four poster-size photographs of multiracial families were intended as a focus for group discussion. Individual children were invited to respond to sixteen smaller photographs. Their educational purpose or function was identified as that of 'stimulating the viewers to talk about their own lives' in class and, to 'learn about how other families live'.[25] The photographs were described as particularly significant for ethnic minority children because they rarely saw themselves and their way of life represented in schools. The teachers' notes which formed a part of this pack included a section about making pictures as a response to the photographs and instructions for taking photographs with students.

While the emphasis on children's immediate experience of their everyday worlds and on their recording their responses through the media of the arts was similar in my own curriculum experiments, there were important differences. Most significantly the recommended method of studying everyday subjects or themes such as 'families' or 'our neighbourhood', was concept based. Teachers' were advised to organise their curriculum content around social studies concepts and/or issues, such as tradition, social change, conflict, and/or the division of labour; and, to invite pupils to discuss them. Also, while these primary education resource books and packs for social studies teaching tended to advocate approaching the understanding of these concepts or issues through their practical application in everyday life (i.e. through children observing and investigating and recording examples around them), their instructions for teaching art and design concepts and skills were minimal.

Audio-visual resources
Life overseas

Government quangos and international and national charities appeared to be the key providers for much of the more global or internationalist curriculum input about people in other cultures that was available for primary and secondary social studies and environmental studies teaching. In the course of my search for curriculum strategies that shared the same experientially based and comparative perspective as my own, I came across a number of slide-packs, educational videos, poster and photo-sets and picture books produced by UNICEF, Christian Aid, and OXFAM, in which life in non-European cultures was presented as if through the eyes of children. While none of these resources could be described as art-based, much

of their visual and verbal content appeared pertinent to specialist teaching in art and design.

A series of slide-sets for environmental studies teaching called *The Way We Live*, produced by OXFAM for children aged eight to ten, for example, focused on three main areas of the world - the Indian sub-continent, West Africa and Indonesia - which, it was claimed, had often been misrepresented in school texts, information books and, also, in popular fiction and films. As a result many children thought of them as primitive and generally unsuccessful at making a living

Figure 3.9:
Bangladeshi woman making a sika

Figure 3.10:
Potter in Bihar, India

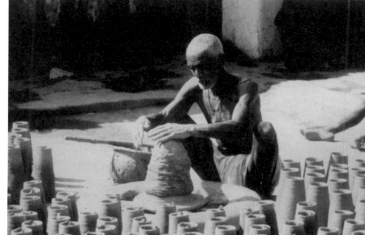

from their environments. This slide-series included cross-cultural sets of images of clothes, homes, games, transport and crafts. Written commentary was provided, but an enquiry method of learning was favoured in which factual information was only supplied *after* children had questioned what they had viewed in the slides. It was suggested, also, that questions could be separated out into 'those to which answers could be found in books' (e.g. 'What is the weather like in India'?) and those which required imagination and empathy (e.g. 'Are the people in the slide happy or not'?); and, that the latter type of questioning could lead to creative writing or art. An enquiry based approach was recommended on the grounds that it consolidated skills in observation, recall, analysis, research and recording.

UNICEF had produced a series of slide-kits about people in other

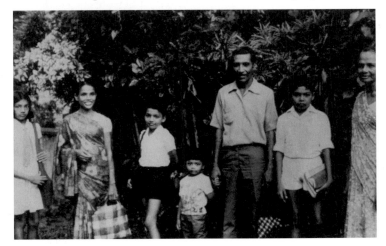

Figure 3.11:
With Shiromi in Sri-Lanka

cultures all of which attempted to answer the question 'What would it be like to be an eleven or twelve year old child in a developing country?' Each kit contained approximately thirty slides, maps, diagrams and detailed case study material on an individual child and its country of origin; for example, about Nabil from the Lebanon, Kwadjo from Ghana, or Anadia from the Sudan. One of these packs told the story of Shiromi Gomes and her family in Sri Lanka in slide images and a commentary - as if through Shiromi's eyes and words. It also included teachers' notes containing history and facts about Sri Lanka, back-ground papers on systems of self-help in remote regions, some Sri Lankan folk tales and a worksheet, together with information about UNICEF activities. The worksheet questioned European children about how Sri Lankan children were similar and different to themselves and invited them to write an essay, or draw pictures, about what their lives might be like. Since the slide-set showed Shiromi learning traditional Kandyan dancing, climbing up a rock to show visitors a fifth century rock sculpture and looking at and talking about an antique statue of Lord Buddha, and it included numerous examples of crafts and design in Sri Lankan everyday life, its relevance for

Figure 3.12:
**Arts and crafts in
everyday life:
Decorated
wedding car, India**

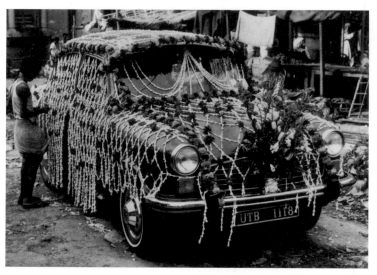

specialist art and design teaching was indisputable. These slide-packs and other audio-visual resources, such as a *Families of the World* video series, were listed in development education catalogues and distributed from organisations such as the Centre for World Development Education, and The Commonwealth Institute.

Life in Britain

While some development education materials addressed multicultural, multiracial or multi-ethnic curriculum issues, such as immigrants in Britain, or teaching about prejudice, the audio-visual resources that depicted life in Britain through the eyes of ethnic minority children tended to emanate from educational television and to take the form of video and/or film. Thames Television's *Seeing and Doing* series for six to seven year olds, on the theme of *My Special Day* were typical of many commercially produced educational videos I reviewed. They featured a wedding in a Greek Cypriot family, a West Indian birthday party and a visit to the zoo by an Asian family. The commercially produced 'Day in a life of' type of film, which this series exemplified, and which tended to be documentary in style, made much of the social role played by the arts in confirming ethnic minority group identity and in marking particular cultural events. But audio-visual resources for multicultural, multi-ethnic and multiracial education included a number of video-films made by ethnic minority pupils in schools which depicted their experience of life in British society somewhat differently. The relevance of video-films such as *Why Prejudice?*, in which a group of students in a multiracial school discussed their experiences of racial prejudice, or, *I'm Here*, which represented life in Britain through the eyes of secondary school students born in Bangladesh, for art and design teachers lay in their exploration of video and film media as expressive arts forms.

Personal and Social Education

Finally, the multicultural curriculum initiatives described in chapters one and two incorporated a concept of educating pupils to develop as persons (i.e. to become persons in a fuller sense) and to develop important personal qualities that Richard Pring[26] had identified as central to personal and social educational aims. While Pring pointed out that virtually every subject in the school curriculum can make a contribution to these aims, he was sceptical of social studies input because of its tendency to be taught as if it in no way affects the development of personal values. Instead, he identified the humanities (drawing on the resources of history and literature) as the most appropriate curriculum space for systematic reflective thinking about one of the most important issues we must face as a society. Namely, racism and how to live in harmony and respect with people of different backgrounds and cultures. In the next chapter, I intend to explore some ways in which art and design understood as a humanistic enterprise can be said to constitute a form of values education and can contribute to personal and social development with particular reference to what Allison has called the cultural domain.

Notes

1. Chris Mullard, in J. Tierney (ed.) *Race, migration and schooling*, (Holt, Rinehart and Winston, London, 1982).

2. Anne Taber, in J. Lynch (ed.) *Teaching in the multicultural school*, (Ward Lock Educational, London, 1981).

3. Commission for Racial Equality, *Arts education in a multicultural society*, (CRE, London, 1981), p. 20.

4. Gulbenkian Foundation, *Arts in schools*, (1982), p. 38.

5. Department of Education and Science, Committee of Enquiry into the Education of Children from Ethnic Minority Groups, *Education for all*, (HMSO, London, 1985), p. 322.

6. Department of Education and Science, Committee of Enquiry into the Education of Children from Ethnic Minority Groups, *West Indian children in our schools*, (HMSO, London, 1981), p. 27.

7. Alan Leary, *Assessment in a multicultural society: Art and design at 16+*, (Schools Council, London, 1984), p. 22.

8. Ibid., p. 29.

9. Horace Lashley in R. K. Arora and C. G. Duncan (eds.), *Multicultural education: Towards good practice*, (Routledge and Kegan Paul, London, 1986).

10. Kwesi Owusu, *The struggle for black arts in Britain*, (Comedia Publishing, London, 1986).

11. Brian Allison, *Art education and teaching about the art of Asia, Africa and Latin America*, (Voluntary Committee on Overseas Aid and Development Education Unit, London, 1972), p. 3.

12. Brian Allison, 'Identifying the core in art and design', *Journal of Art and Design Education*, vol.1, no. 1, (1982), pp. 59-66.

13. Brian Allison, Martyn Denscombe and Chris Toye, *Art and design in a multicultural society: A survey of policy and practice*, (Leicester Polytechnic, Leicester, 1985).

14. N. Stanley, 'The power of art', unpublished, City of Birmingham Polytechnic, 1986.

15. Elliot Eisner, *The Educational imagination* (Macmillan, New York), p. 67.

16. *Using Third world art forms for creative activities*, Teachers' packs, Centre for World Development Education.

17. Museum of Mankind Educational Services, *Lost magic kingdoms: An exhibition arranged by Eduardo Paolozzi*, (British Museum Publications, London, 1986).

18. Jane Grant, 'African arts: An adventure in education', *Studies in Design Education and Craft*, vol. 17, no. 2, (1985), pp. 79-89.

19. Kwesi Owusu, *The struggle for black arts in Britain*, (Comedia, London, 1986), p. 78.

20. Jagdish Gundara in J. Tierney (ed.), *Race, migration and schooling*, (Holt, Rinehart and Winston, 1982). Gundara's view is that teachers should help consolidate the lessons gleaned from the history of the black struggle and attempt to unify the different sub-groups of the oppressed by providing classroom space in which students can learn about the resistance of such peoples to domination. *The Art and development education 5-16 project* (known as *Art as social action* and located at Effra school, Brixton) was the nearest equivalent. This three year curriculum development initiative had received funding from OXFAM, Christian Aid, the European Economic Community and the ILEA. It arose out of the work of the South London Development Education Unit reported previously, but could be interpreted as focusing as much on the visual arts activities of blacks, women and working class groups in British society as on third world art forms. It was schools based and information about the project activities was disseminated via news sheets

21. Inner London Education Authority, *Social sciences in the primary school*, ILEA curriculum guidelines, (ILEA, London, 1980), pp. 2-3.

22. Inner London Education Authority, *History and social sciences at secondary level*, (ILEA, London, 1983), p. 16.

23. Ibid., p. 53.

24. H. Mehlinger (ed.) *UNESCO handbook for the teaching of social studies*, (Croom Helm, London, 1981), p. 361.

25. Inner London Education Authority, *Just like us*, (ILEA, London, 1976).

26. Richard Pring, *Personal and social education in the curriculum*, (Hodder and Stoughton, London, 1984).

References

Andrews, E. M. (1983) 'The innovation process of culturally-based art education', unpublished PhD dissertation, University of Bradford

Araeen, R. (1984) *Making myself visible*, London, Kala Press

Afro Caribbean Resources Project, (1981) *Words and faces*, ACER, London

Bowen, D. (ed.) (1980) *The arts of Africa*, Visual Publications, London

Brown, M. and Clarke, M. (1981) *The way we live*, OXFAM Education Department, Oxford

Brudenell, I. A. (1986) *Cross-cultural art booklets*, Nottingham Education Supplies, Nottingham

Craft, M. (1984) *Education and cultural pluralism*, Falmer, London

Department of Art, Ethnographic Resources in Art Education (1979) *Pottery cultures*, City of Birmingham Polytechnic

___(1983) *Dyed and printed textiles*, City of Birmingham Polytechnic

___(1985) *The art of play*, CSV Publications, London

___(1985) *Peoples, processes and patterns*, Islam and Japan, Birmingham Polytechnic

Department of Education and Science (1983) *Art in secondary education. 11-16*, HMSO, London

Families of the world series, Commonwealth Institute, London

Gleeson, D. and Whitty, G. (1976) *Developments in social studies*, Open Books, London

Gutzmore, C. (1986) 'Caribbean visual history project,' unpublished, University of London

Hall, S. and Jefferson, T. (1976) *Resistance through rituals*, Hutchinson, London

I'm here, ILEA Learning Resources, Kennington

Khan, N. (1976) *The arts Britain ignores: The arts of the ethnic minorities in Britain.* Community Relations Commission, London

Inner London Education Authority, (1976) *Education in a multi-ethnic society: The primary school,* ILEA, London

___(1978) *People around us: Families,* A. and C. Black, London

Living in a multicultural society, ITV Schools

Lusted, D. (1981) *Images and blacks,* British Film Institute, London

Lynch, J. (1981) *Teaching in the multicultural school,* Ward Lock Educational, London

___(1986) *Multicultural education: Approaches and paradigms,* University of Nottingham, School of Education

My day, Video letter from Japan, External Services Division, School of African and Oriental Studies, University of London

My special day, Seeing and doing series, Thames Television International

Rogers, P. (1984) 'Multicultural art', *Changing traditions,* Department of Art, City of Birmingham Polytechnic

Ruddell, D. and Phillips-Bell, M. (1980) *Race relations teaching pack,* AFFOR, Birmingham

Searle, C. (1977) *The world in a classroom,* Writers and Readers Publishing Co-operative, London

Smibert, T. and Burns, C. (1979) *Art, nature and life: An introduction to Japanese culture,* Educational Media Australia, Melbourne

Topouzis, D. (ed.) (n.d.) *With Shiromi in Sri Lanka,* United Nations Children's Fund, London

Van Santen, J. (1986) 'Resources for multicultural art education: A framework for evaluation', unpublished report, Institute of Education, University of London

Why prejudice? Scene series, BBC Schools Television

Chapter Four

Experiments in interdisciplinary curriculum planning

Education in and through art

In Britain, art instruction in primary schools is understood as being part of general education and could be described as interdisciplinary, or integrated. An American observer, Jan Hitchcock, writing in *School Arts*, summed it up as follows:

> *During my three weeks of working directly with teachers, administrators and children, I discovered that art, as an isolated subject, was negated altogether. Instead, there was a continuously integrated flow of ideas between all subjects and activities. All inter-related areas of learning were of equal importance and gained equal respect from students, teachers and administrators. Each learning area was dependent on the other for providing students with a relevant learning experience.*[1]

It is a curious fact of British educational life that art in primary schools is integrated and generalist, whereas in secondary schools it is subject-specific and vocational.[2] This subject-specific, vocational curriculum orientation is a reflection of a system of teacher training in which future subject specialists spend three to four years acquiring the competencies and skills necessary to their becoming artists or designers; following which, they enrol on one year teacher training programmes to learn how to teach art and design in isolation from other school subjects. It is my experience, that the prospective secondary school teachers pursuing these courses tend to confuse the role of their subject in general education with professional training. Their conceptual grasp of their discipline is weak and confined to what Feldman has called 'narrow psychological or technical conceptions of curricula'.[3] It is possible, however, to broaden their conceptions of their subject's educational function by introducing them to theoretical models or frameworks of ideas for curriculum that incorporate extra, or non-aesthetic aims. Also, by requiring them to formulate teaching strategies that allow for the possibility of inter-relating forms of knowledge.

This chapter reports on a group of student-teachers' experiments in

this kind of curriculum development. It documents, describes and criticizes their attempts to design, implement and evaluate curriculum units that focused on children's practical activity in art and design, but which responded to so-called humanistic[4] general educational aims. The group concerned experienced considerable difficulty conceptualising curricula that incorporated general educational aims; but the chapter ends with a critique of the existing specialist curriculum in secondary schools and with a further analysis of the role and function of art and design in a humanistic educational framework. The implications of this framework for the curriculum at secondary level are that specialist teachers would have to adopt an approach to curriculum planning and implementation that is much more typical of the primary school situation, in that their teaching would have to become more interdisciplinary and thematic.[5]

The curriculum experiments

The humanistic functions of art

The relationship between humanistic learning and art education has received considerable attention from American art educators over the last decade. Katchadourian,[6] who admits to avoiding the issue of curriculum practice, has identified six humanistic functions of art as being those of (1) keeping alive and nourishing the inborn capacity to feel, imagine, dream and remain sensitive to beauty and order: (2) preserving the inborn capacity to form human relationships: (3) helping to bring human beings together socially: (4) providing a certain degree of continuity: (5) bringing order into chaos; and, (6) giving existence a meaning or purpose. Smith[7] has analysed an arts in general education movement as having two distinct strands rooted in traditional conceptions of the humanities and of humanistic psychology. Levi[8] has noted that some of the most crucial questions in education today hinge on the partial overlap of the humanities, social sciences and fine arts, but has denied the practice of art any place in a humanistic education which aims at the goal of inculcating human values. Smith and Smith[9] on the other hand, have insisted that humanistic education and visual arts education coincide in the study of the arts as cultural artefacts, the cultivation of an aesthetic attitude, the acquisition of aesthetic preferences and standards and in educational programmes that stress art as a paradigm for self-development. To the best of my knowledge, the notion of humanistic education as such, has received scant attention from British art educators, but over a period of nine months my students and I examined its implications for curriculum planning in art and design.

The educational context

Our curriculum experiments were conducted in an art teacher training institution where the students were enrolled on a one year postgraduate teacher-training course. The majority of them had completed

three to four years of specialist subject training in fine art, but others had specialised in graphics, fashion, textiles, art history and industrial design. As part of their professional studies in art and design ducation they organised informal workshops for children on Saturday mornings. The workshops provided them with a different sort of educational experience from their practice teaching in secondary schools because the majority of their pupils were younger. They attended Saturday classes voluntarily and were very highly motivated. The student-teachers' postgraduate year was divided into three terms and each student-teacher participated in one session of the workshops organised over an eight week period during either the autumn, spring, or summer terms. They worked singly or in pairs, planning and teaching curricula to groups of approximately fourteen children of mixed ages and ability.

The curriculum assignment

At the beginning of each of the three sessions, the student-teachers were required to formulate written plans for sequences of lessons which focused on children's practical activity utilising art and design media and materials. They were advised, however, that successful art and design teaching involves much more than mere instruction in art and design skills and techniques and that it should promote a more general form of learning identified as 'humanistic'. They were provided with a number of curriculum models for this kind of teaching in the form of the textbooks *Art, Culture and Environment, Becoming Human Through Art* and *Art and the Built Environment*,[10] but were encouraged, also, to pursue their own ideas concerning relationships between humanistic education and art and design. When their workshop sessions were over, the student-teachers compiled written reports[11] in which they commented, among other things, on their success or failure at integrating art and design teaching with 'humanistic' or 'liberal' educational objectives and, on their appropriateness, or otherwise, for their future attempts at curriculum design and planning.

Learning about people

The student-teachers organising the first set of workshops had only just commenced their educational studies and had no previous experience of practice teaching in schools. Consequently, they associated the teaching and learning situation very closely with what had occurred during their three or four years of professional training in art and design. After reading some of the suggested source material in the textbook *Becoming Human Through Art*,[12] they agreed to interpret humanistic educational aims and objectives as referring to 'any kind of learning which is about people'.

Two of them organised a photography workshop around the curriculum sub-theme, or concept, of 'expression', and directed chil-

Figure 4.1:
**Photographing
people**

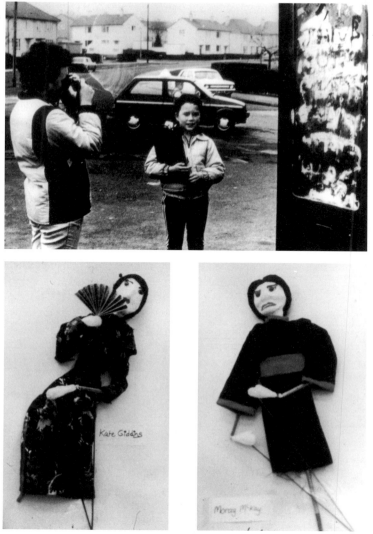

Figure 4.2:
**Bunraku puppets,
Morag and Kate**

dren to photograph people. These student-teachers developed some extremely effective educational strategies for motivating children's photographic production and for inducing facial expression in their human subjects. Their teaching incorporated simulation exercises in which their pupils acted out the roles of professional photographer and model, and in which they utilised studio 'props' to good effect. They sent the young photographers out into the neighbourhood to take candid-camera shots of people walking their dogs, shopping or running for the bus, and encouraged them to photograph their friends sawing wood, painting and drawing, or manipulating clay in adjacent workshops. Pupils acting as models were photographed struggling to build playing card houses, threading sewing needles, listening to comic radio programmes and chewing sticky toffees.

At the close of this session, all those concerned agreed that the aesthetic, artistic and technical qualities of the resulting photographs were excellent, but that the student-teachers had mistakenly assumed that the aim of merely increasing children's interest in photographing facial expression was synonymous with their teaching them something about peoples' life-styles, emotions and character. In their final report, they themselves admitted that, while they had successfully taught children basic photography skills and how to look for facial expression, they could not claim to have contributed anything to their general understanding of human nature.

Two more student-teachers decided that anything that enabled children to gain insights into human beings as 'individuals with unique characters and feelings' would meet their group's humanistic brief. Having identified puppets as 'symbols of human characters in exaggerated form' they encouraged pupils to experiment with making puppet forms and to utilise them to express particular kinds of character and emotion. They split the class into three groups for the

Figure 4.3:
Ceramic sculpture, Simon

Figure 4.4:
Painting the legend of Robin Hood

purpose of constructing shadow, rod and Bunraku puppets. Then they asked each group to write and produce a puppet play.

In their report, one of these student-teachers was critical of the fact that they had emphasised practical activity in the arts at the expense of the 'cognitive aspects of humanistic learning'. She observed that her pupils had thoroughly enjoyed making puppets and inventing good and bad characters, but that they had not really understood the motives underlying their choice of characters, or the moral ingredients in their plays. She concluded that their chances of effecting humanistic learning would have been much improved if they had limited their artistic endeavours to making Bunraku puppets and to learning something about this Japanese tradition of puppetry and the society in which it operated. The other student-teacher thought that some humanistic learning had been achieved as a consequence of their having directed the pupils to work in groups. In her report, she commented that their project had forced them to co-operate both in planning and designing their puppet characters and in producing and performing their plays.

Another student-teacher identified the sub-theme of men-and-machinery as an appropriate focus around which to organise humanistic lesson content. While she professed to share the art and built environment curriculum development team's[13] interest in increasing children's knowledge and understanding of the interaction between people and places, her teaching was limited almost exclusively

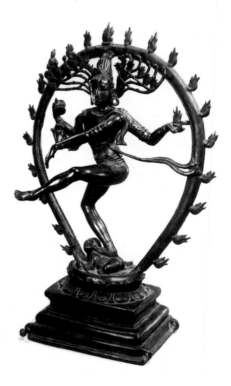

Figure 4.5:
Siva Natagarranga,
**Bronze, Chola
style, 11th cent.**

84

to improving ceramics skills and techniques. The photographic images of men at work that she utilised to motivate her pupils' personal expression in the medium of clay, inspired one teenager to include the following passage of humanistic reflection alongside a sculpture he exhibited in his final workshop display.

> *Our project was to produce a piece of work on men and and machinery. I decided to expand on this and concern myself with man in a city environment. I wanted to suggest the idea of a city as being more important than its inhabitants - the people who created it. The vast sprawling mass of ugly concrete architects' failures has become a Frankenstein monster and turned against its creators - the people were drab shadows, not really important to the city any more. Look at the people at ground level; some are down-and-outs, rejects and cast-offs of the uncaring city, others are just servants to the system - like ants in a massive complex of tunnels, emotionless and not really human any longer. My city exists in the future, but that is immaterial. It could just as easily be present-day London or New York, or any other large city. Have you seen the London underground during the rush hour? A more perfect example of what I am trying to express would be hard to find. A huge conglomeration of separate human beings, all units in the quest for a seat on a journey to another boring day in the office. The only human element is the buskers! (See figure 4.3).*

Heroes and heroines

The group of student-teachers responsible for organising the second session of workshops were the recipients of at least some formal instruction in art and design curriculum content and methods and had observed and participated in teaching in both primary and secondary schools. They found it difficult to agree on a common humanistic educational aim, but identified 'heroes and heroines' as a general theme around which to structure their curriculum ideas.

Two of them interpreted humanistic learning as necessitating that they selected subject matter for practical activity in art that 'maximized social content' and that they designed curricula that 'furthered children's understanding of themselves, the society in which they lived and other societies'. Subsequently, they identified the legend of Robin Hood as a sub-theme for a mural.

These student-teachers had plenty of good ideas about the possible contribution legends and folk stories, such as Robin Hood, could make to children's rational and imaginative understanding of the human situation. Their lesson plans included the information, for example, that legends symbolised good and evil and that children should learn that they featured different sorts of heroes and heroines - historical, religious, political and literary and, most importantly in their view, working class. But, they experienced difficulty translating their curriculum ideals into practice. A mural was completed on time, but their failure to anticipate the organisational problems associated

with group work in design and with integrating the different forms of knowledge, caused it to be judged unsatisfactory technically and aesthetically. The student-teachers, however, had made valiant attempts to combine instruction in art and design with instruction that was more typical of humanities or social science teaching; and, in their report, they commented on the fact that legends such as Robin Hood provided an excellent focus for integrating art and design and humanistic learning. They wrote that,

> *The pupils were asked to discuss the different types of characters in the stories; they were asked to consider if Robin Hood ever existed and, if so, who he was; and, they had to research the costumes and buildings typical of the historical period in which he was supposed to have lived.*

Two student-teachers with a specialist training in textiles involved a group of girls in reconstructing costumes worn by their favourite heroes and heroines. The student-teachers taught the girls how to make wearable garments out of card and how to decorate them with cut, folded and applied paper designs. The life-size results were enthusiastically paraded, in person, during the final workshop display. In her report, one of these student-teachers claimed that their workshop had included a humanistic component which took the form of the girls telling stories to each other and exchanging information about their chosen characters. But the other student-teacher admitted that they had both found the humanistic requirement an intrusion on their teaching, since it had necessitated the children 'talking and writing' which in their view 'had nothing to do with education in art'. Since their pupils were afforded total freedom of choice in selecting favourite characters, it was hardly suprising that the majority picked popular stars of the media and entertainment world and that the student-teachers reported that they had failed to achieve their humanistic aims of 'teaching them about the history of costume and the lives of their heroes and heroines'.

Indian culture

The student-teachers planning and implementing the third sequence of workshops had taught in two schools and were about to commence practice-teaching in a third. The majority of them had been placed in at least one school in an inner-city location with a large proportion of pupils of Asian-Indian ethnic origin and they had received some course input on the need to formulate multicultural curriculum objectives and aims. As a consequence of this, the group as a whole selected 'The Indian Culture' as a common theme around which to structure their curriculum unit's art and design content, but were divided as to their humanistic educational focus and aims. Some of them interpreted them as meaning that they should work towards increasing their pupils' general knowledge and understanding of the Indian continent and its art; others interpreted them as necessitating that they developed children's understanding of the manner in which visual

Figure 4.6:
An enchanted scene

forms in the local environment manifested both Indian and European cultural values and beliefs.

One student-teacher introduced her painting workshop by showing very young pupils slides of Indian and European paintings and involving them in a discussion about their similarities and differences. She reported that,

> They noted that Indian paintings were about religion and the spiritual world; that they depicted gods, some in human form and some fantastic beings, that they were painted in gold and silver and bright colours with symbolic significance and that important figures were painted without regard to perspective.

She continued to build on these concepts in subsequent weeks and to utilise mythological and religious stories, and illustrations to motivate her group's artistic production. On one occasion, for example, they sat on the floor and looked at and discussed a picture of the Hindu god Siva, prior to painting 'an enchanted scene'. On another, they looked at slides of Indian designs before painting border patterns. She read them an Indian fable about a lion and hare and asked them to illustrate it.

In her report, this student-teacher explained that she had utilised legends and myths to motivate their painting because she had read that they were 'a psychological necessity for children's imagination and essential to the proper understanding of mankind'.[14] While acknowledging that she had engaged in a great deal of preparatory research and had utilised the humanistic theme of the Indian subcontinent to good effect, I thought she was confused about her educational intentions with regard to her pupils' learning in art. On several occasions, for example, she had directed her pupils to utilise Indian artistic subject matter, or content, while teaching them European colour concepts. In her report, she noted that they had

enjoyed painting in bright colours and using gold and silver, and that they had learned something about Indian culture, but concluded that her curriculum experiment probably had been a more valuable learning experience for herself.

Figure 4.7:
**Printmaking
workshop**

Figure 4.8:
**Life on the
Indian continent**

Two student-teachers who organised a printmaking workshop introduced their pupils to techniques associated with mono-printing and collage while attempting, simultaneously, to extend their knowledge of the Indian continent and its art. Their curriculum unit incorporated geographical facts about India (e.g., the programme began with discussion about the map of India and with a slide-tape presentation of Indian village life). It included detailed information about Indian architecture, costume and social and religious functions. (An Indian friend was invited into class to demonstrate how to put on a sari.) The student-teachers drew their pupils' attention to narrative and decorative aspects of Indian miniature painting and directed them to incorporate them into their drawings. Finally, the group collaborated on printing a visual narrative representing an Indian village wedding.

Figure 4.10:
An Indian wedding

In her report, one of these student-teachers observed that their humanistic curriculum emphasis had necessitated their doing a lot of preparation, but that this had had certain advantages. She wrote,

> . . . prior to the commencement of the workshop, I had little or no knowledge of the Indian culture, or the printing processes I was going to teach. This meant doing a lot of research and experimentation. Despite the obvious disadvantages, this had its benefits because the information I was passing on was fresh and of as much interest to me as to the children. I got quite a lot of feedback from parents informing me of what the children had learned about India.

The second student-teacher noted that their theme of Indian culture had motivated the children's interest and had consolidated their learning in art and design. He reported that,

> In our group, an affinity developed with the theme. The children were never bored and took a sufficient interest in it to bring in Indian arte-facts, such as ornamental ironwork to discuss.

He commented, also, on the important role the other visual aids, such as the film-strip and the map, had played in effecting the so-called humanistic element of their teaching.

Another student-teacher introduced a sculpture workshop by showing his pupils photographs of an urban environment in the locality and engaging them in a discussion about the manner in which the visual appearance of its shops, houses, churches and other buildings exemplified the different cultural traditions of the people who had built them (in the late 19th century) and the Asian community who lived there now. I remained confused about his overall objectives for humanistic, as opposed to artistic, learning. But he showed them reproductions of work by the American artists, Keinholtz and Segal, and claimed he wanted them to 'develop their understanding of the way sculptors utilised made environments as a source of inspiration and how they utilised three dimensional forms to express creative ideas'. His pupils' wooden, stone and perspex sculptures were undeniably individualistic and he commented on them as follows,

> *David utilised a traditional Western sculptural process to produce an Indian head. I don't think he understood exactly what he was meant to be doing, but the fact that some sort of comparison had been made led me to believe that some of the humanistic learning I had identified had been achieved. Julie and Anne-Marie made a wood construction. They added sequins, bits of old jewellery, silver foil decorations and*

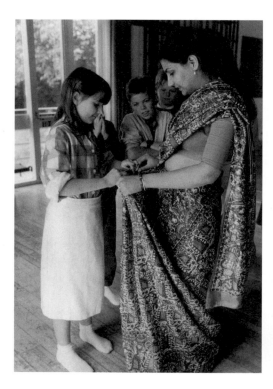

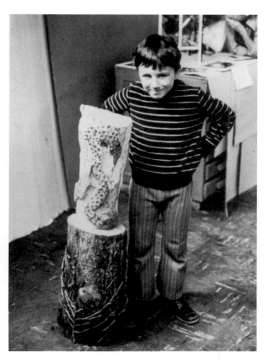

Figure 4.11:
Learning how to put on a saree

Figure 4.12:
Woodcarving, David

coloured gems like those on Hindu religious objects. Glyn made a bird-table and superimposed a contrasting visual form on it - a brightly coloured Indian bird with contrasting plumage. He had obviously grasped some of the principles involved.

Finally, two student-teachers working with the medium of collage utilised photographs of the same urban environment as a means of motivating a group project culminating in the production of a wall-hanging or frieze. In their preliminary plans for the workshop they reiterated McFee and Degge's claim that art and design teachers should seek to increase children's awareness of the way in which art (in which they included not only painting and sculpture, but photography, buildings, designed tools and body ornament) 'expresses a peoples' sense of reality and communicates their values and beliefs';[15] and suggested that humanistic learning would occur as a consequence of the children comparing and talking about British and Indian cultural values evidenced in the design and content of the neighbourhood's shop fronts. On reflection, however, I think they said this just to please me. While the project did, in my view, have enormous potential for promoting humanistic learning of a cross-cultural or comparative kind, their teaching remained resolutely skills-based. Moreover, the finished collage showed absolutely no evidence of the children having considered, or talked about, the different cultural values apparent in the street scene they had recreated.

The student-teachers' evaluations

The student-teachers participating in the curriculum experiments outlined above can be described as the recipients of Smith's narrow specialised career preparation[16] and of a vocational and technical subject training. How did they respond to my suggestion that they integrate art and design education into a general educational ideology and formulate so-called humanistic curriculum practices and aims?

A number of them rejected it absolutely, insisting that art and design and humanistic learning occupied separate pedagogical domains. A student-teacher trained as an art historian, described humanistic educational aims as 'an excuse for art' and equated humanistic practice with the geography lessons she had hated at school. She found Feldman's suggestion that 'children can gain an understanding of humanity through art' congenial, but interpreted it as 'too general to be useful' and inappropriate for studio-based activity. Moreover, her Christian beliefs led her to question his unqualified support for 'broadening children's reference to life'.[17]

There comes a time, surely, when one must decide whether broadening their references to life in a particular way might not do more harm than good. I am unconvinced, for example, of the usefulness of teaching children about certain types of African tribal art which are used to conjure up evil spirits which are very real.

Another student-teacher with a first degree in fine art, observed that a humanistic general education ideology necessitated her integrating art and design with other school subjects. She was critical of the fact they had been expected to do this without an appropriate knowledge base.

The difficulty I found in combining our paper-making workshop with humanistic learning, under the theme of the Indian continent, stemmed in part from us choosing the practical activity before the theme. However, I'm not convinced that we would have been any more successful with any other humanistic theme with which we were unfamiliar. I found that I did not know enough about the Indian culture to teach it to others. I have learned a lot during the workshop, but I still feel it is wrong to teach something one can only be knowledgeable about after years of study.

A second group of student-teachers identified appropriate humanistic functions for their subject but experienced difficulty formulating extra-aesthetic frameworks of ideas around which to organise art and design teaching. The majority of these student-teachers exploited the humanistic themes formulated by their colleagues because they utilised them merely for motivating children's personal expression or as an excuse for teaching art and design techniques. In doing this, they trivialised or abused what theorists have identified as the humanistic possibilities for teaching art and design.

The student-teachers who successfully integrated learning in their subject with humanistic general educational objectives identified learning about people as their general educational aim and organised their teaching around a number of humanistic curriculum themes. Finally, in implementing their humanistic, general educational objectives they adopted one or more of the following teaching-learning strategies or modes.

● They encouraged their pupils to represent and communicate character, emotion and feeling in their artistic products and utilised creative activity in a range of media and materials as a means of increasing children's general understanding of human nature.

● They identified legends and myths as an appropriate focus for stimulating children's artistic imagination together with teaching them about a particular race, society or ethnic group's sense of its collective identity, values and beliefs.

● They focused their pupils' attention on aspects of the built environment (e.g., houses and shops) and utilised studio-based activity as a means of increasing their awareness of the interaction between people and environments.

● They encouraged pupils to look at and talk about designed objects with non-European cultural origins and utilised concrete examples as a means of teaching them specific art skills and techniques while, at the same time, increasing their understanding of the peoples in the societies in which they originated.

While acknowledging that the student-teachers' efforts were stumbling and, in many cases, naive, I contend that any one of these four pedagogical strategies offers a practical solution to the problem of extending the art and design specialists' thinking beyond technical and vocational educational objectives, towards more liberal and humane conceptions of curricula; and, that they stand a good chance of fulfilling at least one of Katchadourian's humanistic artistic functions or aims.

Art and design at secondary level

Since these experiments concluded, and as a consequence of continuing to work with student-teachers along the same lines, I have come to understand the notion of a 'liberal or humane' approach to curriculum in art and design that is responsive to the fact that British culture is exceedingly diverse, ethnically and racially, as necessitating a much more radical restructuring of the teaching-learning process in secondary education than my report of these curriculum experiments implies. It is my view that the issue of cultural diversity makes it an imperative that art and design specialists working at this educational level understand that the development of children's critical skills in art and design is at least as important as so-called studio activity; and that they improve their ability to formulate goals and objectives in which subject-based instruction is clearly related to general educational functions and aims. They must, also, be prepared to treat seriously official proposals[18] for integrated studies or for a multidisciplinary teaching approach. Given this shift in their educational orientation, I think they need to develop their understanding of the range and application of so-called thematic modes of curriculum design and planning.

Art education goals and objectives

With regard to the question of goals and objectives, art and design education experts such as Eisner and Smith[19] have helped by distinguishing essentialist from instrumentalist, or contextualist, curriculum aims. The former focus on the fact that art is a unique form of knowledge, worth learning for its own sake, and the latter emphasise the contribution this subject or discipline can make to extra-aesthetic, or non-aesthetic educational ends. The following instrumentalist objectives have been culled from the three specialist textbooks referred to earlier. They inform specialist teachers that.
- art and design can help people to take a more positive role in environmental decision-making;
- it can teach children about people, society and places; and
- it can help them to understand different cultural attitudes, values and beliefs.

While I agree with Chapman[20] that instrumentalist goals and objectives such as these can lead to a fragmentation of purpose, or discriminate against the formal teaching of art and design, I believe

that it is possible to design curriculum units that incorporate learning experiences which are essential to the subject, but which, simultaneously, fulfil one or more of these instrumentalist, general educational ends.

The prospective secondary school teachers with whom I have worked have responded to this idea in a variety of ways. A number of them have rejected instrumentalist, or extra-aesthetic aims on the grounds that they seem like an excuse for art, or make it sound unworthy of study. This view is supported by theorists in both Britain and the USA, who argue for essentialist justifications or for basic arts curricula. Other student-teachers have paid lip service to the notion of instrumentalist objectives in that they admit only to finding them useful for subject-specific ends. The student-teachers who made genuine attempts to integrate essentialist and instrumentalist objectives have told me that they value the latter on three counts. First, because they helped to break down the barriers between art and other forms of knowledge. Second, because they have afforded them an opportunity to examine important, moral, political or social issues with their pupils. Or, third, because they have enabled them to link their subject with their pupils' practical or personal concerns.

Interdisciplinary teaching

With regard to interdisciplinary teaching, it is common for primary teachers to integrate or correlate arts activities with instruction in other subjects, but art and design specialists in secondary schools generally do not. While recognising that interdisciplinary teaching can lead to mis-education; that it runs the risk of diluting art and design instruction and necessitates an enormous amount of preparation and research, I contend that secondary school pupils would benefit from integrating learning in art and design with learning in other subjects. Integrated programmes have to be planned on the premise that art is a subject worthy of study in its own right, but art and design specialists should make it their business to explore the links that exist between art and other forms of knowledge.

Some of the inter-relationships between art and other forms of knowledge may appear, in the first instance, to be logically more consistent than others. The student-teacher referred to earlier, for example, who elected to increase her pupils' knowledge of Indian art, rejected the notion of interdisciplinary teaching initially, but discovered that concepts located in religion were a prerequisite to its understanding. Others, who explored links between art and environmental studies capitalised on principles of observational drawing which could be described as scientific and which complemented learning characteristic of biology. I take issue, however, with the curriculum theorists like Adams,[21] who describe some combinations of subjects as more basic, or fundamental, than others. We are conditioned to thinking that related arts subjects, such as drama, music and dance, lend them-

94

selves to interdisciplinary links with the visual arts, yet my student-teachers have successfully combined learning in art with history, health education, languages, social studies, literature and science.

Thematic modes of curriculum planning

Specialist teachers planning, implementing and evaluating interdisciplinary curriculum units will obviously need help from other subject specialists in formulating organising frameworks of ideas around which to structure approaches to learning. Words, concepts or themes cannot, in themselves, provide strategies for teaching; consequently attempts to plan curricula this way run the risk of emphasising highly abstract or naive relations among subjects. Nevertheless, they supply a specific focus around which specialists can begin to develop ideas about interdisciplinary curriculum content. In this connection, would-be experimentalists might find it helpful to examine the four thematic modes of curriculum planning that Bolam[22] has identified as characteristic of interdisciplinary practice.

First, they could select a single area or field of study, such as a foreign country or local environment, and develop a synoptic overview of the chosen topic. Some of the more successful curriculum experiments conducted by my student-teachers evolved from this form of curriculum planning. Second, they could organise curriculum units around an overarching concept or theme pertinent to several disciplines. In spite of the fact that many of my student-teachers were familiar with the educational strategy of organising art and design subject matter around basic design concepts, they seemed to experience difficulty with this approach to interdisciplinary planning. Third, they could organise curriculum units around basic human issues that affect the world, themselves and social organisations, and address their teaching to a depth study of these issues. This approach proved popular with many of my student-teachers. Fourth, they could organise their curriculum units around a practical concern that affects children's everyday lives (e.g., safety on the road) and develop an approach to enquiry aimed at producing a synthesis of cognitive and evaluative insights. (Bolam has described this as a variation of the social problem unit and as cognitive and evaluative mapping.) The student-teachers who adopted this approach frequently developed inventive and imaginative teaching strategies. They managed to combine learning in art and design with practical learning which is, typically, neglected in more formal, academic curricula.

Conclusion

In making a case for interdisciplinary curricula at secondary level, I am aware that many leading theorists have argued against the strategies I have just described. Chapman,[23] for example, has attacked them on the following counts. She has claimed that general education ideals such as humanistic understanding, or multiculturalism, are nothing

but empty slogans that seem important at the time but are unworthy of serious attention; that the long tradition of the pursuit of instrumentalist objectives in primary schools has prevented children from learning anything about the arts; that the arts should be viewed as a broad field of study like the sciences, social sciences and humanities with their own patterns of behaviour and skills; and, that interdisciplinary teaching always means planning art round other subjects; and, that thematic approaches to curriculum planning are shallow and misleading and militate against depth study in the field.

I do not deny that there is a need for teachers to formulate essentialist objectives and to implement and evaluate what North Americans call basic arts curricula. I accept the fact that thematic approaches have serious limitations and that art and design is a distinct form of knowledge with its own logical structures of enquiry. But I do not understand this as negating the possibility of the kind of curriculum experimentation I have described.

Art and design specialists evaluating such experiments would have to ask themselves whether they were using the content of their subject to enhance general educational aims. They would have to consider the problem of whether some interdisciplinary relationships were more logical than others and question whether their integrated curricula were built onto prior learning concepts; and whether they were structured in such a way that they increased their pupils' understanding of each of the disciplines involved. Also, whether or not the themes that determined their choice of content were appropriate, significant and educationally worthwhile. Given these kinds of considerations, I understand these kinds of educational strategies as more appropriate for secondary schools than existing forms of technical, vocational, or psychologically orientated curricula.

Notes

1. Jan Hitchcock, 'Art in British child-centred schools', *School Arts*, vol. 82, no. 7 (1983), pp. 33.

2. The distinction between generalist and vocational, or technical art educational objectives is well documented in American literature. See Edmund Feldman, 'Varieties of art and design curricula', *Journal of Art and Design Education*, vol. 1, no. 1 (1982), pp. 21-45.

3. Feldman, ibid, claims that advocates of psychological and technical curricula focus their educational attention, almost exclusively, on children's artistic performance and emphasising technical mastery, or on the psychological benefits of art-making.

4. Ralph Smith, 'On the third realm: Two decades or politics in art education', *Journal of Aesthetic Education*, vol. 16, p. 3 (1982), pp. 5-16, has identified humanistic education as one of a number of general educational tendencies that have influenced American art

educators' thinking over the past decade. To the best of my knowledge, the notion of humanistic education as such has received scant attention from British art educators. Although some discussion can be located in educational literature related to integrated or interdisciplinary curricular humanities in the late 1960s and 1970s.

5. Richard Pring, *Knowledge and schooling*, (Open University Books, London, 1976) has observed that terms like 'integrated and 'interdisciplinary' refer to a confusing range of educational practices. They may be used to denote attempts to correlate subjects in the curriculum, or to organise work around themes; they may refer to collaboration between staff in team teaching situations, to discovery learning or to a particular form of timetabling known as integrated study. In this instance, they refer to attempts to correlate distinct subjects and to organise work around themes.

6. H. Katchadourian, 'Humanistic functions of the arts today,' *Journal of Aesthetic Education*,' vol. 4, no. 2 (1980), pp. 11-22.

7. Ralph Smith, 'On the third realm: Two decades of politics in art education, *Journal of Aesthetic Education*, vol. 16, no. 3 (1982), pp. 5-15.

8. A. Levi,'The humanities, their essence, nature and future', *Journal of Aesthetic Education*, vol. 17. no. 2, (1983), pp. 5-17.

9. Ralph Smith and C. Smith 'On the third realm: Once more the case for liberal education', *Journal of Aesthetic Education*, vol. 16, no. 2 (1982), pp. 6-9.

10. Feldman, *Becoming human through art* (Prentice Hall, New Jersey, 1970). McFee and Degge, *Art, culture and environment*, (Wadsworth, California, 1971). Adams and Ward, *Art and the built environment* (Longmans, London, 1982). While these textbooks offer different descriptions of practice, they all advocate what Feldman ('Varieties of art curricula', *Journal of Art and Design Education*, vol. 1, no. 1, p. 30) calls liberal or humane conceptions of curricula; i.e., they propose that children study humanity through art, and that teachers seek to free them from a variety of restraints, or confinements. The latter include, according to Feldman, 'the psychological confinements of the self or ego; the genealogical confinements of the family, tribe and race; the physical confinements of the neighbourhood, town or region and the societal confinements of class or occupational background'.

11. The quotations included in this chapter which do not have reference numbers have been extracted from these reports.

12. In *Becoming human through art*, Feldman discusses art about people and places and makes a plea for the study of humanity through art. He claims that people are basically curious about the

varieties of experience, feeling and appearance that it is possible for human beings to have, or think of and suggests that children can get to know the feelings they are capable of having and gain an understanding of life by looking at, discussing and appreciating images of people and places represented in the visual arts.

13. Adams and Ward's *Art and the built environment*, interrelates art and environmental studies. The authors promote a curriculum approach in which children make intensive studies of their local environment, with particular reference to the critical analysis and appraisal of townscape and favour integrating art teaching with other aspects of the curriculum such as social studies, history, urban geography and English. They understand the role of art in general education as being that of increasing pupils' understanding of the way humans shape and control their environment with the aim of enabling them to take a greater part in environmental decision making.

14. R. Lavender, *Myths, legends and lore*, (Blackwell, Oxford, 1975), p. 11.

15. McFee and Degge's *Art, culture and environment* includes suggestions on 'seeing and drawing', 'organizing and designing', 'creating art', 'art and environmental education' and 'exploring art's cultural meaning'. The authors understand the importance of art in general education as being that of helping pupils to evaluate the qualities of art in different cultural contexts so that they may become more critically aware of the impact of their own and other peoples' art. Their general education focus is on the manner in which art 'expresses a people's sense of reality and communicates their internal values and beliefs'.

16. Smith, 'On the third realm' (1982).

17. Feldman, *Becoming human through art*, p. 214.

18. Inner London Education Authority, Committee of enquiry on the Curriculum and Organisation of Secondary Schools. *Improving secondary schools*, (ILEA, London, 1984). (The Hargreaves Report.)

19. e.g., Elliot Eisner, *Educating artistic vision* (Macmillan, New York, 1972), and Smith, 'On the third realm' (1982).

20. Laura Chapman, *Instant art, instant culture* (Teachers College Press, New York, 1982).

21. Anthony Adams, *The humanities jungle* (Ward Lock Educational, London, 1976).

22. D. Bolam, 'Integrating the curriculum: A case study in the humanities', *Paedagogica Europaea*, vol. 6, pp. 157-71.

23. Chapman, *Instant art, instant culture*, pp. 36 – 59.

References

Archer, W. G. (1960) *Indian miniatures*, Studio Books London

Arnheim, R. (1971) 'Art and humanism', *Art Education*, vol. 24, no. 7, pp. 5-9

Barrow, R. (1976) *Commonsense and the curriculum*, George Allen and Unwin, London

Broudy, H. (1977) *The whys and hows of aesthetic education*, CEMREL, St. Louis; Eisner, E. (1982) 'The relationship of theory and practice in art education', *Art Education*, vol. 35, no. 1, pp. 4-5

Falk, T., Smart, E. S., and Skelton, R. (1978) *Indian painting*, Lund Humphries, London

Mason, R. (1985) 'Some student teachers' experiments in art education and humanistic understanding', *Journal of Art and Design Education*, vol. 4, no. 1, pp. 19-33

____(1986) 'Helping student-teachers broaden their conceptions of art curricula', *Art Education*, vol. 39, no. 4, pp. 46-51

Rader, M. and Jessup, B. (1976) *Art and human values*, Prentice-Hall, New Jersey

Stenhouse , L. (1968) 'The humanities curriculum project', *Journal of Curriculum Studies*, vol. 1, no. 1, pp. 26-33

Warwick, D. (1973) *Integrated studies in the secondary school*, Schools Council, London

Wilson, A. (1983) 'From the specific to the general', *The Times Higher Education Supplement*, vol. 14, no. 18, p. 15

Critical Studies and the Anthropology of Art

Critical studies in Britain

In the late 1980s, there was a flurry of interest in what has been variously described as critical appraisal, critical studies and art appreciation in the art and design curriculum. This interest was discernible at both national and local levels in the inclusion of critical and historical study as one of a number of possible approaches to classroom enquiry in the new examination syllabuses for the General Certificate of Secondary Education examination syllabuses (e.g. the Midlands Examining Group syllabus for 1988); in a spate of small conferences and teachers' workshops on the topic organised by local authority advisers and other professional bodies and associations (e.g. National Society for Education in Art and Design, Association of Art Advisers); and, by the attention afforded the most recent publication to arise out of the work and research of the Critical Studies in Art Education Curriculum Development Project, Rod Taylor's *Educating for Art*.

The Critical Studies in Art Education Project had received substantial funding from the Arts Council, Crafts Council, Schools Council and School Curriculum Development Committee. In his introduction to *Educating for Art*, Taylor explained this public interest in the potential and contribution of critical studies to art and design in general education as 'arising out of a growing concern that the emphasis on practical work in many schools has become too dominant'. He referred to two major education reports, the Gulbenkian Foundation's *Arts in Schools* and the Department of Education and Science's *Art in Secondary Education, 11-16*, in support of his thesis that there had been a decline in the teaching of art history which had resulted in the virtual disappearance of what he called the 'more reflective and contemplative aspects' of art education and that there was a need to develop and clarify a range of alternative approaches to giving pupils 'a critical awareness and understanding of art and craft objects'.[1]

Taylor's claims, namely that there was general concern about an imbalance in the art and design curriculum between making and doing art on the one hand and contemplating it and talking about it on the other, and that teachers were disenchanted with art history, were supported by other observers of the contemporary scene. Dyson,[2] for example, commented that there seemed to be a growing

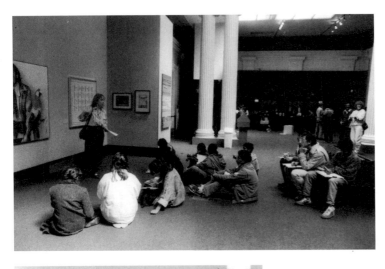

Figure 5.1:
Collaborative curriculum venture in a museum

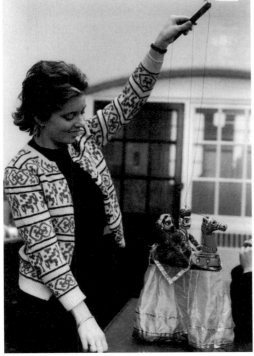

Figure 5.2:
Dialogue with objects, student-teacher with Rajasthani Marionette

inclination to include a significant element of 'appraisal' in art and design courses and that teachers were substituting terms like 'appreciation', 'criticism', 'visual education' and 'cultural studies' for 'art historical studies'. But while Dyson and Taylor referred to a range of possible alternatives to teaching art history it was difficult to determine just what these were. Taylor's *Educating for Art* drew on David Hargreaves' theory of aesthetic learning by conversive trauma[3] and emphasised 'appreciation'. In this connection, Taylor afforded the in-depth study of original works in galleries and museums a key role in

art and design teaching. Moreover, he understood the kind of verbal discussion that results when children respond to them in terms of individual interests and desires as contributing to the development of a lifelong interest and enthusiasm and as complementing their expressive work in schools. Whereas Taylor and his supporters tended to advocate a re-activation of the historical, critical and appreciative aspects of the curriculum with a view to this motivating personal expression and response, critical studies enthusiasts of a different persuasion, such as Palmer,[4] were calling for a new form of visual education that concentrated on 'the theoretical aspects of the subject' in such a way that it resulted in children being able to place what they looked at and made in a more public arena and to establish relationships across school subjects, cultures and art forms. Similarly, Margaret Iversen,[5] a participant at an annual conference for art history teachers, chastised her colleagues for their tendency to treat works of art as objects of aesthetic contemplation and to study them in isolation from their social context. She identified a need for a radically different theoretical framework for talking about works of art: one that was based on moral and political considerations, psychoanalysis and a theory of signs.

The Critical Studies in Art Education Project team favoured a synthesis of the historical, appreciative, critical and productive aspects of art and design teaching. Rod Taylor's publications presented their case for collaborative curriculum ventures, involving art teachers, artists and gallery educators, by means of descriptive accounts of interviews with highly motivated students and of curriculum experimentation in museums, galleries and schools. The enthusiastic response these publications aroused was welcome evidence of a renewed interest, on the part of teachers, in the educational significance of talk about art in schools; but, the team's conception of critical theory and of art and design education had me worried on a number of counts. The alternative proposals for visual education, cultural studies and for a new form of art history referred to earlier, suggested art and design educational purposes, practices, and outcomes that appeared to have escaped their attention and I found the distinctions between terms such as 'appreciation', 'criticism', 'appraisal' and 'knowledge' much more significant than their curriculum theorising allowed. I was worried, also, by Taylor's treatment of multicultural and international educational issues and concerns. From the evidence arising out *Educating for Art*, he was seemingly content to relegate multicultural, antiracist and cross-cultural curriculum issues to the realm of being aware of and sensitive to individual differences and acknowledging the social value of group work. Admittedly, one chapter addressing itself to multicultural issues, identified a need to broaden the art and design curriculum so that it drew upon non-European sources of stimulus, but its model of the artist, art activity and artworlds remained resolutely Western-European and monocultural. In this connection, I judged it important that Taylor and his

colleagues acquainted themselves with the critique of Western aesthetic theory and practice that was being mounted by sociologists and anthropologists and which I felt had important ramifications for the teaching of critical studies in schools.

The 'Lost Magic Kingdoms' exhibition

The anthropological critique was brought home to me most forcibly by the exhibition called *Lost Magic Kingdoms* referred to in chapter three. The exhibition, at the Museum of Mankind in London, was meant to be provocative. The several hundred or so ethnographic specimens it featured had been selected from the museum collections and arranged by an artist-teacher, Eduardo Paolozzi. He displayed them in the manner of the early ethnological exhibits which were commonplace until the 1970s but had all but disappeared since then - in seemingly random arrangement with little or no written information.

The exhibition catalogue[6] included a transcript of a conversation in which Paolozzi admitted that ethnological museums were an important source of his artistic inspiration and in which he accused British artists of being particularly insular and disinterested in 'primitive art'. The largest part of the catalogue, however, consisted of an article by Malcolm McLeod in which Paolozzi's working methods and his artistic response to 'things of other cultures' were subjected to critical scrutiny from an anthropological perspective.

In this article, McLeod noted that Paolozzi's visually complex graphic work tended to be built up from pre-existing images cut up, rearranged and placed in juxtaposition with other images. He pointed out that this working method necessitated Paolozzi isolating what he regarded as the essential elements of his source material from its original context with a view to recombining them in his own art in novel or original ways. McLeod observed, also, that while he was selecting objects from the museum collection, Paolozzi had appeared absolutely fascinated by the way in which his 'tribal' colleagues had used simple tools - with their technology of the mind as opposed to that of the machine - and with their ability to produce images from unusual materials; but disinterested in the items' cultural contexts and in their function in the societies in which they had been made. McLeod pointed out that Paolozzi's concern for the museum specimens had been limited to an interest in their formal properties and materials.

With reference to a carved, wooden figure originating from the Maori society, New Zealand, for example, McLeod commented that it was one of a series chosen purely for formal and stylistic reasons. He wrote that Paolozzi had not expressed any interest in the fact that they were houseposts, nor in the symbolic significance of the curvilinear markings on their surface which he identified as tattoos - an art form in their own right. Similarly, Paolozzi had selected a wooden medicine figure with attachments of iron nails and blades originating from the

Bakongo, Zaire. McLeod described this image as a fetish and commented that the act of driving a nail into it in its tribal context activated it on behalf of a client; also, that the accumulation of nails testified to its past efficacy. He suggested that Paolozzi was attracted to items like the fetish because their appearance was 'excessively sensational and bizarre'.[7] In McLeod's view, this fascination with their aesthetic shock value coupled with an intellectual distancing of them from their cultural contexts constituted a characteristically Western way of perceiving the world that is unacceptable. It is unacceptable, because it tends to result in crude simplifications about the lives of non-European peoples and because it exaggerates what is different and incomprehensible.

The exhibition featured some recent museum acquisitions including an oil lamp made from an electric light bulb and a tin can. Mcleod wrote that the lamp exemplified the recycling of industrialised goods and the use of discarded materials that is commonplace in contemporary African societies and which Paolozzi admired and has encouraged in his students' work. He questioned their artistic appraisal. He noted, for example, that Paolozzi frequently derived his artistic ideas from a personal collection of scrapbooks, notebooks and folders of pictures of alien cultures extracted from journals and magazines. (The exhibition catalogue included a page from one of the artist's scrapbooks which consisted of a photograph of a young African boy carrying a wooden rifle and wearing a cardboard military cap.) McLeod pointed out that Paolozzi's vision of the worlds to which the museum specimens belonged was derived very largely from European travel books, brochures, illustrated journals and commercial magazines. He appeared apprehensive about this since he described this source material as projecting a misleading and culturally biased interpretation of life in the societies involved.

Anthropologists talking about art

I have spent some time discussing McLeod's article because it highlights important differences in the way artists and anthropologists think and talk about the art of non-European cultures and because artists are the model for much of the discussion about art that goes on currently in British schools. It is an historical fact, of course, that large numbers of twentieth century Western European painters and sculptors (e.g. Picasso, Gaudier Brzeska and Klee) have claimed to be inspired by primitive, ethnic or tribal art. But their appropriation of African forms and motifs is currently interpreted as 'cultural plunder' or as 'imperialist exploitation of Third World peoples' by many practising artists who are representatives of the contemporary Afro-Asian arts movement and by the art critic Robert Hughes.[8] Whether or not this judgement is correct, McLeod's anxiety about the manner in which artist-teachers, such as Paolozzi, and art theorists (namely critics, aestheticians and art historians), think and talk about non-European art is shared by other anthropologists.

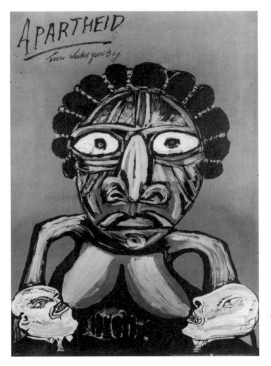

Figure 5.9:
**Anti-apartheid
poster,** *How
whites grow big*

Clifford Geertz, for example, has criticised their specialist talk on the grounds that it is too technical, crafts related and formal. Talking about non-Western art in terms of its formal properties, symbolic content, affective values, stylistic features etc., is problematic, according to Geertz, because,

> *...it is perhaps only in the modern age and in the West that some people (still a minority and destined, one suspects, to remain such) have managed to convince themselves that technical talk about art, however developed, is sufficient to a complete understanding of it; that the whole secret of aesthetic power is located in the formal relations between sounds images, volumes, themes or gestures. Everywhere else - and, as I say, for most of us as well - other sorts of talk whose terms and conceptions are derived from cultural concerns that art serves to reflect, or challenge or describe, but which it does not in itself create, collects about it to connect its specific energies to the general dynamic of human experience.*[9]

It is problematic, also, because 'to study an art form is to explore a sensibility that is essentially a collective formation with foundations that are as wide as social existence and as deep'[10] and because any theory of art is, at the same time, a theory of culture and not an autonomous enterprise.

> *The approach to art from the side of Western aesthetics (which, as Kristeller has reminded us, only emerged in the mid-eighteenth century along with our rather peculiar notion of the 'fine arts'), and*

107

indeed from any sort of prior formalism, blinds us to the very existence of the data upon which a comparative understanding of it could be built. And we are left, as we used to be with studies of totemism, caste or bride wealth - and still are in structuralist ones with an externalised conception of the phenomenon supposedly under intense inspection but actually not even in our line of sight.[11]

Stoller and Cauvel,[12] two college lecturers who devised an interdisciplinary course in anthropology and aesthetics agree with Mcleod and Geertz. They have claimed that teaching students about non-European art forms from the viewpoint of Western aesthetics is problematic because this kind of talk does nothing to encourage them to develop attitudes of respect and sympathetic understanding towards the traditions and ideas of the peoples in the societies in which they have been made.

What advice can anthropologists offer Western artists and art theorists? Nelson Graburn has advised them against viewing the arts of small-scale societies as if they were products of isolated holistic cultures with closed traditions. He says that the majority of the fourth world societies that are the focus of anthropological study now consist of dominant and conquered stratas of peoples whose arts are many and varied and in a constant state of change.[13]

Graburn is not alone in objecting to the indiscriminate application of the terms 'art','primitive art','folk art' and 'sculpture' which he has described as restrictive and hopelessly outmoded. Rather than saddle non-European productions with labels that reflect the 'elitist traditions of high civilisations concerning the value of arts and crafts and

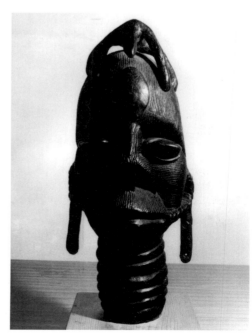

Figure 5.10:
Emmanuel Jegede,
Ebora ile Otin (**The Spirit of Public House**) **1969**

the importance of creativity and originality',[14] anthropologists elect to study 'evidence of human social and environmental relationships' in the form of 'cultural artefacts' or the 'material world'.

Graburn, Geertz and McLeod have advised against aesthetic discourse which seeks to explain non-European art in universalist terms. McLeod has pointed out that their aesthetic preoccupation with the concept of 'beauty' causes Western artists and art theorists to impose ideas about form or aesthetic qualities on cultural artefacts that their makers and users would not necessarily recognise and which, for a variety of reasons, must be entirely speculative. Given that artists everywhere work to their audiences' capacities and that those audiences' capacities to perceive meaning in what they do comes from their participation in particular cultural systems, anthropologists find it very much more illuminating to talk about the social and ritual backgrounds to particular images, to examine their connection with other visual - as well as verbal - modes of expression and to discuss how, why and when they were made and used.

McLeod has advised Western trained artists to question their most cherished art historical assumptions. He disagrees, for example, with those European artists and historians who have interpreted African or Pacific art as initiating or directing the development of Cubism and subsequent non-naturalistic forms of European art; and has suggested instead that they provided a resource of ideas for a movement which was already under way. Finally, Picton[15] has reminded art specialists that their tendency to put non-European artefacts into a glass case and make them into art, rather than attempt to understand them within their own culture, is 're-interpretation'. To which I cannot but reply, along with Barley,[16] that the anthropological trick of interpreting art as part of a complex network of symbolic ideas and meanings which are peculiar to cultures or societies other than their own is 're-creative' also, because all the keys to the symbols are part of that symbolism itself. Nevertheless, I would agree with Graburn that a Western European aesthetic interest in the so-called primitive folk arts has to move beyond concern which is the result of guilt over past sins (colonialism), fascination with the exotic and boredom with a Western European way of life.

What is it about anthropology that enables its practitioners to claim superior insights into non-European art philosophies, forms and processes? Joan Bulmer's *Guide to Teaching Anthropology in Schools and Colleges* has defined their specialist discipline as the study of cultures as 'systems of customs that make social life possible'.[17] Bulmer considers it important that laypersons recognise that even though their chosen focus of study may make it appear that they are interested primarily in things that are singular, exotic and strange, anthropologists' real concerns lie with the most fundamental aspects of life, (such as birth, death, marriage and sex) with which everyone is intimately and directly involved. She describes anthropological

research method and reporting as dependent on the concept of social systems, and on the practice of fieldwork during which anthropologists study their chosen society by living among the people and getting to know them through participant observation. The society is studied as a whole and viewed as a functioning unit with all its parts interrelated. An anthropological text usually includes some ethnographic description of the customs and institutions of peoples evolving out of fieldwork, together with a more analytical interpretation of the fieldwork data which tends to be written up under categorisations such as kinship, marriage, money and law.

Anthropological models of art and design curricula

A number of North American art educators have argued that the cultural anthropologist offers a more comprehensive role model for the art and design curriculum than the art critic, art historian and artist. What are the implications of this for specialist programmes in schools?

For Graeme Chalmers the implications are that any art programme that concerns itself exclusively with the study of the art of so-called high culture is nonsensical. The implications of an ethnological role model[18] are that art and design teachers must broaden their conception of their subject to include the popular arts and folk arts of many cultures, together with the artefacts valued by their students, and not just by themselves. With reference to art historical studies, Chalmers finds an emphasis on aesthetic contemplation and appreciation alone wanting. An art and design specialist operating in accordance with his or her anthropological principles would have to teach children about art's social and cultural functions and emphasise not only what is being valued, but by whom and why.

Edmund Feldman's anthropological model[19] moves the curriculum away from art and design conceived of as a sequence of technical activities, or as a type of performance that parallels a normative psychological development, towards a study of humanity through art. Given this change of focus, there are a number of important curriculum principles that art and design teachers must take on board. First, they must relinquish their traditional emphasis on mastery of skills and on self-expression as the principle goal of instruction. Second, they must study artistic creativity historically - by which he means in all its concrete manifestations at different points of time and space. Third, they must examine the connections between the creation of art and its social function and institutional factors such as, for example, hunting, food production, magic and war. Fourth, they must structure their teaching around an examination of bona fide artistic examples.

June King McFee and Rogena Degge's curriculum textbook *Art, Culture and Environment*, is a most comprehensive attempt to structure an art and design programme around an anthropological

framework. McFee and Degge argue against any curriculum approach that classifies art in terms of historical periods or peoples (e.g. Renaissance, Italian, Ancient Greek, Colonial-Mexican etc.) on the grounds that this encourages stereotyped attitudes and affords teachers only a part of the knowledge they need to teach the subject. They argue in favour of emphasising the fact that the visual arts - taken to mean not only sculpture and painting, but all sorts of designed forms such as architecture, film, clothes and tools - function to communicate a whole range and variety of cultural values, attitudes and beliefs.

For art and design specialists who are unclear about 'cultural values', chapter fifteen of *Art, Culture and Environment* includes the following 'reading' of the cultural meanings embedded in the design of clocks.

> *Clocks range in degrees and ornamentation from kitchen clocks to London's Big Ben, from Mickey Mouse wristwatches to some of the most ornately jewelled bracelets. Each watch or clock tells us something about the values of the person who uses it. Clocks are different even in the same house. Though they all have the same use - to tell us what time of day it is - they can have a different social function. A well-oiled preserved, old clock with ornately carved wood usually belongs to someone who cares about old things, likes their sound, and likes the look and feel of the wood. Living room clocks usually do not look like most kitchen clocks.*[20]

Watches are described as having cultural as well as useful functions and teachers are advised that they can interpret people's role by the watches they wear. For example:

> *Women with big, efficient watches, do different things from women with small, ornate watches. When women change watches, it often means they are changing what they are going to do.*[21]

This same chapter lists possible lesson activities for children at different levels, or stages of artistic development - under headings such as studying images and values in dress, understanding the beliefs and attitudes of artists, comparing the art of different cultures, studying the meaning of placing and arrangement, comparing the meaning of objects, and studying values and roles in costume design - the majority of which have a cross-cultural and comparative focus. While their suggested activities allow for a range of different modes of curriculum presentation and response - students draw pictures of the made objects they most value or think are the most beautiful, analyse the biographies of artists for expressions of their values and beliefs, write about the meanings they get from looking at different examples of body ornament, toys, drawings, doorways, fences, clothing and magazines; and research the influence on their colleagues' taste in clothes - they all emphasise 'sustained looking' and critical discussion or talk about art. While acknowledging that children inevitably learn their sense of visual discrimination and design from a particular cultural environment or background, McFee and Degge leave their readers in no

doubt that these learned responses can and should be modified by new experiences in art lessons in schools. Each lesson plan includes a list of questions designed both to increase pupils' awareness of cultural diversity and to encourage them to become more critically aware of the impact of art on their own and other people's lives.[22]

Chalmers, Feldman, and McFee and Degge understand anthropology as particularly useful for the light it sheds on devising curricula that respond to multicultural issues and concerns. The ethnic heritage initiatives in North America that have focused on the unique or particular contributions of minority cultural groups provide case-study exemplars of curriculum development that is anthropological in kind. Rodriguez and Sherman, for example, have produced a curriculum guide called *Cultural Pluralism and the Arts* designed to help teacher-trainers inform student-teachers about Black, American-Indian and Mexican-American art forms and their purposes. Their curriculum development began when they identified four concepts that addressed the use of visual elements in specific art forms for each of their minority groups - two of which dealt with traditional uses and two with contemporary uses. Next, they researched information about the art forms and their uses. Finally, they devised twelve lesson plans which included reference material together with ideas for practical art activities in schools. Two examples are summarised below:

A lesson dealing with the traditional use of an art form in the section relating to the cultural heritage of black Americans focuses on wooden potlids made by the Woyo people of Cabinda. Prospective teachers are supplied with quite detailed information about the carved motifs on the lids and about the commonly understood proverbs on which they were based, as follows:

> *Several proverbs could be accommodated on each lid and in combination they pictorially spelled out a message. Each proverb was*

Figure 5.11:
Carved wooden pot lids with representations of proverbs, Woyo people of Cabina, 19th century

112

Figure 5.12:
Native Indian school, Vancouver, learning to carve sorpberry spoons. A parent/artist is carving and observing the skill of one of the four students at the table.

symbolised by one figure or object which immediately brought to mind the appropriate proverb. For example, an axe with a handle symbolised the proverb an axe is being fitted with a handle, but not so a person - meaning people must have freedom of choice (McGuire, 1981: 54). The objects (birds, keys, trees, drums, nuts, goats, etc.) were carved in relief, usually around a center figure or object that was larger and in higher relief. Detail was minimal with each object given enough only for it to be clearly recognisable (i.e. feathers, eyes on a bird, notches on a key.[23]

The lesson plan also includes the following information about the potlids' function or use.

Most potlids were exchanged between marriage partners at the communal dining place for men where wives brought their husband's food in earthenware pots. When a wife was angry she substituted the usual cover of leaves with a carved potlid which pictorially described her feelings. A husband could likewise convey his feelings by placing a carved lid on the pot at the end of the meal.[24]

Suggested related activities for schoolchildren include defining what is meant by proverbs, recognising the design characteristics of the potlids, compiling a book of proverbs, selecting proverbs that express feelings, designing objects or figures which pictorially represent the feelings, sketching designs of potlids, carving them out of balsa wood and interpreting each others' messages. Critical discussion should be

focused on the question of how the objects and figures are carved and arranged on the lids, and on their meaning in the particular society concerned. The children should be supplied with information and asked to discuss the role of the village sage in Woyo society who gave instructions to local sculptors for the execution and reading of potlids.

In another lesson focused around a contemporary concept, children learn that Mexican-American painters have a pluralistic cultural heritage which is part Columbian, part Spanish and part American and, that much of their art constitutes an attempt to define this American-Mexican identity. They are shown a visual of a painting called 'Jesus in the Round' by Ray Chavaz, which is described in the teachers' notes as follows:

> . . . (the painting) contains a circular motif which has been divided into four parts. In each of the four quadrants are manifestations of the earth, sky and celestial bodies. The quadrants are separated by the Latin cross. The passage of time is indicated in various aspects of each quadrant. The circular motif and four part division appears to relate to Aztec religion and cosmology that primarily pertained to deities and cycles of time as indicated by the Aztec calendar stone. This circular motif and the Latin cross indicate Chavez's use of both pre-Columbian and Spanish resources.[25]

Children are expected to talk about Chavez's pluralistic heritage and the way it has affected the design and content of his work. Then they produce a painting which illustrates the effect of the earth's revolutions on the seasons to a circular design. The concept around which this lesson plan was structured is defined as 'visual elements are used for the purpose of creating motifs which reflect a cyclical view of the world.'[26]

Beverley Berger's report of the implementation of a special programme in a native Indian cultural survival school in Vancouver, British Columbia[27] provides a second example of an ethnic heritage initiative organised around the anthropological construct of art as cultural artefact. Her programme relied on the extensive support and co-operation of a museum of anthropology both for the loan of Kwakiutl Indian artefacts, such as fish knives, masks, baskets, bead chokers, cedar bark boxes etc., and for supporting educational materials. Whereas its objectives were to teach children about the Indian culture of the past, it was designed in such a way that the skills and traditional way of life of the Kwakiutl peoples were introduced through direct experience of nature and materials. Skills with tools were added later. What follows is a summary of the fourteen lessons she outlined in her report.

> The first lesson introduced the art programme, made reference to ancestors and established the relations between BC, Canada and the world. The second lesson dealt with Native Indian life before contact, and tools that students' ancestors used were examined in pictures. The

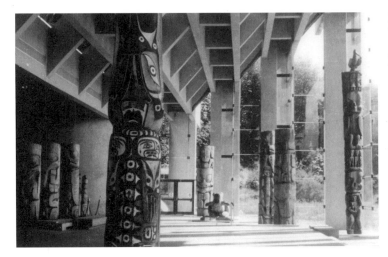

Figure 5.13:
UBC Museum of Anthropology, Vancouver, interior

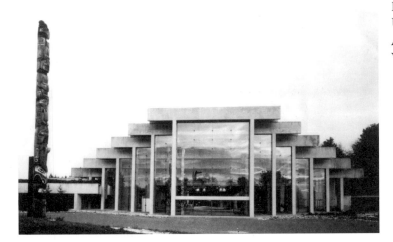

Figure 5.14:
UBC Museum of Anthropology, Vancouver, exterior

third lesson was a field trip to the beach, where the students experienced the beach and forest in winter. The theme of the fourth lesson was fishing, a traditional occupation. Wood was the theme of the three lessons that followed. Students discovered that red cedar made the fishing technology of Kwakiutl fishermen possible. Their interest in woodcarving resulted in a lesson being added to the two originally planned. During the ninth lesson the students used a traditional spindle whorl to spin sheep fleece. They dyed it traditionally, in horsetail dye bath and used it for weaving on small card salish looms. They also made masks using contemporary papier mache.

In Spring, the students returned to the beach and forest to see the changes that had occurred since they had been there in winter. Next, they went to the Museum of Anthropology to find those objects that they had learned about during the art programme. The fourteenth lesson introduced them to contemporary print making techniques in the form of mono prints, cardboard prints and silk screening. The last

*class gave them the opportunity to make a group decision about what
they wanted to do. The majority wished to have a field trip. . .[28]*

Berger was fortunate in that she was able to utilise anthropological
resources and expertise at first hand. Sherman and Rodriguez regretted
the fact that their resource material was confined to information in
books. But, I can see no good reason why the anthropological frame-
works underlying both these ethnic heritage curriculum initiatives
should not be applied to the study of majority as well as minority art
forms.

What do these anthropological curriculum innovations have in
common? First, the curriculum developers all espouse a degree of rela-
tivism as a necessary under-pinning to a multicultural art educational
approach (as, for example, when Chalmers argues for teaching chil-
dren that there is no one period or type of art that can be claimed to
be absolutely right or true). Second, they all favour detailed, system-
atic study of authentic examples of material culture or of peoples'
constructions of their material worlds. Third, they all emphasise the
importance of a critical/analytical curriculum domain. But, unlike the
majority of the critical studies in art education enthusiasts in this
country, North American curriculum workers insist that the critical
and analytical skills supplied by artists, art critics and art historians
provide a less than adequate understanding of the nature and meaning
of art and design forms; and they urge that the talk about art that goes
on in general education should be organised around extra or non-
aesthetic constructs or themes. For example, they want art and design
teachers to direct their pupils' attention to a given art form's original,
social and institutional context and function at least as much to its
formal properties or stylistic characteristics. They want to emphasise
knowledge about why it was valued or made, at least as much as an
individual artist's biography, or its aesthetic possibilities as a stimulus
for personal expression in schools.

Publications by museum education personnel provide useful resources
for British teachers interested in organising critical studies discussion
anthropologically. Shirley Cuthbertson's[29] article, for example, lists
eight ways of engaging in dialogue with cultural artefacts. These
include looking at the artefact to study how it was made, trying to
determine how it was used, speculating about its physical and cultural
environment, looking at its development through time, comparing it
with artefacts of similar use in other cultures, investigating its design
and decoration, speculating about its meaning, significance and
cultural values and thinking about it as part of the museum collection.
Cuthbertson admits that many of these questions cannot be answered
without reference to research materials or books and insists that it is
essential that a teacher, or museum guide, knows in advance what
minimum anthropological data is required (e.g. vocabulary). But also,
she emphasises the importance of people needing to feel they have a
relationship with the object discussed. Another museum curator[30]

has written about a workshop entitled 'Learning to Look with Teachers.' Teachers were encouraged to spend time drawing museum artefacts and building hypotheses about their origin, function and meaning, using criteria such as shape, size, materials, techniques of construction and 'wear marks' before they encountered what she identifies as the 'more informed or educated guesses of museum professionals'. She recommends, also, that students study ethnographic items in series rather than the usual sample of, at best, two or three.

A critique of the models

The difficulty with all this, as critical theory enthusiasts have quickly pointed out, is that the anthropological view of society and of human beings is educationally naive. Its emphasis on the subjective self, or on humans as knowing beings intentionally constructing their social realities is worrying, as is its assumption that art as artefact is 'good' because it has meaning or matters for a particular cultural group. Jagodzinski,[31] for example, has complained that the North American art educators who adopt an anthropological curriculum model become too relativistic. They ignore the fact that cultures can develop in many ways that are anti-human; they overstress 'cultural schizophrenia' in modern industrial societies and they cannot offer any criteria for deciding which art forms are progressive and which are not.

An art and design curriculum emphasising the kind of emancipatory endeavour of which critical theorists seem to approve would be radically different in form and content from the anthropological-style programmes just reviewed. Curriculum workers interested in applying this alternative approach might look to the model of 'media studies' in Britain which draws on the work of social historians and on neo-Marxist, or Western-Marxist traditions of educational thought. They might seek to implement, or adapt, the kind of teaching strategies and lesson content that the British Film Institute have promoted in their instructional materials and packs.

Reading Pictures is their introductory package to the study of photography. Its authors emphasise the fact that photographs should be looked at as constructions, not as if they were objects in the real world, and they define their educational intention as that of informing students that 'it is worth asking questions about how photographic meaning is produced'.[32] The pack includes photographic examples and three exercises for students each of which focuses on two elements in the process of meaning production: first, looking within the frame to identify one signifier, or representation, of an object or image and examining what it means by itself and in a given context; and second, considering factors outside the frame, which narrow down or anchor the range of possible interpretations. The first photographic examples consist of a set of four slides centring around an advertisement for eyelash conditioner. The first slide-image has one signifier - a worn teddy bear head seen in three quarter profile against a background of

clean, white fabric, with a pattern of tiny red hearts. The sequence of slides progressively reveals more of the advertisement and teachers are directed to engage children in discussion about each image in such a way that questioning moves from description to interpretation - denotation to connotation. In the last slide, pupils see the entire advertisement in which all the signifiers and signified are anchored by a caption which ensures that it is interpreted in a particular way. In another exercise pupils study two photographs in small groups. The teacher gives them a multiple choice question sheet, included in a centre-fold inside the pack, which forces them to undertake a formal analysis and focuses their attention on a small range of possibilities such as camera lighting and position. Next they are provided with a mastersheet of captions which they cut out and align with the photos. The aim of this exercise is to prompt the realisation that the meaning of a photograph is limited and fixed by a caption and that the same photograph can be used with different captions and its meaning deflected accordingly.

A graduate student of mine studying *Reading Pictures* found the photographic images and their accompanying curriculum text worrying:

> In the first set of slides, to promote eyelash conditioner, an image of a young girl of ambiguous age, lies innocently in bed cuddled under fresh clean sheets with what the authors identify as her 'male' teddy bear. In exercise two, two photographs in snapshot format, show a family in modest dress and appearance; they are huddled together in the first example, their cramped living quarters attesting to their societal abusement, oppression and exploitation as members of the working class; in the second photo they are seen enjoying the freedom of a public park; and in the last set of images, the viewer is confronted by a headless doll, lying at the feet of a soldier, whose automatic rifle is aimed out through a window as he sits comfortably in an ornate carved chair . . . [33]

The student questioned the curriculum developers' choice of images given their stated aim - to demonstrate to secondary school pupils that the meaning of a photograph is limited to a caption. Having concluded that their underlying interests were political and ideological rather than pedagogic, he argued that teachers should present children with a different vision of society, one which he described as extending outwards from the family which is loving, caring and secure. Whilst not denying that the BFI curriculum orientation is political and that the image of the human condition and social relations it presents is somewhat bleak, I am worried by the failure of anthropological art educational initiatives to deal with the issue of the media as 'false communication' and to address transformationist, or social reconstructionist curriculum purposes and aims.[34]

The second BFI example deals similarly with the deconstruction of

media images, but, in this case, images of blacks.[35] Its units on image analysis, representation and racial stereotyping supply art and design teachers with more than enough ammunition for persuading children that the society in which they live is by no means loving, caring and secure. They draw upon the same principles of criticism, derived in the main from semiological theory and invite pupils to look at and discuss a wide range of images of 'blackness' projected in newspapers, posters, cartoons, and films. They include, for example, a press photograph of a black GI having his shoes cleaned in a London street (captioned 'Leicester Square, 1953: A shoeshine scene') and a Sunday Times colour supplement cover-image of a black family captioned 'The society negroes'; together with film images of black gangster 'heavies' and black-face-minstrelsy cartoons intended to illustrate the theory of scientific racism and media images of black protest and riots. The curriculum developers are in no doubt that the images they have selected are prejudicial and justify their inclusion in the curriculum on the grounds that they should be utilised as a means of teaching children that political and ideological forces interact naturally to endlessly reproduce racist - that is culturally and ideologically oppressive - orientations. They describe the strategy of merely taking away negative images and replacing them with positive ones as inadequate in curriculum terms.

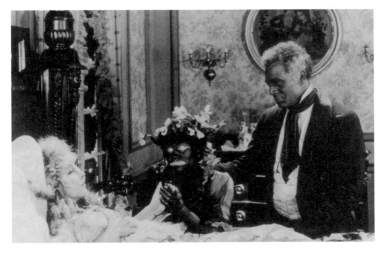

Figure 5.15:
Uncle Tom's Cabin film stereotypes, Uncle Tom and Topsy

Curriculum purposes and aims

Are these anthropological or critical-historical curriculum orientations compatible with contemporary British art and design educational purposes and aims? Not with programmes that operate on the single rationale that art and design education is about personal fulfilment through art experience. Not with programmes in which critical or historical studies are understood simply as transmitting an appreciation of a monocultural heritage that is Western European in kind. But Laura Chapman has proposed a threefold rationale which includes the purpose of developing children's awareness of the role of art and

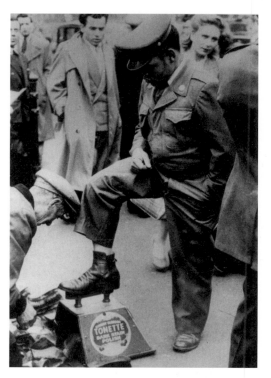

Figure 5.16:
**Leicester
Square 1953: A
shoeshine scene**

design in society. This third purpose, which is intended as a response to the general education function of developing children's social consciousness' is stated thus:

> *Children should understand that the visual forms they create help them to express their own identities as well as their membership in groups. Visual forms also mark important events in their lives. In the same way, tools and spaces for living reflect people's expressive and physical needs in everyday life. The colour, shape and arrangement of objects in stories and in advertisements have a profound effect on behaviour. We should help people to become aware of the many ways visual forms can shape and express the feelings of peoples of all cultures.*[36]

As Chapman herself has observed, social studies curriculum texts already include instructions for lessons in art that are cross-cultural and designed so as to extend a child's frame of reference for under-standing social groups. A North American coursebook for middle school, *Our World, Lands and Culture*, for example, contains seven curriculum units organised around the social studies themes of 'How societies are similar and different', 'How people learn to live together', 'Who we are', 'How people use their resources', 'Leadership in Government' and 'International dependence' and 'Culture change'. Unit one, which features Japan, France, Peru and Egypt, includes one chapter in which learning is structured around the single concept or idea that 'art expression varies from people to people'.[37] In the

media images, but, in this case, images of blacks.[35] Its units on image analysis, representation and racial stereotyping supply art and design teachers with more than enough ammunition for persuading children that the society in which they live is by no means loving, caring and secure. They draw upon the same principles of criticism, derived in the main from semiological theory and invite pupils to look at and discuss a wide range of images of 'blackness' projected in newspapers, posters, cartoons, and films. They include, for example, a press photograph of a black GI having his shoes cleaned in a London street (captioned 'Leicester Square, 1953: A shoeshine scene') and a Sunday Times colour supplement cover-image of a black family captioned 'The society negroes'; together with film images of black gangster 'heavies' and black-face-minstrelsy cartoons intended to illustrate the theory of scientific racism and media images of black protest and riots. The curriculum developers are in no doubt that the images they have selected are prejudicial and justify their inclusion in the curriculum on the grounds that they should be utilised as a means of teaching children that political and ideological forces interact naturally to endlessly reproduce racist - that is culturally and ideologically oppressive - orientations. They describe the strategy of merely taking away negative images and replacing them with positive ones as inadequate in curriculum terms.

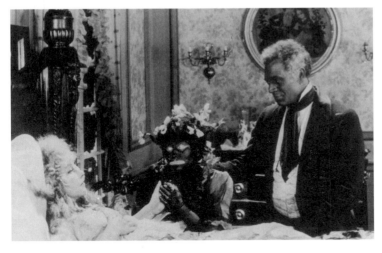

Figure 5.15:
Uncle Tom's Cabin film stereotypes, Uncle Tom and Topsy

Curriculum purposes and aims

Are these anthropological or critical-historical curriculum orientations compatible with contemporary British art and design educational purposes and aims? Not with programmes that operate on the single rationale that art and design education is about personal fulfilment through art experience. Not with programmes in which critical or historical studies are understood simply as transmitting an appreciation of a monocultural heritage that is Western European in kind. But Laura Chapman has proposed a threefold rationale which includes the purpose of developing children's awareness of the role of art and

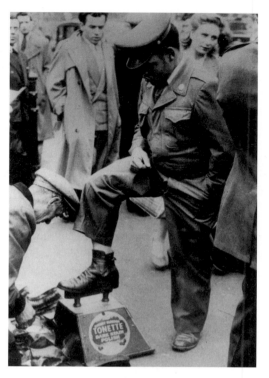

Figure 5.16:
Leicester Square 1953: A shoeshine scene

design in society. This third purpose, which is intended as a response to the general education function of developing children's social consciousness' is stated thus:

> *Children should understand that the visual forms they create help them to express their own identities as well as their membership in groups. Visual forms also mark important events in their lives. In the same way, tools and spaces for living reflect people's expressive and physical needs in everyday life. The colour, shape and arrangement of objects in stories and in advertisements have a profound effect on behaviour. We should help people to become aware of the many ways visual forms can shape and express the feelings of peoples of all cultures.* [36]

As Chapman herself has observed, social studies curriculum texts already include instructions for lessons in art that are cross-cultural and designed so as to extend a child's frame of reference for understanding social groups. A North American coursebook for middle school, *Our World, Lands and Culture*, for example, contains seven curriculum units organised around the social studies themes of 'How societies are similar and different', 'How people learn to live together', 'Who we are', 'How people use their resources', 'Leadership in Government' and 'International dependence' and 'Culture change'. Unit one, which features Japan, France, Peru and Egypt, includes one chapter in which learning is structured around the single concept or idea that 'art expression varies from people to people'.[37] In the

media images, but, in this case, images of blacks.[35] Its units on image analysis, representation and racial stereotyping supply art and design teachers with more than enough ammunition for persuading children that the society in which they live is by no means loving, caring and secure. They draw upon the same principles of criticism, derived in the main from semiological theory and invite pupils to look at and discuss a wide range of images of 'blackness' projected in newspapers, posters, cartoons, and films. They include, for example, a press photograph of a black GI having his shoes cleaned in a London street (captioned 'Leicester Square, 1953: A shoeshine scene') and a Sunday Times colour supplement cover-image of a black family captioned 'The society negroes'; together with film images of black gangster 'heavies' and black-face-minstrelsy cartoons intended to illustrate the theory of scientific racism and media images of black protest and riots. The curriculum developers are in no doubt that the images they have selected are prejudicial and justify their inclusion in the curriculum on the grounds that they should be utilised as a means of teaching children that political and ideological forces interact naturally to endlessly reproduce racist - that is culturally and ideologically oppressive - orientations. They describe the strategy of merely taking away negative images and replacing them with positive ones as inadequate in curriculum terms.

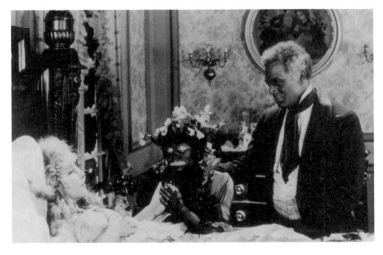

Figure 5.15:
Uncle Tom's Cabin film stereotypes, Uncle Tom and Topsy

Curriculum purposes and aims

Are these anthropological or critical-historical curriculum orientations compatible with contemporary British art and design educational purposes and aims? Not with programmes that operate on the single rationale that art and design education is about personal fulfilment through art experience. Not with programmes in which critical or historical studies are understood simply as transmitting an appreciation of a monocultural heritage that is Western European in kind. But Laura Chapman has proposed a threefold rationale which includes the purpose of developing children's awareness of the role of art and

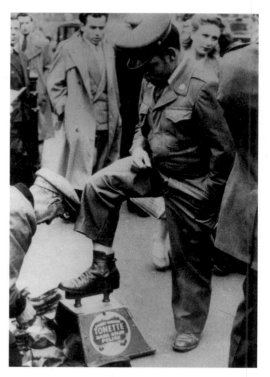

Figure 5.16:
**Leicester
Square 1953: A
shoeshine scene**

design in society. This third purpose, which is intended as a response to the general education function of developing children's social consciousness' is stated thus:

> *Children should understand that the visual forms they create help them to express their own identities as well as their membership in groups. Visual forms also mark important events in their lives. In the same way, tools and spaces for living reflect people's expressive and physical needs in everyday life. The colour, shape and arrangement of objects in stories and in advertisements have a profound effect on behaviour. We should help people to become aware of the many ways visual forms can shape and express the feelings of peoples of all cultures.*[36]

As Chapman herself has observed, social studies curriculum texts already include instructions for lessons in art that are cross-cultural and designed so as to extend a child's frame of reference for understanding social groups. A North American coursebook for middle school, *Our World, Lands and Culture*, for example, contains seven curriculum units organised around the social studies themes of 'How societies are similar and different', 'How people learn to live together', 'Who we are', 'How people use their resources', 'Leadership in Government' and 'International dependence' and 'Culture change'. Unit one, which features Japan, France, Peru and Egypt, includes one chapter in which learning is structured around the single concept or idea that 'art expression varies from people to people'.[37] In the

section on art among the Bedouin, children learn about the manner in which the Islamic religion and desert environment affects Bedouin artistic expression and are supplied with detailed information about the structure and form of Qasida story poems and woven Qatas. Suggestions for practical work include studying the geometric forms of Bedouin art, making up poems 'the way the Bedouin do', designing and colouring Bedouin patterns and learning about the construction of handlooms. The section on art in France features information about Paris as an art centre, about government patronage and support for the arts and about the age of impressionism. Activities include studying artistic techniques in reproductions of paintings by French impressionist painters, researching information about one of the artists mentioned and planning a miniature art gallery. The authors of this chapter remind teachers to guide their pupils to recall their learning about the religion, social organisation, technology and resources of social groups in France, Peru, America, Egypt and Japan in other chapters and to bring this knowledge to play in making comparisons between their art.

Chapman's descriptive accounts of the educational content and strategies that she deems appropriate for the fulfilment of her social consciousness curriculum rationale allow for both anthropological and critical/historical curriculum purposes, practices and outcomes. But they read like a plea for integrating art and social studies. The majority of the curriculum initiatives explored in this chapter have been proposed as replacements for the cultural heritage component of a specialist art and design programme. Is interdisciplinary teaching an inevitable consequence of taking a social consciousness rationale on board?

The late Laurence Stenhouse thought not. He argued for the development of the social consciousness of youth through a core curriculum that was was subject-specific and arts and science based.[38] Stenhouse understood the function of general education as cultural transmission, but he likened the classroom to a kind of cultural laboratory in which a new face-to-face culture is generated at a humble level. He described the teacher's role as that of acting as a critic who represents tradition against the innovating individual; the result, he claimed, was a dialectic interchange serving to assimilate and discipline cultural innovation. Stenhouse's criterion for the selection of every subject, including the visual arts, was not just that they had something to offer from the cultural tradition, but that they raised controversial issues of value in practice and were chosen for their relevance to life. He wrote that literature, science and art:

> . . . should be selected for its relevance to the fundamental human problems which concern pre-adolescents and adolescents not for its illustration of form or technique or, for its importance in the history of the subject. The procedure should be to stimulate interest in moral and human problems and then to feed discussion.[39]

Recently, Kristin Congdon has been calling for both the inclusion of folk arts in the curriculum and a 'folkloric' approach to the study of art.[40] Congdon has described the study of a folk art as necessitating an analysis of its techniques of construction, the craftsperson's role, status and function within the community; the economics of the craft; the craftsperson's creativity, the craft style, changes and influence on its design, aesthetic perception among the creators and their public and socio-economic relationships between producers and consumers. But she has admitted also, that her folkloric approach, which is process orientated and which emphasises the study of artworks complete with the beliefs, values and attitudes that surround them, requires a recognition and sharing of the folk speech that takes place alongside the works made by the folk artist which explains them from an insider, or community membership perspective.

In conclusion it was my contention that the patterns of verbal communication that the Critical Studies in Education Project team had been promoting were best described as a particular form of insider (folk) speech in Congdon's terms; and that anything else that took place in British classrooms tended towards that 'spiritualization of the technical' that Geertz had claimed is characteristic only of Western aesthetic thought.[41] I agreed with the American art educator, Feldman, when he suggested that, at a general educational level, students need a curriculum plan of action that provides them with tools that will help them to recognise, appreciate and cope with the plethora of cultural expressions and forms that exist, not only within their own complex civilisation, but in those labelled non-European. If the critical studies enthusiasts in Britain were interested in responding to the issue of cultural diversity at anything more than purely cosmetic or political levels, they had no choice but to consider educational methods, purposes and outcomes that arise out of anthropology and social theory. They offered them the necessary means of adopting an outsider perspective on their specialist subject. To insist on the orthodox role models of the artist, aesthetician, art critic and historian, was to remain locked inside a particular tradition of educational discourse that appeared incapable either of addressing the issue of social reconstruction or of embracing a genuine understanding of the arts and artisans of non-European cultures on their own terms.

Notes

1. Rod Taylor, *Educating for art: Critical response and development* (Longman, London, 1986), p. xi.

2. Anthony Dyson, 'Art history and criticism in schools', *Journal of Art and Design Education*, vol.1, no.1, p. 124.

3. David Hargreaves,'The teaching of art and the art of teaching: Towards an alternative view of aesthetic learning,' in M. Hammersley and D. Hargreaves (eds.), *Curriculum practice: Some sociological case studies* (Falmer, London, 1983), pp. 127-147. For

Hargreaves, an adequate theory of aesthetic learning must include the notion of 'conversive trauma.' Conversive, traumatic experiences have four characteristics: concentration of attention, a sense of revelation, inarticulateness and arousal of appetite.

4. F. Palmer in A. Dyson, (ed.) *Art history and criticism in schools*, University of London, Institute of Education, 1986) p. 12.

5. M. Iversen in J. Lubbock (ed.) 'Art history and visual education; aims and methods for 11/18 year olds', unpublished, University of Essex, 1983, p. 3.

6. British Museum, *Eduardo Paolozzi: Lost Magic Kingdoms*, (British Museum Publications, London, 1985).

7. Malcolm McLeod, 'Paolozzi and identity', Ibid, pp. 12- 60.

8. Rasheed Araeen, *Making myself visible*, (Kala, London, 1984) p. 87. Robert Hughes, *The Shock of the New* (BBC, London, 1980) p. 20.

9. Clifford Geertz, *Local knowledge: Further essays in interpretive anthropology*, (Basic Books, New York, 1983), p. 95. His definition of technical talk is intriguing because it includes what he calls the spiritualization of the technical - anything in fact which is talk about art separated from talk about the general course of social life. Also, because he identifies structuralism and semiotics as modern moves towards aesthetic formalism.

10. Ibid, p. 99.

11. Ibid, p. 98.

12. Marianne L. Stoller and M. Jane Cauvel in J. Cordwell (ed.) *The visual arts: Plastic and graphic*, (Mouton, The Hague, 1979) p. 93.

13. Nelson Graburn, *Ethnic and tourist arts*, (University of California Press, Berkeley, 1976), pp. 5-9, has identified six different types of art typical of small scale societies. They are a) traditional or functional fine arts, b) commercial fine arts, c) souvenirs or ethno-kitsch, d) re-integrated arts, e) assimilated fine arts, utilised) popular arts, each of which merits serious attention.

14. Ibid, p. 3

15. John Picton, unpublished, School of Oriental and African Studies, University of London, (1986).

16. N. Barley, 'The warp and woof of culture', *Royal Anthropological Institute News*, no.59, 1983) pp. 7-8.

17. Joan Bulmer, *Guide to teaching anthropology in schools and colleges*, (School of African and Oriental Studies, University of London, 1977), p. 3.

18. F. Graeme Chalmers, 'Art education as ethnology', *Studies in Art*

Education, vol. 22, no. 3 (1981), pp. 6-14. In 'Teaching and studying art history', *Studies in Art Education*, vol. 20, no.1 (1978), p. 21, Chalmers lists the cultural and social functions that inform anthropological discussion as differentiation and stratification; co-operation, accommodation, assimilation; social conflict (including revolution and war); communication (including opinion formation, expression and change; socialization and indoctrination; social evaluation (the study of values); social control; deviance; social integration; and social change.

19. Edmund Burke Feldman, 'Anthropological and historical conceptions of art curricula', *Art Education*, vol. 33, no.6 (1980), pp. 6-10.

20. June King McFee and Rogena Degge, *Art, Culture and Environment*, (Wadsworth, California, 1977), p. 300., identify clocks as an excellent example of objects to study because time is so central to many different people that they come in all kinds of designs and sizes. They advise primary teachers to collect a range of familiar everyday objects (e.g. clocks) that represent different historical periods or cultures. First, they should encourage children to compare them through questioning. Next, they should encourage children from different cultural backgrounds to talk to their families about the examples so as to gain more information about how they were used. Finally, they should encourage children to extend their understanding of the objects by researching their design function in a given culture more fully.

21. Ibid, p. 301.

22. Ibid, p. 297.

23. Fred Rodriguez and Anne Sherman, *Cultural pluralism and the arts*, (University of Kansas, Lawrence, 1983), p. 22.

24. Ibid, p. 21.

25. Ibid, p. 101.

26. Ibid, p. 101.

27. B. Berger, 'The implementation of an art-based programme designed to develop cultural awareness among students in an urban native-Indian class', unpublished Masters dissertation, University of British Columbia, 1983.

28. Ibid, pp. 103-124.

29. S. Cuthbertson, 'Dialogue with objects; Asking questions,' *Museum Quarterly*, British Columbia Museum Association, no. 84 (1982), pp. 21-23.

30. Madeleine Bronsdon-Rowan, 'Learning to look with teachers', Ibid. pp. 40-42.

31. John Jagodzinski,' Art education as ethnology: Deceptive democracy or new panacea?' *Studies in Art Education*, vol. 23, no.3, (1982), p. 7. He defines the media as 'false communication' and protests that youth do not consciously subscribe to pop culture.

32. British Film Institute, *Reading pictures*, (BFI, London, n.d.).

33. J. Mroczkowski, unpublished, University of British Columbia, 1986.

34. Elliot Eisner, *The educational imagination*, (Macmillan, New York, 1979). Robert Jeffcoate, *Positive image: Towards a multicultural curriculum*, (Writers and Readers, London, 1979).

35. D. Lusted (ed.) I*mages and blacks: The American experience*, (British Film Institute, London, 1981).

36. Laura H. Chapman, *Approaches to art in education*, (Harcourt, Brace and Jovanovich, New York, 1978).

37. Scott Foresman Social Studies, *Our World: Lands and cultures*, (Scott, Foresman and Company, Illinois, 1983).

38. Lawrence Stenhouse, *Authority, education and emancipation*, (Heinemann, London, 1983), p. 26, considered both the sciences and the arts a vital ingredient in every pupil's general education because they offer the teacher access to the living culture and because they are modes of creative innovation that feed on culture. He described the teacher's educational function as that of disciplining cultural innovation by generating in his or her class a culture based on standards that he or she approves and claimed to support any teacher who was trying to bring within the experience of the majority of their pupils those moral and human issues which in the past were generally regarded as open to enquiry only to an educated elite.

39. Ibid, p. 26.

40. Kristin Congdon, in 'The study of folk art in our school's art classrooms: some problems and considerations', *Journal of Multicultural and Cross-cultural Research in Art Education*, vol. 3, no.1, (1985), p. 70, she describes the language used by art historians, museum curators and art educators as 'esoteric'. She is concerned that art educators are not trained to recognise other sorts of verbal expressive modes such as 'folk speech'.

41. Geertz, *Local knowledge*, p. 96.

References

Calouste Gulbenkian Foundation (1982), *The arts in schools: Principles, practices and provision*, Gulbenkian, London

Department of Education and Science (1983) *Art in secondary education, 11-16.* HMSO, London

Gautier, G. (tr. British Film Institute) (1976) *The semiology of the image*, British Film Institute, London

Geertz, C. (1979) 'Deep play: Notes on the Balinese cockfight,' in P. Rabinow and W. M. Sullivan (eds.), *Interpretive social science: A reader*, University of California Press, Berkeley

Gibson, R. (1986) *Critical theory and education*, Hodder and Stoughton, London

Giroux, H. A. (1981) *Ideology, culture and the process of schooling*, Falmer, London

Greenhalgh, M. and Megaw, W. (eds.) (1984) *Art in society: Studies in style, culture and aesthetics*, Duckworth, London

Halpin, M. M. (1978) *Viewing objects in series*, University of British Columbia, Museum of Anthropology

Hamblen, K. (1984) 'Artistic perception as a function of learned expectations', *Art Education*, 37, 3, pp. 20-25

Layton, R. (1981) *The anthropology of art*, Granada, London

Lubbock, J. (1984) 'Art history at A-level: Policy, curriculum and marking', unpublished, University of Essex

McGuire, H. (1980) Woyo Potlids, *African Arts*, 18, pp. 54-7

McLeod, M. and Mack, J. (1985) *Ethnic Sculpture*, British Museum, London

Moses, Y. T. and Higgins, P. J. (eds.) (1981) *Anthropology and multi-cultural education: Classroom applications*, University of Georgia, Athens

National Association for Art Advisers (n.d.) *Using pictures with children*, North Eastern Group, York

Phillips-Bell, M. (1981) 'Multicultural education: A critique of Walking and Zec', *Journal of Philosophy of Education*, 15, 97-105

Rubin, A. (1979) 'The Pasadena tournament of roses', in Cordwell, J. (ed.) *The visual arts: Plastic and graphic,* Mouton, The Hague

Stewart, H. (1979) *Looking at Indian art of the Northeast coast*, Douglas and McIntyre, Toronto

Willett, F. (1971) *African art*, Thames and Hudson, London

Postscript 1994

There have been some important developments in art education since the first printing of this book that warrant a few remarks. Among them are (1) the *Arts Education in a Multicultural Society* (AEMS) project and (2) National Curriculum (Art) in England, Wales and Northern Ireland, and (3) the debate about and modifications to Discipline Based Art Education (DBAE) in the USA.

The AEMS project is noteworthy in that it was a national curriculum development project set up and administered by the Arts Council of Great Britain between 1989-1992. In keeping with Arts Council educational policy in general and the ethnic arts initiatives described in chapter three (p. 84), their approach to multicultural curriculum reform was via the non-European or minority artist-in-residence route. Art and design staff in selected universities, colleges and schools intending to conduct small-scale multicultural curriculum experiments were linked to a consultative network of black artists specifically trained to act in an advisory capacity. The outcomes of these experiments were reported in Arts Council AEMS bulletins and disseminated at national and regional exhibitions. My analysis of the AEMS documentation suggests that the project did not add any significant new insights about the nature and substance of multicultural curriculum to those already explored in my book; but it is worth commenting on one project in a further education college that confirms the conclusions about types of multiculturalism presented at the beginning of chapter one. In the project under discussion, mainstream (white) graphic design lecturers were persuaded by their minority artist advisers to abandon an 'agnostic' curriculum plan to involve their students in photographing a local Asian community. It was replaced by one which was more 'dialectical' and in which the students ended up applying their specialist skills to fulfil the communities' stated graphic design priorities and needs.

Following the Education Reform Act of 1988, a National Curriculum for Art has been formally embedded in the English school system. My personal response to this, together with those of a colleague, Sudha Daniel, is included in a chapter about the visual arts in *The Multicultural Dimensions of the National Curriculum* edited by Anna King and Michael Reiss which was published by Falmer Press in 1993. To summarise, we applauded its policy of commitment to a pluralistic, or culturally diverse conception of art, but concluded that the effects on classroom practice would be slight. In support of this view, we pointed to the gap in the majority of practising teachers' knowledge of anything other than European fine art and the paucity of non-European exemplars in the national curriculum programmes of study. This shortfall in teachers' ability to implement pluralist curriculum policy is currently being exacerbated by government plans for more schools-based teacher training and the demise of in-service art education provision by local authority advisers.

A significant development for multicultural reform enshrined in the national curriculum statutory orders and non-statutory guidance (National Curriculum Council, York, 1992) was the requirement that learning objectives for pupils must be directed towards 'knowledge and understanding' of art, not just 'making and investigating'. The decision of the National Curriculum Art Working Group to mandate against a curriculum exclusively dedicated to 'practical work' appeared promising given the significance that multicultural reformers such as myself attach to what Brian Allison has called the historical-cultural curriculum domain (p.79). Unfortunately, analysis of the working group's *Interim Report* and the Secretary for State's *Proposals for Art for Ages 5-14* (National Curriculum Council and Department of Education and Science, 1991) shows that the curriculum goal of knowledge and understanding proposed was premised on and legitimates the 'critical studies' principles and practices rejected in this book in chapter five. A major weakness of critical studies as a theoretical base for art education practice is that the recommended role models for thinking and talking about art are the artist and art critic - with lip-service being paid to the art historian and aesthetician; and absolutely no concessions are made to the more aesthetically distanced, yet intellectually penetrating, analyses of social theorists and anthropologists. (Admittedly, theorising about art in any shape or form is alien to the majority of teachers in British schools, but I remain convinced that this kind of shift in the discipline base to the subject is an essential for authentic multicultural curriculum reform.)

In the USA, where acceptance of cultural pluralism and diversity of arts is an educational imperative for demographic reasons (see Banks, J. [1988], *Multi-ethnic Education: Theory and Practice,* Allyn and Bacon, Newton, Mass.), multiculturalism was the single most topical and widely debated art education issue between 1989 and 1993. It dominated presentations at the annual National Art Education Association conventions and was the subject of numerous special conferences and papers in professional journals and magazines. (See, for example, Jacquie Chanda writing about 'Alternative Concepts and Terminology for Teaching African Art History' in *Art Education* [Vol. 45, No. 1, 1992] and the NAEA publication, *Art Culture and Diversity,* edited by Bernard Young [Reston, Virginia 1990]).

Since 1988, also, the Getty Center for Education in the Arts, whose Discipline Based Art Education (DBAE) had become something of a national curriculum orthodoxy in the USA, has had to reconsider its theory and recommendations for practice in the light of persistent criticism that its orientation was eurocentric and failed to address the diversity of American culture and arts. To give them their due, they responded positively with an extended programme of consultation with multicultural art education experts (e.g. June King McFee and Graeme Chalmers), many of whose publications are referred to in this book; and by organising an 'Issues Based Seminar' the results of which

are recorded in *Discipline Based Art Education and Cultural Diversity* published by the J. Paul Getty Trust (Santa Monica, California) in 1993.

Does all this mean that the nature and substance of multicultural art education has become crystal clear and that culturally diverse art education is about to be effected throughout the British and American school systems? I am unable to comment on the situation in the United States, but am confident that this is not yet the case in Britain. Arguments to support this are presented in my paper included in the report of the Getty seminar referred to previously. In it, I applied a typology of reform strategies developed by the multicultural education authority James Banks (1989) to recent developments in multicultural art practice in the UK. Briefly, I argued that although multicultural art education is no longer a contested concept in British schools, and although art room walls show clear evidence that more children are being introduced to non-European art forms, much of what goes on is 'tokenistic'. Typically, the so-called multicultural reforms are effected by means of cultural additions to a mainstream art curriculum that remains resolutely eurocentric and biased towards Western fine arts . Examples of art teaching that challenge what Banks would call the European fine arts 'canon' and seek to transform or alter its fundamental conception of what art is or might be are rare; as are social reconstructionist curriculum exemplars that set out to address and redress issues of racism and social equity.

While these problems persist, it is abundantly clear that interest in multicultural reform is not going to disappear and that it is becoming a global issue. Over the past five years I have worked with research degree students who are practising art teachers from Korea, Portugal, the Netherlands, Canada and Japan all of whom have elected to make it the focus of individual programmes of research. What is needed to translate the research and policies that are already in place in many countries into classroom practice - given that I see multicultural reform as an inevitable consequence of demographic shifts in world populations and the spread of global culture word wide - I am unsure. Clearly there is a need for strong art educational leadership in this regard. In the preface to this book, in 1988, I mentioned how important it was for mainstream (white) art educators in Britain to open up more space for the views of minority colleagues, a comment that is equally relevant in 1994.

On a personal level, I continue to be intrigued by the theoretical insights of anthropologists into art and global culture although I recognise this runs the risk of annihilating the kind of knowledge and understanding of the subject that is derived from the more traditional discipline-bases of art history, criticism and aesthetics. I am curious as to why Western aesthetic theory attributes aesthetic value to such a limited range of made objects and why there is no equivalent to ethnomusicology in art. Also why is there no equivalent in art to the

comparative study of religion in schools? Could it be that the anthropologist Alfred Gell is right when he suggests that art in modern societies is a substitute for religion and that the charge of aesthetic philistinism (the equivalent of methodological aetheism in the study of religion) he levels against art education is just too hard for us to swallow? For readers wishing to update themselves on Gell's theorising and other matters pertaining to anthropology and art, I recommend *Anthropology, Art and Aesthetics* edited by Jeremy Cootes and Anthony Shelton, published by Clarendon Press, Oxford in 1992, together with Ellen Dissanayake's *What is Art For?* published in 1998 by the University of Washington Press.

R.M.M. 1994

Appendix

Film Script: *Sunita and Sanjay's Adventure at Diwali*

First Girl	This is a story about a girl and a boy. The girl's name is Sunita and the boy's name is Sanjay.
First Boy	One day, Sanjay and Sunita were walking down Belgrave Road and they were buying food, sweets, clothes and jewellery for Diwali.
Second Girl	The next day Sanjay and Sunita went to school and, when they got home, their mum said, 'I've forgotten something I wanted to buy' and, their dad said, 'I want to go to the temple to pray'. So, their mum went shopping and, their dad went to the temple...
Second Boy	And Sunita climbs onto a stool and she gets a box; and she thinks its some sweets; but really, they were fireworks and she was calling Sanjay. Sunita said 'just one firework, please', and Sanjay said, 'alright, only one'.
Third Boy	So, they went out into the garden and they left the door open and they got a glass bottle from the crate and they put the rocket in the bottle and they lit it. Suddenly the rocket went off 'Whoosh' and it went right through the door and hit the curtains.
Third Girl	The next-door neighbour's wife saw that the kitchen was on fire and she called the fire-engine and the fire engine came and put the fire out.
Fourth Girl	After a while, their mum came back and she gave them a good telling off and said 'Sanjay, you better go and tell your dad'.
Fourth Boy	So Sanjay ran to the temple and shouted 'Dad, Dad' and everyone started looking at him: and his dad was very angry because he was in the middle of a prayer.
Fifth Boy	When they got home, dad was very angry. He said they had spoiled all their Diwali preparations because all the good things were in the kitchen.
Fifth Girl	The children were very upset for the rest of the week...
Sixth Boy	But on Friday, their dad came back and said, 'I've got some good news for you. I've just won the football pools. I got a lot of money. It just came out . . .
Fourth Boy	And there's enough money to do the kitchen again, so we can all go down to the recreation ground for Diwali and see the fireworks there anyway.

Third Girl So they all went down to the recreation ground and had lots of fun.

First Girl But Sanjay and Sunita never ever touched fireworks again without their mum and dad's permission.

Boys and Girls (laughing) And, they all lived happily ever after.

Bibliography

Adams, A. (1976) *The humanities jungle*, Ward Lock Educational, London

Adams, E. and Ward, C. (1982) *Art and the built environment*, Longman, London

ACER. (1981) *Words and faces*, Afro-Caribbean Resources Project, London

Alexander, R. (1980) 'The evaluation of naturalistic, qualititative, contextualist, constructivist research in art education', *Review of Research in Visual Arts Education*, vol. 13, pp. 345- 43

Allison, B. (1972) *Art education and teaching about the art of Asia, Africa and Latin America*, Voluntary Committee on Overseas Aid and Development Education Unit, London

——— (1982) 'Identifying the core in art and design', *Journal of Art and Design Education*, vol. 1, no.1, pp. 59-66

——— Denscombe, M. and Toye, C. (1985) *Art and design in a multicultural society: A survey of policy and practice*, De Montfort University (formerly Leicester Polytechnic, Leicester).

Andrews, E. M. (1983) 'The innovation process of culturally-based art education', unpublished PhD dissertation, University of Bradford

Aoki, T. (1978) 'Toward curriculum research in a new key', *Presentations in art education research*, no.2, Concordia University, Montreal

Araeen, R. (1984) *Making myself visible*, Kala Press, London

Archer, W.G. (1960) *Indian miniatures*, Studio Books, London

Armstrong, M. (1980) *Closely observed children; the diary of a primary classroom*, Writers and Readers Publishing Cooperative, London

Arnheim, R. (1971) 'Art and humanism', *Art Education*, vol. 24, no.7, pp. 8-9

Arora, R. K. and Duncan, C. G. (eds.) (1986) *Multicultural education: Towards good practice*, Routledge and Kegan Paul, London

Art and Development Education 5-16 Project (1986) *Art as social action*, Effra School, Brixton

...

Arts Council (1982) *Broadening the context*, Critical Studies in Art Education Project, Occasional Publication no.1, London

—— (1983) *The illuminating experience: Critical studies in art education*, Critical Studies in Art Education Project, Occasional Publications no.2, London

Barley, N. (1983) 'The warp and woof of culture', *Royal Anthropological Institute News*, no. 59, pp. 7-8

Barrow, R. (1976) *Commonsense and the curriculum*, George Allen and Unwin, London

Becker, H. S. (1982) *Art worlds*, University of California Press, Berkeley

Berger, B. (1983) 'The implementation of an art-based programme designed to develop cultural awareness among students in an urban native Indian class', unpublished Masters dissertation, University of British Columbia

Bennet, O. (1984) *A busy week-end*, Hamish Hamilton, London

Blakeley, M. (1977) *Nahda's family*, A. and C. Black, London

Bolam, D. (1971) 'Integrating the curriculum: A case study in the humanities', *Paedagogica Europaea*, vol. 6, pp. 157-171

Bowen, D. (ed.) (1980) *The arts of Africa*, Visual Publications International, London

Bridger, P. (1969) *A Hindu family in Britain*, Religious Education Press, Oxford

British Film Institute (n.d.) *Reading pictures*, BFI Publications, London

British Museum (1985) *Eduardo Paolozzi: Lost Magic Kingdoms*, British Museum Publications, London

Bronsdon-Rowan, M. (1982) 'Learning to look with teachers', *Museum Quarterly*, British Columbia Museum Association, no. 84, pp. 40-42

Brown, M. and Clarke, M. (1981) *The way we live*, Oxfam Education Department, Oxford

Brudenell, I. A. (1986) *Cross-cultural art booklets*, Nottingham Educational Supplies, Nottingham

Bulmer, J. (1977) *Guide to teaching anthropology in schools and colleges*, School of Oriental and African Studies, University of London

Burckhardt, T. (1976) *Art of Islam: Language and meaning*, World of Islam Festival Publishing Company, London

Burgess, R. G. (1980) 'Field problems in teacher-based research', *British Educational Research Journal*, vol. 6, no. 2, pp. 165-73

—— (ed.) (1984) *The research process in educational settings*, Falmer, London

Calouste Gulbenkian Foundation (1982) *The arts in schools: Principles, practices and provision*, Gulbenkian, London

Chalmers, F. G. (1978) 'Teaching and studying art history; Some anthropological and sociological considerations', *Studies in Art Education*, vol. 20, no.1, pp. 18-25

—— (1981) 'Art education as ethnology', *Studies in Art Education*, vol. 22, no.3, pp. 6-14

Chapman, L. H. (1978) *Approaches to art in education*, Harcourt, Brace and Jovanovich, New York

—— (1982) I*nstant art, instant culture*, Teachers College Press, New York

Commission for Racial Equality (1981) *Arts education in a multicultural society*, CRE, London

Condous, J. (ed.) (1980) *Arts in cultural diversity*, Holt, Rinehart and Winston, Sydney

Congdon, K. (1985a) 'The study of folk art in our school's art classrooms: Some problems and considerations', *Journal of Multi-cultural and Cross-cultural Research in Art Education*, vol. 3, no.1, pp.65-76

—— (1985b) 'A folk group focus for multicultural education', *Art Education*, vol.38, no. 1, pp. 13-16

Coombs, J. (1986) 'Multicultural education and social justice', *International Yearbook of Higher Education*, no. 14, pp.1-13

Cordwell, J. (1979) *The visual arts: Plastic and graphic*, Mouton, The Hague

Corlett, J. and Parry, G. (eds.) (1985) *Anthropology and the teacher*, ATSS Resources Unit, Department of Sociology, University of York

Craft, M. (1984) *Education and cultural pluralism*, Falmer, London

Cragg, K. (1978) *Islam and the Muslim*, Open University Press, Milton Keynes

Crawford, D. (1983) 'Nature and art: Some dialectical relationships', *Journal of Aesthetics and Art Criticism*, vol. 43, no. 1, pp. 49-59

Cuthbertson, S. (1982) 'Dialogue with objects: Asking questions', *Museum Quarterly*, British Columbia Museum Association, no.84, pp. 21-23

Denscombe, M. and Conway, L. (1981) 'Anecodotes, examples and curriculum development', unpublished, Leicester Polytechnic

Department of Education and Science, Inspectorate of Schools (1978) *Art in junior education*, HMSO, London

—— (1981) Committee of Enquiry into the Education of Children from Ethnic Minority Groups, *West Indian children in our schools*, HMSO, London

—— (1982) *An illustrative survey of 80 first schools in England. Education 5-9*, HMSO, London

—— (1983) *Art in secondary education* (11-16), HMSO, London

—— (1985) Committee of Enquiry into the Education of Children from Ethnic Minority Groups, *Education for all*, HMSO, London

Dufty, D. (ed.) (n.d.) *Four windows on Pakistan: Art, crafts and daily life*, Educational Media, Australia, Melbourne

Dyson, A. (1982) Art history and criticism in schools, *Journal of Art and Design Education*, vol. 1, no.1, pp. 123-133

—— (ed.) (1986) *Art history and criticism in schools,* University of London, Institute of Education, London

Efland, A. (1976), 'The school art style: A functional analysis', *Studies in Art Education*, vol. 17, no.2, pp.37-44

Eisner, E. W. (1972) *Educating artistic vision*, Macmillan, New York

—— (1974) *English primary schools: Some observations and assessments*, National Association for the Education of Young Children, Washington DC

—— (1979) *The educational imagination: On the design and evaluation of school programs*, Macmillan, New York

—— (1982) 'The relationship of theory and practice in art education', *Art Education*, vol. 35, no. 1, pp. .4-5

Ethnographic Resources in Art Education (1979) *Pottery cultures*, Department of Art, City of Birmingham Polytechnic

—— (1983) *Dyed and printed textiles*, City of Birmingham Polytechnic

—— (1985a) *The art of play*, CSV publications, London

(1985b) *Peoples, processes and patterns: Islam and Japan*, City of Birmingham Polytechnic

Ewan, J, (1977) *Understanding your Hindu neighbour*, Lutterworth Press, Guildford

Falk, T., Smart. E. S. and Skelton, R. (1978) *Indian Painting*, Lund Humphries, London

Feldman, E. B. (1970) *Becoming human through art*, Prentice-Hall,

New Jersey

—— (1980) 'Anthropological and historical conceptions of art curricula', *Art Education*, vol. 33, no.6, pp. 6-10

—— (1982) 'Varieties of art curricula', *Journal of Art and Design Education*, vol.1, no.1, pp.21-45

Gardner, H. (1980) *Artful scribbles*, Jill Norman, London

Gautier, G. (1976) *The semiology of the image*, British Film Institute Publications, London

Geertz, C. (1983) *Local knowledge: Further essays in interpretive anthropology*, Basic Books, New York

Gibson, R. (1986) *Critical theory and education*, Hodder and Stoughton, London

Gilmore, P. and Glatthorn, A. (eds.) (1982) *Children in and out of school: Ethnography and education*, Centre for Applied Linguistics, Washington DC

Giroux, H. A. (1981) *Ideology, culture and the process of schooling*, Falmer, London

Gleeson, D. and Whitty, G. (1976) *Developments in social studies*, Open Books, London

Gollnick, D. and Chinn, P. (1983) *Multicultural education in a pluralistic society*, C. V. Mosely, St. Louis

Graburn, N. H. (ed.) (1976) *Ethnic and tourist arts*, University of California Press, Berkeley

Grant, J. W. (1985) 'African arts-an adventure in education', *Studies in Design Education and Craft*, vol. 17, no. 2, pp. 79-89

Greenhalgh, M. and Megaw, W. (eds.) (1984) *Art in society: Studies in style, culture and aesthetics*, Duckworth, London

Grigsby, J. E. (1977) *Art and ethnics*, William C. Brown, Dubuque, Iowa

Guba, E. G. and Lincoln, Y. S. (1981) *Effective evaluation: Improving the usefulness of evaluation results through responsive and naturalistic approaches*, Jossey-Bass, San Francisco

Guise, F. (1983) 'To what extent do Asians have a choice in where they live?' unpublished BEd dissertation, De Montfort University (formerly Leicester Polytechnic, Leicester).

Gundara, J., Jones, C. and Kimberley, K. (eds.) (1986) *Racism, diversity and education*, Hodder and Stoughton, London

Gutzmore, C. (1986) 'Caribbean visual history project', unpublished, University of London

Hall, S. and Jefferson, T. (1976) *Resistance through rituals*, Hutchinson, London

Halpin, M. M. (1978) *Viewing objects in series*, University of British Columbia, Museum of Anthropology

Hamblen, K. (1984) 'Artistic perception as a function of learned expectations', *Art Education*, vol. 37, no.3, pp.20-25

Hammersley, M. and Hargreaves, A. (1983) *Curriculum practice: Some sociological case studies*, Falmer, London

Hitchcock, J. H. (1983) 'Art in British child-centred schools', *School Arts*, vol. 82, no. 7, pp. 32-33

Hughes, R. (1980) *The shock of the new*, BBC, London

Husain, S. S. and Ashraf, S. A.(1979) *Crisis in Muslim education*, Hodder and Stoughton, London

Inner London Education Authority, (1976) *Just like us*, ILEA, London

—— (1978) *People around us: Families*, A. and C. Black, London

—— (1980) *Social sciences in the primary school*: ILEA curriculum guidelines, ILEA, London

—— Inspectorate (1983) *History and social sciences at secondary level*, ILEA London

—— Cocking, C. and Craig, D. (eds.) (1984) *Education in a multi-ethnic society: The primary school*, ILEA, London

—— Committee on the Curriculum and Organization of Secondary Schools (1984) *Improving secondary schools*, ILEA, London

Iqbal, M. and Maryam, K. (1976) *Understanding your Muslim neighbour*, Lutterworth press, Guildford

Jagodzinski, J. (1982) 'Art education as ethnology: Deceptive democracy or a new panacea?' *Studies in Art Education*, vol. 23, no. 3, pp. 5-7

Jantjes, G. (1983) 'The words about use', *Art Libraries Journal*, Winter, pp. 14- 83

Jeffcoate, R. (1979) *Positive image: Towards a multiracial curriculum*, Writers and Readers Publishing Co-operative, London

Katchadourian, H. (1980) 'Humanistic functions of the arts today', *Journal of Aesthetic Education*, vol. 14, no. 2, pp. 11-22

Khan, N. (1976) *The arts Britain ignores: The arts of the ethnic minorities in Britain*, Community Relations Commission, London

Lavender, R. (1975) *Myths, legend and lore*, Blackwell, Oxford

Layton, R. (1981) *The anthropology of art*, Granada, London

Leary, A. (1984) *Assessment in a multicultural society: Art and design at 16+*, Schools Council, London

Leicester City and County Council (1983) *Survey of Leicester*

Levi, A. (1983) 'The humanities, their essence, nature, future', *Journal of Aesthetic Education*, vol. 17, no. 2. pp. 5-17

Lubbock, J. (1983) 'Art history and visual education: Aims and methods for 11-18 year olds', unpublished report, University of Essex

———— (1984) 'Art history at A level: Policy, curriculum and marking', unpublished report, University of Essex

Lusted, D. (ed.) (1981) *Images and blacks: The American experience*, British Film Institute, London

Lyle, S. (1978) *Pavan is a Sikh*, A. and C. Black, London

Lynch, J. (1981) *Teaching in the multicultural school*, Ward Lock Educational, London

———— (1986) *Multicultural education: Approaches and Paradigms*, University of Nottingham, School of Education

Marett, V. (1983) 'The resettlement of Ugandan Asians in Leicester 1972-80', unpublished PhD dissertation, University of Leicester

Mason, R. (1985a) 'Some student-teachers' experiments in art education and humanistic understanding', *Journal of Art and Design Education*, vol. 4, no.1. (1985) pp. 19-33

———— (1985b) *Using art to increase social understanding: Teachers' guide*, De Montfort University (formerly Leicester Polytechnic, Leicester).

———— (1986) 'Helping student-teachers to broaden their conceptions of art and design curricula', *Journal of Art and Design Education*, vol. 39, no. 4, pp. 46-51

McFee, J. K. and Degge, R. M. (1977) *Art, culture and environment*, Wadsworth, California

McGuire, H. (1980) 'Woyo Potlids', *African Arts*, vol.18, pp.54-7

McLeod, M. and Mack, J. (1985) *Ethnic sculpture*, British Museum, London

McNeil, F. and Mercer, N. (1982) *Here I am: Primary language project*, A. and C. Black, London

Mehlinger, H. (ed.) (1981) *UNESCO handbook for the teaching of social studies*, Croom Helm, London

Midland Examining Group (1988) *Art and design: General certificate of secondary education examination syllabuses*, 1988

Miller, D, (1983) 'Things ain't what they used to be,' *Royal Anthropological News*, no. 59, p.1

Mischel, T. (ed.) (1974) *Understanding other persons*, Blackwell, Oxford

Moses, Y. T. and Higgins, P. J. (eds.) (1981) *Anthropology and multicultural education classroom applications*, Publication 83-1, University of Georgia, Athens

Mountfield, A. (1977) *The firefighters*, C. Tibling and Co., London

Musgrove, F. (1982) *Education and anthropology: Other cultures and the teacher*, John Wiley, Chichester

Nadaner, D. (1984) 'Developing social cognition through art in the primary school', unpublished report, Simon Fraser University, Vancouver

National Association of Art Advisers (n.d.) *Using pictures with children*, North Eastern Group, York

Nattress, B. (1983) 'Approaches towards art in primary education: An analysis of curriculum rationales', unpublished Masters dissertion, University of Lancaster

Owusu, K. (1986) *The struggle for black arts in Britain*, Comedia publishing, London

Phillips-Bell, M. (1981) 'Multicultural education: A critique of Walkling and Zec', *Journal of Philosophy of Education*, vol. 15, no.1, pp. 97-105

Pring, R. (1976) *Knowledge and schooling*, Open Books, London

—— (1984) *Personal and social education in the curriculum*, Hodder and Stoughton, London

Rabinow, P. and Sullivan, W, M. (1979) *Interpretive social science: A reader*, University of California Press, Berkeley

Rader, M. and Jessup, B. (1976) *Art and human values*, Prentice-Hall, New Jersey

Reid, L. A. (1986) *Ways of understanding and education*, Heinemann, London

Rice, D. T. (1965) *Islamic art*, Thames and Hudson, London

Rodriguez, F. and Sherman, A. (1983) *Cultural pluralism and the arts*, University of Kansas, Lawrence

Rogers, P. (1984) 'Multicultural art', *Changing Traditions*, University of Central England (formerly City of Birmingham Polytechnic, Birmingham).

Rubin, B. (1982) 'Naturalistic evaluation: Its tenets and application', *Studies in Art Education*, vol. 24, no. 1. pp. 57-63

Ruddell, D. and Phillips-Bell, M. (1980) *Race relations teaching pack*, AFFOR, Birmingham

Schools Council (1977) *The Muslim way of life*, Hart Davis Educational, St. Albans

Searle, C. (1977) *The world in a classroom*, Writers and Readers Publishing Co-operative, London

Schutz, A. (Wagner, H. R. ed.) (1972) *Alfred Schutz on phenomenology and social relations: Selected writings*, University of Chicago Press, Chicago

Scott, Foresman Social Studies (1983) *Our world: Lands and cultures*, Scott, Foresman and Company, Illinois

Simkin, D. and J. (eds.) (1984) *Curriculum development in action*, Tressel, London

Smibert, T. and Burns, C. (1979) *Art, nature and life: An introduction to Japanese culture*, Educational Media Australia, Melbourne

Smith, R. (1982a) 'On the third realm, two decades of politics in art education', *Journal of Aesthetic Education*, vol. 16, no. 3, pp. 5-15

—— and Smith, C. (1982b) 'On the third realm - once more the case for liberal education', *Journal of Aesthetic Education*, vol.16, no. 2, pp.6-9

—— (1983a) 'The arts in general education ideology: Some critical observations', *Art Education*, vol. 36, no.4, pp.34-37

—— (1983b) 'Forms of multicultural education in the the arts', *Journal of Multi-cultural and Cross-cultural Research in Art Education*, vol. 1, no.1, pp.23-32

Soloman, J. (1984) *Sweet tooth Sunil*, Hamish Hamilton, London

Stanley, N. (1986) 'The power of art', unpublished report, City of Birmingham Polytechnic

Stenhouse, L. (1968) 'The humanities curriculum project', *Journal of Curriculum Studies*, vol. 1, no. 1, pp. 26-33

—— (1975) *An introduction to curriculum research and development*, Heinemann Educational, London

—— (1978) 'Case study and case records: Towards a contemporary theory of education', *British Journal of Educational Research*, vol. 4, no. 2. pp. 21-28

—— (ed.) (1981) *Curriculum research and development in action*, Heinemann, London

—— (1983) *Authority, education and emancipation*, Heinemann, London

Street-Porter, R. (1978) *Race, children and cities*, Open University Coursebook E. 361, Milton Keynes

Taylor, R. (1986) *Educating for art: Critical response and development*, Longman, London

Tierney, J. (ed.) (1982) *Race, migration and schooling*, Holt, Rinehart and Winston, London

UNICEF School Series No.5 (Topouzis, D., ed. 1985) *With Shiromi in Sri Lanka*, United Nations Children's Fund, London

Van Santen, J. (1986) 'Resources for multicultural art education; A framework for evaluation', unpublished paper, Institute of Education, University of London

Warwick, D, (1973) *Integrated studies in the secondary school*, Schools Council, London

Willet, F. (1971) *African Art*, Thames and Hudson, London

Willis, G. (ed.) (1978) *Qualitative evaluation: Concepts and cases in curriculum criticism*, McCutchan, Berkeley

Wilson, A. (1983) 'From the specific to the general', *Times Higher Education Supplement*, vol. 14, no.18, p.14

Wilson, B. and Wilson, M. (1982) *Teaching children to draw*, Prentice-Hall, New Jersey

Index

146